# THE CROWN IN
# VOGUE

# THE CROWN IN
# VOGUE

Robin Muir & Josephine Ross

ThunderBay
P·R·E·S·S

San Diego, California

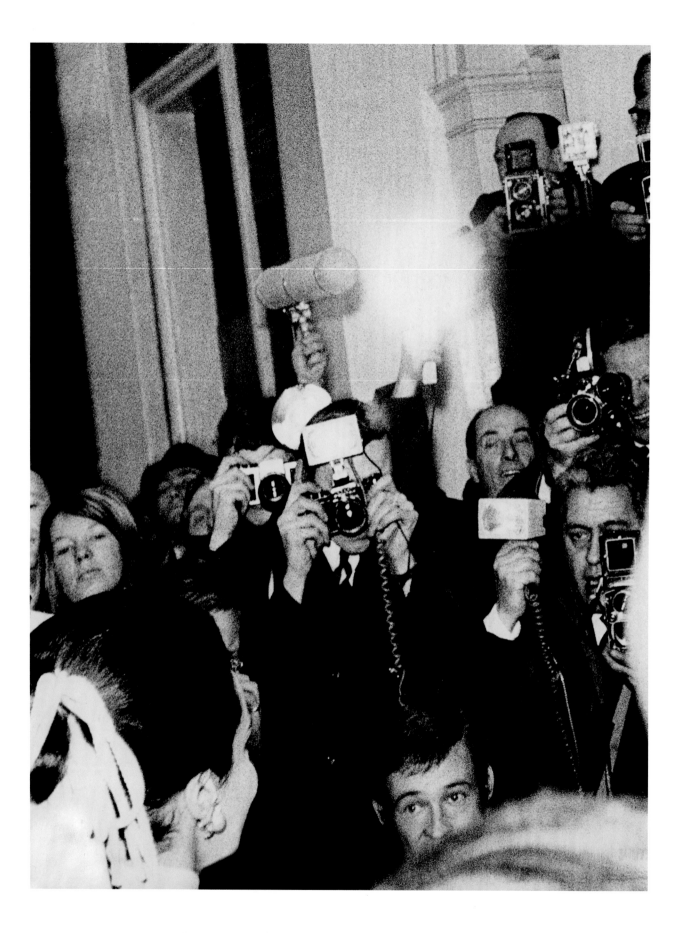

# Contents

# Foreword
## *by Edward Enninful OBE*

In my time as Editor-in-Chief of British *Vogue*, I do seem to have become known as something of a changemaker – and of course I'm proud of that. Though I do sometimes notice that I can surprise people when they actually come to meet me. Because you know what? I also like the classics. I admire public service. I admire loyalty. I admire a solid work ethic and a thoughtful sense of duty, and I especially admire anyone who can learn and adapt and evolve with the times.

My mind boggles when comparing the woman born as Princess Elizabeth in 1926 and the world she looks out on today, and the path of hard yet slow evolution that has brought her here. And so it is, in the 70th year of her reign as Her Majesty the Queen, that *Vogue* publishes this special royal salute.

Shaping it has been an important job that Robin Muir, our longstanding Contributing Editor at British *Vogue*, together with Josephine Ross, have taken on with aplomb. *Vogue*, like the royal family, has been through many evolutions of its own, and to view Her Majesty's life though the record of our pages is truly a document of history.

As we move ever deeper into the 21st century, for many people, and certainly any person born in a one-time British colony such as myself, in Ghana, the relationship to the British Royal Family can be complicated, to say the least. When I received my OBE for services to diversity in fashion several years ago, before my arrival at British *Vogue*, I thought carefully about what the decision to accept it would mean. Ultimately, I saw an ancient institution led by a monarch who was setting out on a program of change. If they had noticed and wanted to recognise my work as something worth spotlighting, given the fact my endeavours were all about spotlighting under-represented people too, then I felt comfortable – keen even – to engage.

It is a lesson I still hold dear today. I will always love a show-stopping moment, but over the years I have also come to enjoy slow, meaningful engagement, the sort that unites rather than alienates, that is fair rather than unnecessarily firm, that leans into the collective and brings all types of voices together. Rather, I hope, as the woman this book celebrates has done.

→ **A Coronation Christmas, 1953, by André François.**

# VOGUE

Christmas
Number

Q ♥

♥ Q

*Price*

DECEMBER 1958

THE CONDÉ NAST PUBLICATIONS LTD.

# Introduction:
## *Chronicling the Crown*

'The camera has a unique capacity to conserve a moment in time,' observed a photo caption in *Vogue* in February 1981. It was no mere chance that those words appeared above a portrait, by royal photographer Lord Snowdon, of a fresh-faced, wide-eyed, somewhat ingénue 19-year-old aristocrat, Lady Diana Spencer. Within days of the magazine appearing on the bookstalls, the engagement of Lady Diana and the heir to the throne, Prince Charles, the Prince of Wales, would be announced, and the 'moment in time' conserved in that *Vogue* image would come to represent the start of one of the most celebrated public lives and careers of the 20th century. It was a striking instance of the role continuously played by the world's most famous fashion magazine in recording – and at times even shaping – the story of the Crown in modern British history.

Founded in America in 1892, *Vogue* had been a modest little gazette with a declining circulation when, in 1909, it was acquired by an ambitious young publisher named Condé Nast and relaunched as an illustrated magazine that would appeal (in his words) to women 'not merely of great wealth,' but more importantly, 'of taste'. To attract such an elite readership, Nast ensured that his new *Vogue* would faithfully reflect the worlds of the fashionable and glamorous; and this, even in republican America, had to include well-informed royal reporting. Figures such as the Kaiser of Germany and the Tsar's pretty daughters featured in early issues; but after World War I, when a separate British edition had been launched, other thrones had fallen and the spotlight was firmly on British royalty. What Britain's Royal Family did, what they wore and – above all – whom they married were of unfailing interest to readers on both sides of the Atlantic, and Nast spared no expense in commissioning the greatest photographers, writers and illustrators of the day to record their lives and activities.

The result today is an astonishing treasury of royal reporting, contained in over a century of past issues. To look back through them now is to share the original readers' experience of seeing the great events of four reigns unfold: coronations and jubilees, weddings and births, an abdication and 'the death of kings', all recorded with incomparable style – and often exclusive access. 'I must be seen to be believed,' the present Queen Elizabeth II has reportedly stated; and from the outset, *Vogue*'s reputation for quality and 'taste' was such that royalty were happy to be seen in its pages. When, in 1922, King George V and Queen Mary's only daughter Princess Mary was married, the Queen and Princess – as *Vogue* wrote – 'waived their usual dislike of unnecessary

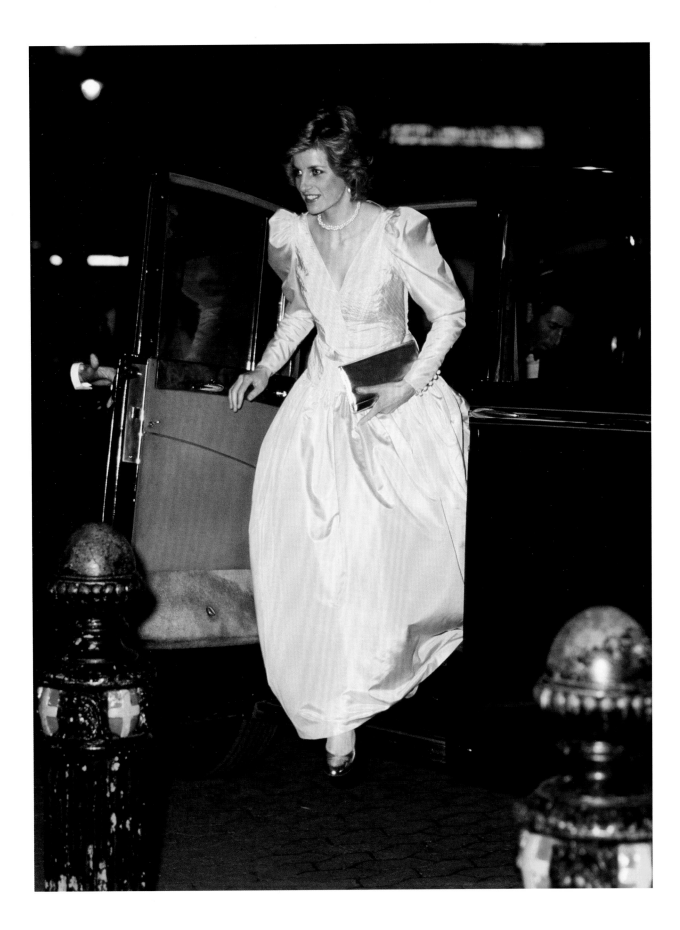

publicity' to release advance details of the bride's dress to the magazine. Twelve years later in 1934, when the beautiful Princess Marina of Greece and Denmark married Britain's Prince George, Duke of Kent, *Vogue* was granted the extraordinary privilege of a fashion shoot with the duchess-to-be, who modelled her couture trousseau for the great photographer Horst. And when, in 1981, Lady Diana Spencer was revealed as the next Princess of Wales – and supposedly future Queen – *Vogue* would be called on to help restyle her image for her momentous new role.

Royalty and romance could be relied on to sell copies, and some of Nast's most beautifully produced early issues were created to celebrate the royal weddings of the 1920s and '30s. The first, for Princess Mary's marriage, had a lavish silver cover; its successor, for the wedding of the Duke of York and Lady Elizabeth Bowes-Lyon in 1923, had a still more sumptuous gilded cover – and unbeknown to Nast or his readers at the time would prove to be a still more historic issue. The Duke of York was King George V's second son; his bride, though a Scottish aristocrat, was a 'commoner', the first non-royal woman to marry a British prince for generations. Yet, with all the drama of a fictional dynastic saga, this popular but unassuming young couple were destined to become two of the most important figures in

the history of the Crown, as King George VI and his Queen Consort Elizabeth: the nation's and Empire's leaders in World War II and parents of the next great monarch, Queen Elizabeth II.

The real-life royal dynastic saga continued with the births, in 1926 and 1930, of the Yorks' two daughters, Elizabeth and Margaret Rose. The heir to the Crown, the future King Edward VIII, was still unmarried; with his legendary good looks and evident fondness for women, it was assumed that this situation would not last, and he would have heirs of his own. In the meantime, however, the Yorks' delightful 'Little Princesses' were, after their father, next in line to the throne. Doted on by the press and public, from babyhood they were often seen in *Vogue*, photographed by Marcus Adams.

According to the American journalist John McMullin, 'the two tiny Princesses ... brought down the crowd' when they appeared in the state procession for their grandfather King George V's Silver Jubilee in 1935. Reporting for American *Vogue*, McMullin professed himself utterly overwhelmed by the scenes, as vast crowds celebrated the 25th anniversary of their sovereign's accession. The appearance of the King's consort, Queen Mary, in her customary attire, with a pink lamé toque hat, dazzled him: 'The most glamorous woman in the world, a

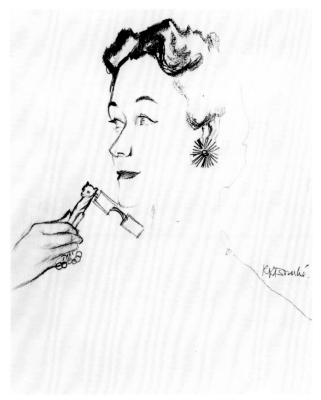

demi-goddess!' he wrote with rapture. British *Vogue* marked the great occasion with another lavish special edition, including a photograph of the King on a richly gilded background, surrounded by decorative little drawings of times past by one of the magazine's staff members, the writer Lesley Blanch.

A still more renowned regular contributor was the prized and prolific Cecil Beaton. Beaton had initially joined *Vogue* as a freelance illustrator, but his other talents were swiftly recognized by Condé Nast. As photographer, writer, artist and designer, he would create some of the century's most iconic coverage of the Crown, and his friendships with royalty – including the future Duchess of Windsor – were among his myriad assets.

Following George V's death in 1936, *Vogue* had a historic coup, when the world learned what Beaton, and many of the magazine's readers, had known for months: that the new King, Edward VIII, was infatuated with a twice-married American named Wallis Simpson. Unable as King to wed a divorcee, Edward abdicated to marry 'the woman I love', as he famously announced. Within weeks, American *Vogue* published the results of an exclusive portrait-sitting Beaton had already been granted with the woman who would become the Duchess of Windsor. Four months later, at the Windsors' wedding in France, Beaton took the official pictures, which appeared in *Vogue* accompanied by a unique portfolio of photographs of the Duchess modelling her trousseau.

A major royal fashion moment came in 1938. With war in Europe looming, and royal foreign tours to secure major alliances in the offing, the somewhat matronly image of George VI's Queen Consort Elizabeth was given a radical makeover. Inspired by a portrait of the French Empress Eugénie in a Victorian crinoline gown, royal dressmaker Norman Hartnell created a new look for the Queen as a 'fairy tale' vision of regal femininity, in romantic, floaty, full-skirted gowns. Immortalized in Beaton's photographs,

the crinoline look launched a new fashion, and set the keynote for the future Queen Mother's picturesque, enduring style.

The World War II years would, however, bring a far more profound change to the royal image. From matriarch Queen Mary down to nine-year-old Princess Margaret, the Royal Family were all now seen 'doing their bit' – most in (well-tailored) uniform. Morale-boosting *Vogue* articles stressed the King and Queen's cheerfulness as they shared the restrictions of ration books and clothing coupons – and the peril of air raids. Beaton's camera now captured Their Majesties inspecting bomb damage at Buckingham Palace; the Princesses wearing recycled gowns; and the teenage Heir Presumptive Elizabeth in her first military role, as Colonel-in-Chief of the Grenadier Guards. As the post-war era dawned, the focus would increasingly be on her – and the future of the Crown.

The marriage of Princess Elizabeth to Philip Mountbatten, Duke of Edinburgh, on November 20, 1947, took place amid continuing rationing and austerity, and the charming cover of their Royal Wedding issue, by the illustrator Carl Erickson ('Eric'), conveyed romance, not ostentation. The tone of *Vogue*'s royal coverage, while reverent as ever, now increasingly stressed the work and service of the Royal Family – and

after the birth of her son and daughter, Prince Charles and Princess Anne, in 1948 and 1950, Princess Elizabeth's role as a young mother, to which all could relate. Yet the appeal of regal pomp and pageantry never waned; and when, after George VI's untimely death, the young Queen Elizabeth II was crowned in 1953, the magnificent ceremonial was recorded in *Vogue* in pages of spectacular photographs by Cecil Beaton and Norman Parkinson. Accompanying them were Beaton's vivid notes and sketches, made inside Westminster Abbey during the proceedings. 'This is history, but it is of today, living and new,' was one of his eloquent comments, and looking now at the story of the British Crown, through *Vogue*'s past issues, it still reverberates.

Fittingly for the 'New Age', this coronation was the first ever broadcast on television – seen by an audience of millions worldwide. Nowhere outside Britain was interest higher than in America, where, in 1957, the Queen's first official visit would be greeted (American *Vogue* wrote) by 'a wave of excitement', based not on 'pure romanticism', but 'respect ... for a young woman, barely out of her twenties, who performs an enormously complicated and taxing job, with courage and sensitivity, industry and intelligence.' The times were certainly changing.

**Princess Margaret,
1949, by Cecil Beaton.**
'She looked very pretty and
wore quite a lot of make-up,'
recalled Beaton. 'And the eyes
are of a piercing blue – cat-like
and fierce and so very youthful.'

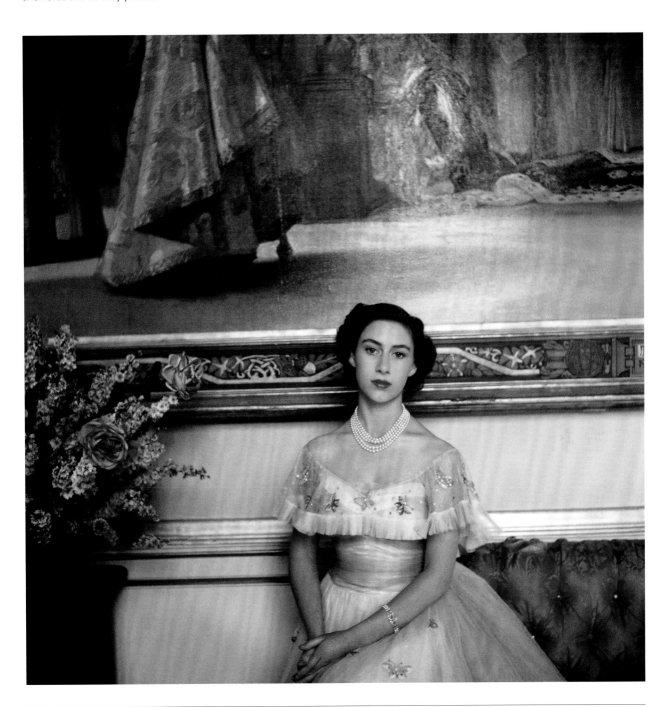

In 1960, the nation rejoiced when the Queen's sister Princess Margaret married the society photographer 'plain Mr Armstrong Jones', as *Vogue* knew him. Her ill-fated love affair with Group Captain Peter Townsend, 16 years her senior and divorced, was over. Armstrong Jones had been with the magazine since 1956, his best work hard-edged and documentary in style, very unlike the good-natured studio pictures that marked out early post-war *Vogue*.

Times were changing both in and out of *Vogue*. The world suddenly belonged to the young, willing to question accepted beliefs and unwilling to treat established institutions with due reverence. Conventions were reversed: working-class photographers rubbed shoulders with aristocrats who had dropped their titles, and a new democracy of models, photographers, pop musicians, art directors and advertising supremos was born. Egalitarianism of opportunity ruled at the *Vogue* studios too, as the careers of its leading and emerging photographers intertwined.

David Bailey, *Vogue*'s rising star, had been offered his first break by Armstrong Jones (and tea from a silver teapot in his trendy Rotherhithe studio). Bailey's best friend was Terence Donovan, like him from London's East End. Donovan would years later make portraits of Diana, Princess of Wales, with whom he struck up a personal friendship. (Bailey would photograph the Queen and make her laugh). The third in a triumvirate of working-class photographers was Brian Duffy, slightly older and the first to make his name. For *Vogue* in 1960 he took snapshots of Armstrong Jones (now the Earl of Snowdon) and his new wife at the window of the glass coach returning them to the Palace. Norman Parkinson, from *Vogue*'s older generation, called his younger colleagues 'The Black Trinity' and was mostly genial and encouraging. His career as a royal photographer would not properly get underway until 1969, when he was appointed official photographer for the Investiture of the Prince of Wales, and he would become a firm favourite of the Queen Mother. In Princess Anne, *Vogue* found a suitably lively and youthful subject for these new times and, in 1971, with a portrait by Parkinson, she became the first royal to be photographed for the cover. Meanwhile, Parkinson's snapshots of the Snowdon family at play blurred the distinction between convention and innovation, something of a novelty for *Vogue*.

Cecil Beaton, however, was horrified. When Princess Margaret remarked to him that her husband had no intention of giving up his day job, he sensed his position as Photographer Royal, so long and dearly held, was in jeopardy.

*A new generation of photographer, experienced in the practice of fashion photography and the art of artifice, brought the more stylish members of the Royal Family into* Vogue.

He need not have worried. Throughout the decade the Royal Family's patronage continued and in 1977, for its Silver Jubilee issue, *Vogue* featured as its chief image his spare and striking 'admiral's cloak' portrait of the Queen from 1968. That session would, however, turn out to be his last with her. Snowdon meanwhile was rarely far from the public eye, as his once fairy tale marriage unravelled.

Beaton died in 1980, aged 76, and was not to participate in the pageantry around the Prince of Wales's wedding. With his inside knowledge, Snowdon was well informed about the progress of 19-year-old Lady Diana Spencer. *Vogue* had its own impeccable sources, and the magazine was first to present to the world the bride-to-be in her first set of formal portraits. Snowdon's fashion photographer's eye discerned an innate poise and elegance long before it was her principal commodity. The Princess's extensive association with *Vogue*, chiefly through her friendship with fashion editor Anna Harvey, whose advice was frequently sought, would last from 1981 until 1997 and her unexpected death. She sat for three British *Vogue* covers and appeared posthumously on another, an out-take from an earlier sitting. She was determined to be modern, not fashionable. Inevitably, *Vogue*'s imprimatur made her both.

Royal photography for *Vogue* in the 1980s, when not documentary in nature – snapshots of royal visits, tours and official engagements – continued in much the same way as it always had. Formal portraits, individual or group, by Snowdon, Lichfield and Parkinson predominated; sittings were arranged to solemnize specific occasions such as royal birthdays, weddings, anniversaries and departures on goodwill tours abroad: a little outdated, perhaps, but still keenly devoured. In 1983, *Vogue* devoted several pages in successive issues to the Prince and Princess's visit to the southern hemisphere.

But a new generation of photographer, experienced in the practice of fashion photography and the art of artifice, brought the more stylish members of the Royal Family into *Vogue*, chiefly Patrick Demarchelier, a Frenchman, and Mario Testino, a London-based Peruvian. Both photographers brought a polished sheen to the depiction of their royal subjects, especially, perhaps inescapably, to Diana, Princess of Wales, by 1992 newly separated from her husband. She looked out at the world from the pages of *Vogue* radiating confidence, sure of the message she wanted to convey and the agenda she wished to pursue, and aware that it was through the language of gesture and dress

*One constant has remained, assured and unwavering, as if she had always been there and would be for ever. Anyone under 70 has known of no other monarch than our present Queen.*

that the message would be best understood. In her wake came a realization that to stay relevant, the family must periodically adjust the way it is seen. But when the lines between royalty and celebrity became blurred, it would be hazardous. 'Dangerously for her, dangerously it might be argued for the Royal Family as a whole,' observed *Vogue* presciently in 1991, 'the press does not make the distinction between the Princess of Wales as a royal figurehead and "Princess Di", the celebrity they have invented.'

While the Princess's currency was strong at *Vogue*, Prince Charles was, inevitably, a little under-sung, but as his interests, enthusiasms and tireless sense of duty chimed with a new age, *Vogue* was appreciative of his pioneering work. In 1992, David Bailey made a reportage portrait of what would become The Prince's Foundation. In 'Royal Green' for American *Vogue* in 2010, Prince Charles expanded on his commitment to sustainability, one of the central themes of his life's work: 'Fashion clearly makes people feel good, but now it has to do the world good, too, by contributing to the creation of a virtuous circle, with nature protected at the centre.' In a similar vein, for British *Vogue* at Christmas 2020 – when his portrait by Nick Knight made Prince Charles the most recent member of the Royal Family to appear in *Vogue* – he reminded readers that 'the

vital thing now is to buy more time in the battle to make the transition to an infinitely more sustainable, decarbonised economy.'

Prince Charles's two sons, William and Harry, were for much of their childhood kept away from public gaze, their appearances in *Vogue* limited, among a few other glimpses, to snatched shots in sailor suits at family weddings. A session by Patrick Demarchelier, specially taken at Highgrove for Christmas 1989, marked their formal debut in *Vogue*. In five of the six pictures, their mother throws a protective arm around them. Two years later, their next appearance, also at Highgrove and photographed by Snowdon, was a pastoral fantasia, a conversation piece intended to reinforce the notion of a happy family life. The reality was, as insiders knew, very different: the marriage was disintegrating on a near-daily basis, and in 1992 the royal couple announced their separation.

Notwithstanding December 2001's issue, 'A Royal Salute', devoted almost entirely to royalty past and present, it was the wedding of Prince William to Catherine Middleton that brought modern royalty firmly back into *Vogue*. In 2016, the Duchess of Cambridge (as the bride became) agreed to appear on *Vogue*'s centenary cover, suggesting that a more understated approach be taken, one that would see her less as a ceremonial

figurine, and more as an ordinary person with tastes and opinions perhaps not far removed from *Vogue*'s own readership. Editor Alexandra Shulman understood instinctively that 'the monarchy adds something precious to our national identity,' and that *Vogue*'s history is our own shared history.

Three years later, in September 2019, and in something of an unanticipated triumph, new editor Edward Enninful invited the Duchess of Sussex to guest-edit the magazine. The result was a *coup de théâtre* of an issue, emphasizing views and themes close to the Duchess and her new husband, and chiming with Enninful's desire for an all-inclusive *Vogue*, authentic and relevant for the modern era. He was impressed by his guest editor's willingness 'to wade into more complex and nuanced areas, whether they concern female empowerment, mental health, race or privilege.' The issue, 'Forces For Change', propelled *Vogue* firmly into the socio-political arena, one it had historically shied away from.

Since 1916 and its very first issue, British *Vogue* has had a special relationship with the Royal Family, and down the decades it has produced images and texts that have defined royal history. It has lived through the reigns of four monarchs, two coronations, the funerals of two reigning kings and four royal consorts, and numerous royal weddings. Here, then, from the depths of the *Vogue* archives, from hundreds upon hundreds of well-handled prints, delicate drawings and time-worn colour slides, is our tribute to an exceptional monarch, her predecessors and those who have played their part – mostly for good, if sometimes, as history has shown us, for ill.

Through it all, one constant has remained, assured and unwavering, as if she had always been there and would be for ever. Anyone under 70 has known of no other monarch than our present Queen. In 1953, in anticipation of a new reign, *Vogue* wrote: 'if the nation will follow her example – catch something of her enthusiasm and devotion, of her brave spirit and youthful vigour – we may indeed find we have moved into the glories of a second Elizabethan Age.' Few would doubt that it came to pass; many would marvel that it has lasted so long.

*Vivat Regina!*
*Josephine Ross & Robin Muir*

# VOGUE

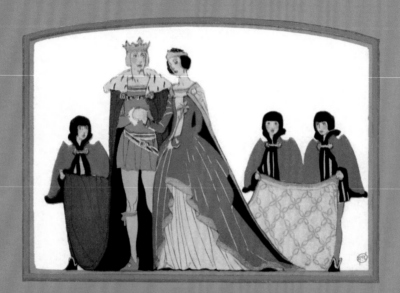

# ROYAL WEDDING
# NUMBER

*Late April*

CONDÉ NAST & CO. LTD.
LONDON

*Price Eighteenpence*

# 1.

# *The Old Order &
the New Glamour*

**The cover for *Vogue*'s Royal Wedding issue for the Duke and Duchess of York, 1923, by Frederick Chapman.** The sumptuous use of gilding reflected the magazine's expectations of high demand for this special commemorative issue. No one could have known at the time that the couple would become King George VI and Queen Elizabeth (the future Queen Mother).

When the British edition of *Vogue* was launched in 1916, a readership fighting 'For King and Country' in the Great War regarded the monarchy with almost unqualified devotion and deference. Early *Vogue* photographs showed staid, upright King George V and his stiffly corseted consort, Queen Mary, as staunchly unfashionable figures – but to an embattled nation and Empire they represented, reassuringly, the timeless values of duty, service and blameless family life.

With the advent of the Jazz Age of the 1920s and '30s, however, that antiquated image would increasingly be challenged, as a new generation of 'Bright Young Royals' emerged. Alongside coverage of such traditional events as the presentation of debutantes at Court, and the wedding of King George and Queen Mary's only daughter Princess Mary, *Vogue*'s readers now enjoyed fascinating insights into the gilded world of princes and princesses who drank cocktails, danced in nightclubs, and not only followed fashion but made it.

'Daughters of royalty,' *Vogue* noted in 1924, were now 'as pretty and modish as the girls one sees on magazine covers.' When, in 1934, Princess Marina, bride of the Duke of Kent, actually appeared on a *Vogue* cover, and posed for a fashion shoot inside, it was the confirmation of a growing alliance between royal mystique and modern glamour that would prove a winning formula for both the Crown and *Vogue*.

# Queen & Family

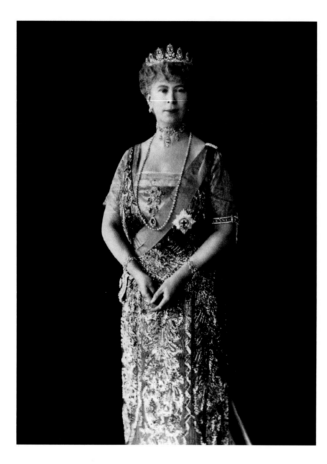

*Queen Mary came to be admired on both sides of the Atlantic for her resolute individuality.*

← **Queen and Empress, Mary, consort of George V, 1922, by W. & D. Downey.**
'Fashionable dressing – anything but that!' Queen Victoria famously decreed for women in the Royal Family, and there was certainly nothing remotely fashionable about her grandson King George V's consort, Queen Mary. Born Princess Mary of Teck (known in the family as 'May'), she had been an attractive young woman; but as Britain's Queen Empress, above trends and wedded to tradition, she continued to dress in the styles of her late-19th-century youth – evolving a unique and enduring image of a stately figure draped in dazzling jewels, with long skirts and the turban-style toque hats that became her signature accessory.

Although mildly mocked in *Vogue*'s earliest, exclusively American issues, Queen Mary came to be admired on both sides of the Atlantic for her resolute individuality, and for her role as matriarch to the nation, as well as to her own family of five sons and one daughter.

→ **Members of the Royal Family on holiday at Balmoral, 1910, tear-sheet from American *Vogue*.**
Some of Britain's royalty would in later decades assert that theirs had been a joyless upbringing, under a rigid, authoritarian tradition. Yet a 1910 American *Vogue* feature shows an apparently happy Royal Family on holiday at their Scottish residence of Balmoral – King George riding a pony; the Princes and Princess on bicycles; and a visiting German cousin – in a kilt – practising his golf swings. Among the 'intimate glimpses' is a striking snap of George and Mary's youngest child, Prince John. Born with a disability, he was rarely seen in public before his death aged 13, in 1919. Nevertheless, he appears in *Vogue* with his sister and supposedly remote mother both tenderly holding his hands. Such 'behind-the-scenes' royal coverage had a powerful role to play in promoting the image of a sympathetic Crown.

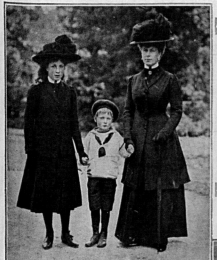

The Queen, Princess Mary and Prince John

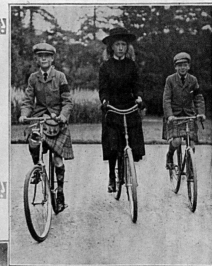

Prince Henry of Prussia, who has been visiting in the Highlands

Prince Henry, Princess Mary and Prince George

The young Prince of Wales on the moors

King George V in the Highlands of Scotland

INTERESTING GLIMPSES OF THE ENGLISH ROYAL FAMILY, WHO HAVE BEEN SPENDING A FEW INFORMAL WEEKS OF THE AUTUMN AT BALMORAL CASTLE, IN SCOTLAND

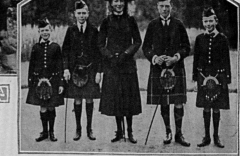

The five children of England's new king. The Princess Mary and her four brothers in Scotch dress

# The Princess Bride

## *From* **Wedding Day**

'It was fitting that pageantry should attend the marriage of the King's daughter and that a wedding watched with so much love and loyalty should take place in the historic setting, with all its age-long beauty, of Westminster Abbey.

It was indeed the Fairy Princess, with Youth, Beauty and Happiness as her attendants, who drove, radiant in her glass coach, among her people – a delicate figure in white, with small wreathed head, smiling her thanks to the great crowds thronging the streets to see her pass and shouting their good wishes and blessings to her.

Later, through the great West Door of the Abbey, she walked slowly up the long aisle in grave beauty, her hand in her father's, in a magical dress of shimmering white, cobwebbed with a myriad of pearls and a train of spun silver and lace. Behind her, the eight lovely bridesmaids in silver dresses streamed like bright ribbons from her train, their heads veiled.

The sanctuary of the Abbey was full of sunlight falling on the gold and silver of the altar, on the gorgeous vestments of the archbishops, on uniforms and gold lace, and on the array of fine dresses. No pains had been spared, and the wonderful stuffs, the colouring and designing formed an especial tribute to the great occasion.'
*Unsigned, March 1922*

**A Picture of Romance: The cover of *Vogue*'s first ever Royal Wedding Issue and accompanying vignette, 1922, by A. E. Marty.**
In February 1922, Princess Mary, King George V and Queen Mary's only daughter, was married to Viscount Lascelles, heir to the Earl of Harewood. Fourteen years the princess's senior, the bridegroom was no stereotypical Prince Charming, despite a fine war record and upstanding character; his bride, though youthfully attractive, was admired rather for her love of music and support for patriotic causes than any more glamorous attributes. *Vogue*'s coverage however brought out all the usual romantic tropes, from love-hearts and cherry blossom to sentimental verses.

# VOGUE

*The*
# ROYAL
# WEDDING
## NUMBER

*Late February 1922*      CONDÉ NAST & Co Ltd
LONDON      *One Shilling & Six pence Net*

# Wedding of Princess Mary

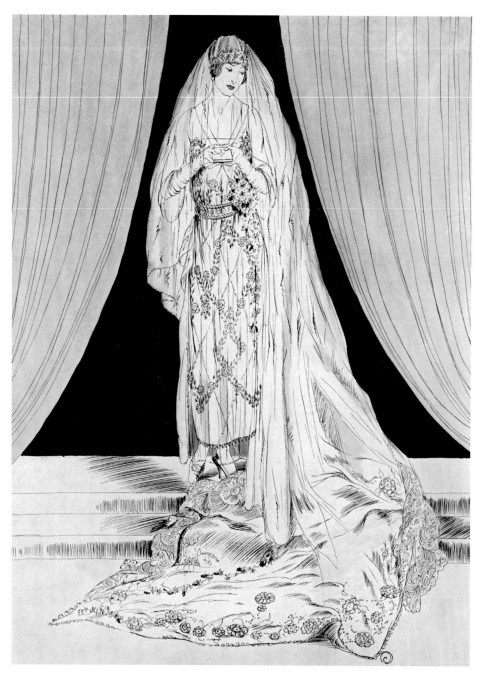

← **The Fairy Princess: Princess Mary's wedding dress by Reville, 1922.**
The Queen and Princess 'waived their usual dislike of unnecessary publicity' to release details of the Princess's dress in time for a sketch to appear in the next issue of *Vogue*. Made by the English designer Reville, in white silk marquisette over an underdress of silver lamé, the dress was stitched with 'a trelliswork of roses' and the train with 'emblematic flowers', including lotus blossoms embroidered in India, as a gesture to the Empire. The result, *Vogue* enthused, combined 'youthful simplicity with royal grandeur'.

→ **Bride and Groom: Viscount Lascelles and Princess Mary, 1922, by Carl Vandyk.**
An official wedding photograph of the happy couple.

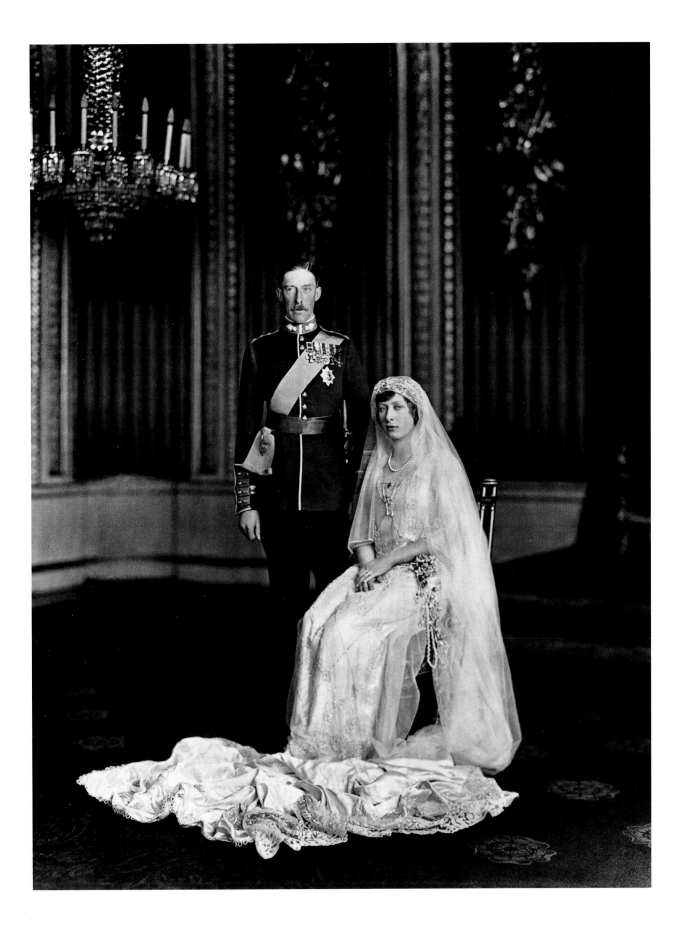

# Leisure & Pleasure

→ (*Top left*) **Prince Henry, Duke of Gloucester, at the Grafton Hunt steeplechase, 1922.** (*Top right*) **The Prince of Wales playing polo, 1923.** (*Below*) **Princess Mary, Viscountess Lascelles, with her husband and brothers the Duke of York and the Duke of Gloucester, and a friend at the Oaks race meeting, 1922.**

Informal snapshots of the Royal Family off-duty, enjoying their favourite pursuits and pastimes, were as popular with magazine readers in the 1920s and '30s as they are today. *Vogue*'s society pages frequently featured sporty younger royals 'caught on camera' – at the races, hunting or playing polo.

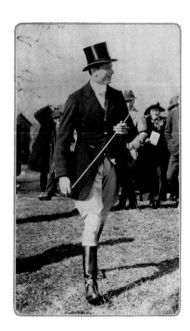
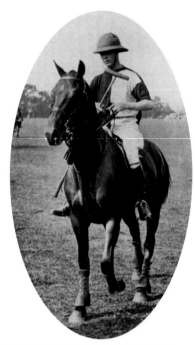

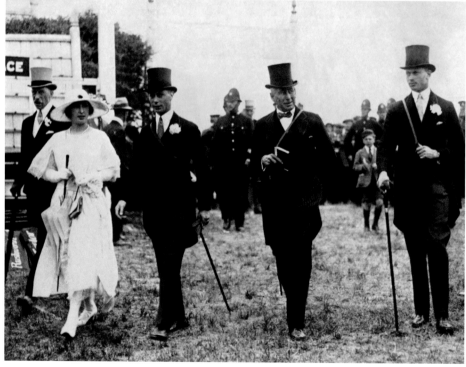

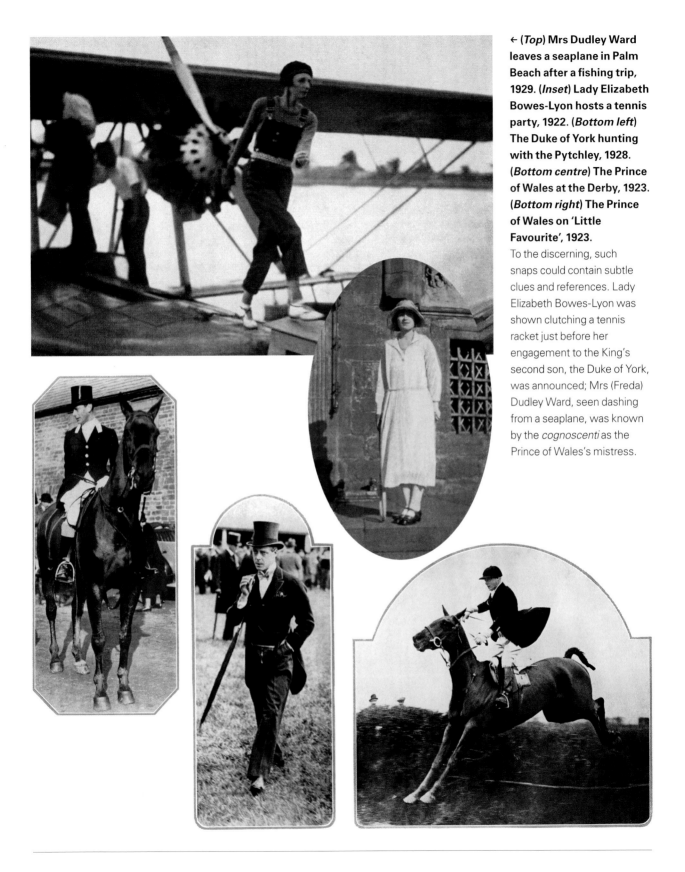

← (*Top*) **Mrs Dudley Ward leaves a seaplane in Palm Beach after a fishing trip, 1929. (*Inset*) Lady Elizabeth Bowes-Lyon hosts a tennis party, 1922. (*Bottom left*) The Duke of York hunting with the Pytchley, 1928. (*Bottom centre*) The Prince of Wales at the Derby, 1923. (*Bottom right*) The Prince of Wales on 'Little Favourite', 1923.**

To the discerning, such snaps could contain subtle clues and references. Lady Elizabeth Bowes-Lyon was shown clutching a tennis racket just before her engagement to the King's second son, the Duke of York, was announced; Mrs (Freda) Dudley Ward, seen dashing from a seaplane, was known by the *cognoscenti* as the Prince of Wales's mistress.

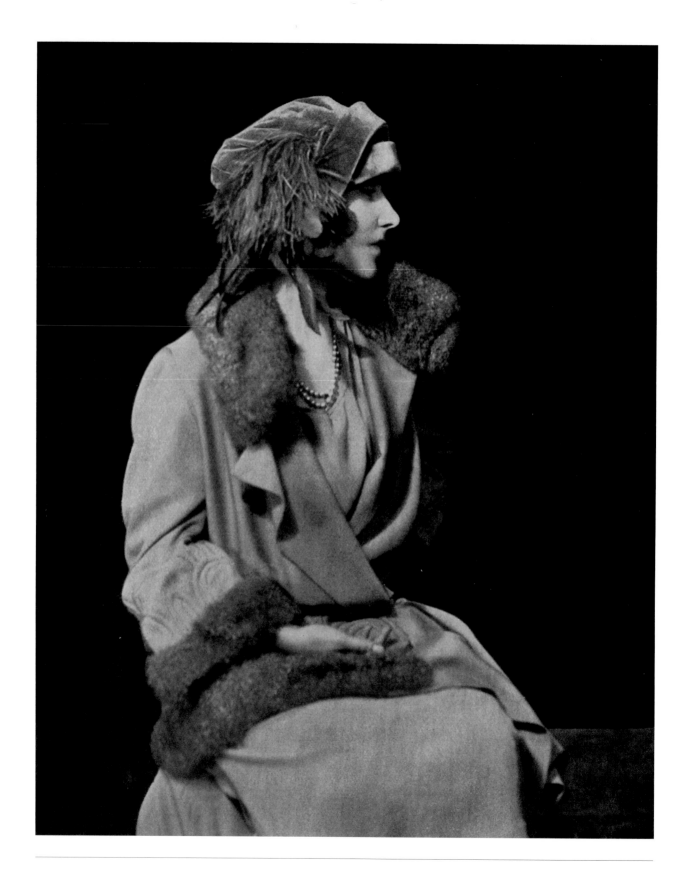

# The People's Duchess

← **Lady Elizabeth Bowes-Lyon, 1923, by Beck and Macgregor.**
From the outset of her royal life, the future Queen Elizabeth and Queen Mother endeared herself to both press and public. On her engagement to King George V's second son, the Duke of York, in 1923, the then Lady Elizabeth Bowes-Lyon naively gave an interview to a *Daily Express* reporter who knocked on her door – outraging the King, who strictly forbade any such future media dealings. However, the irascible King was swiftly enchanted by her, as was the world at large. A devoted supporter of the arts, charities and, above all, her husband, the 'Little Duchess' successfully blended the values of royalty's 'Old Order' with the appeal of youthful charm and personal warmth.

→ **Prince Albert, Duke of York (the future King George VI), in naval uniform, 1923, by Carl Vandyk.**
In 1916, the seafaring prince had seen action in the Battle of Jutland.

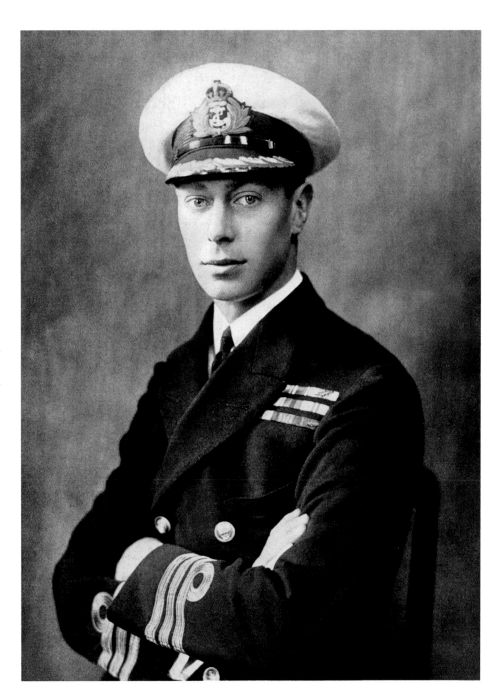

# Wedding of the Duke & Duchess of York

*From* **The Duchess of York** *by Susan Pulbrook*

'Elizabeth Bowes-Lyon was a commoner. She wasn't a princess in her own right. Until then, princes had traditionally married princesses – and although she was lovely, and rather pretty, her family were merely Scottish aristocracy.

Still, we liked her very much. We liked her for precisely that reason, I suppose: she wasn't superior in the slightest. On her way into the Abbey on her wedding day, she laid her bouquet on the Tomb of the Unknown Warrior. Nobody expected her to do that, but it was a gesture typical of her. She had lost a brother in World War I, and helped to run a convalescent home for wounded soldiers in her family seat, Glamis Castle. She had seen, first hand, what the rest of the country had seen. She was one of us in that way.

It was the same during World War II, of course. By then, she had become what no one, least of all she, would have expected on the day of her wedding – the wife of the king. She carried out her duties absolutely beautifully, standing shoulder to shoulder, not just with her husband, but with her husband's people. That, most of all, is what we remember about her, not the rather ordinary woman that she was on her wedding day, but the very remarkable woman that she became.

Prince Albert ("Bertie" to her), was absolutely her opposite in many ways. While she was charming and natural, he was awkward, to the point of being crippled by it. But that, I think, is what made them such a good match, they absolutely complemented each other. It was such an obviously happy union, and it made us happy.

Being born royal doesn't necessarily make you good at *being* royal. Like everything else in life, it's what you put into it that counts.' *May 2011*

*She carried out her duties absolutely beautifully, standing shoulder to shoulder, not just with her husband, but with her husband's people.*

**Bridesmaid to Bride: the new Duchess of York, 1923.** She had been a bridesmaid at the wedding of Princess Mary, and her medieval-style gown, by Handley-Seymour, bore some resemblance to that of her royal sister-in-law in its silver lamé detailing.

However, she created a tradition of her own by spontaneously laying her bouquet on the Tomb of the Unknown Warrior, a precedent followed today, as royal brides send their flowers to be laid on the same sacred spot after their weddings.

Lady Elizabeth's wedding gown is of ivory chiffon moire, its slim straight lines suggesting a mediæval Italian gown. Across the bodice are bands of silver lamé ornamented with embroidery of seed pearls. A band of silver and pearls falls to the hem of the gown From the waist falls a train of moire and from the shoulders floats a mist of tulle edged with ivory Nottingham lace. A length of rare old lace, lent by Her Majesty the Queen, borders the veil, which is held by a chaplet of leaves. Gown from Handley-Seymour

# LADY  ELIZABETH  BOWES-LYON'S  WEDDING  GOWN

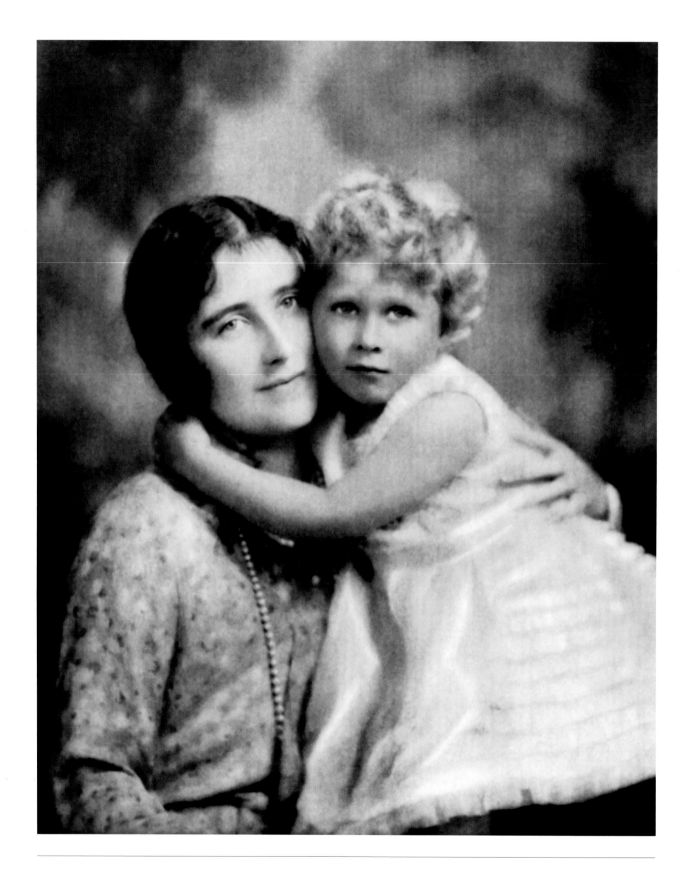

# The Little Princesses

**← Princess Elizabeth, 'Lilibet', 1930, by Marcus Adams.**

From the time they were born, in 1926 and 1930 respectively, the Duke and Duchess of York's daughters, Elizabeth and Margaret Rose, were the most famous little girls in the world. Although not expected to inherit the throne – their uncle, the future King Edward VIII, seemed certain to marry and have heirs to outrank them – the 'Little Princesses' were nevertheless treated as mini-celebrities by a doting press and public, both at home and abroad. A cherubic Princess Elizabeth featured on the cover of US *Time* magazine on her third birthday, with the caption: 'She has set the baby fashion for yellow', and throughout their childhood both sisters would continue to set fashions – not only in clothing, but also as role models for a loving upbringing and close, happy family life.

**→ English Rose Born in Scotland, 1931, by Marcus Adams.**

Christened Margaret Rose, Elizabeth's younger sister later dropped Rose from her name.

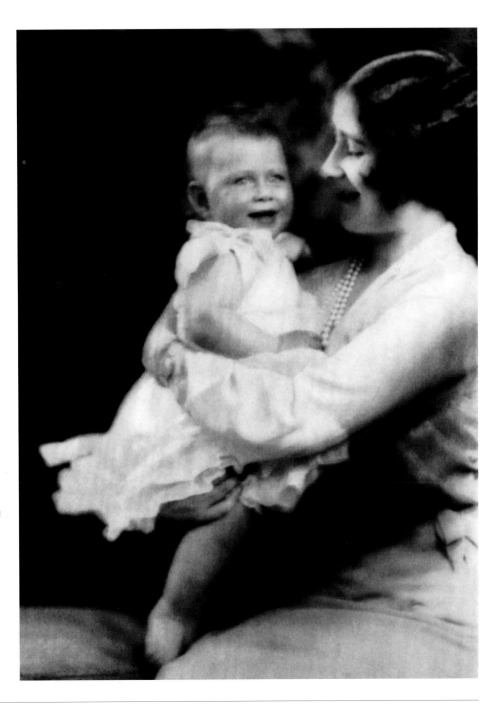

# The Fashionable Kents

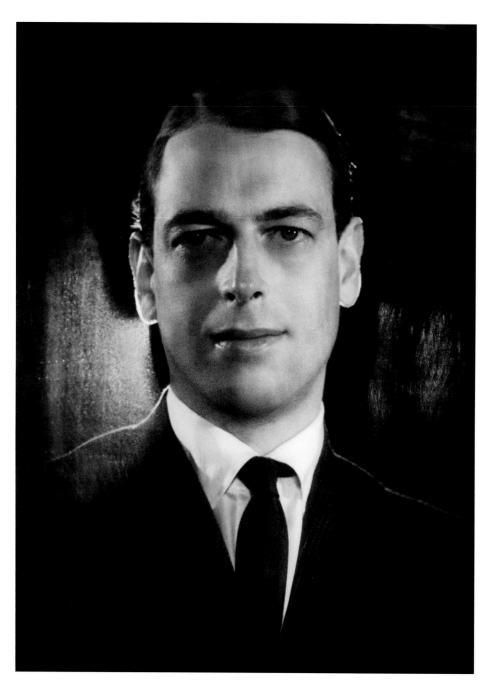

→ **Princess Marina, 1934, by Carl Erickson ('Eric').** In the ravishing Greek-born Princess Marina, wife of Prince George, Duke of Kent, *Vogue* had a senior royal who needed no discreet restyling for the camera. Niece of the deposed King of Greece, Marina had grown up in exile, partly in Paris, and arrived in England to marry George V's fourth son in 1934 with an international reputation as one of the most beautiful and best-dressed women of the day. For their Royal Wedding issue she became the first royal to appear on a *Vogue* cover. 'The Duke and Duchess of Kent represent, in the idiom of this age, the spirit of gaiety, international culture and elegance,' *Vogue* enthused.

← **Prince George, Duke of Kent,1935, by Cecil Beaton.** Sophisticated and artistic, the duke was a popular figure in the world of celebrity, counting as close friends Noël Coward and Tallulah Bankhead.

Vogue

The Royal Wedding
and
Christmas Number
November 28th (24) 1934, price 1/-

# A Classical Princess

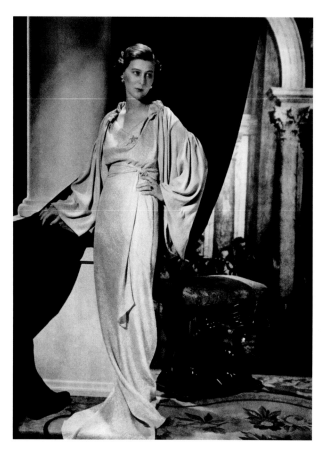

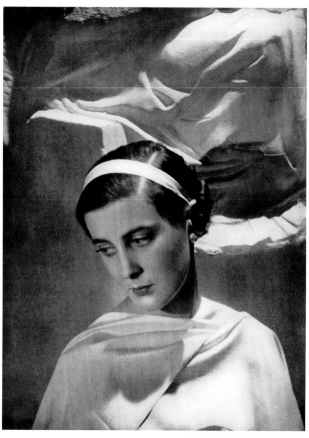

**↑↗ Classical Lines: Princess Marina, 1934, by Horst.** Images from *Vogue*'s first ever fashion shoot with a member of the Royal Family. That Horst, not Cecil Beaton, was chosen for this prestigious assignment fuelled a lifelong enmity between *Vogue*'s two leading photographers.

**→ Princess Marina in Greek national dress, 1938, by Cecil Beaton.** 'Our new Princess has a profile of Grecian beauty and a Parisian perfection of clothes,' *Vogue* declared, and the statuesque, graceful and gracious addition to the Royal Family was a gift for *Vogue*'s photographers.

Cecil Beaton, who created some of her most memorable images for *Vogue*, wrote: 'The Duchess of Kent has provided me with many of my most pleasant photographic memories, imbuing them with her mysterious beauty and dignity, together with all sorts of ravishing dresses, Queen Alexandra hats, Greek national costumes and parures of romantic jewellery.'

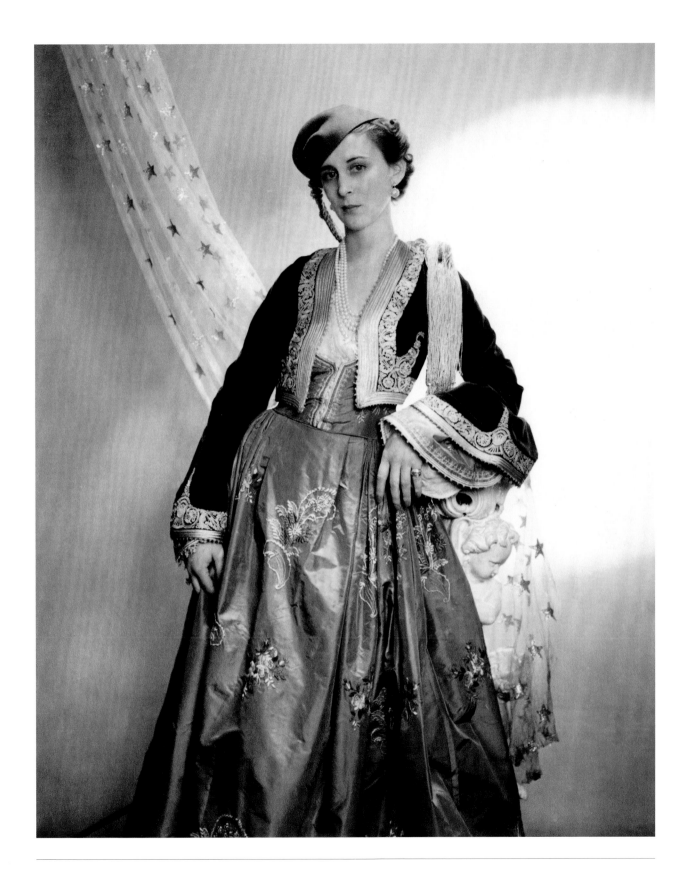

# A Dauntless Duchess

*From* **Lady Alice**
*by Lady Norah Spencer-Churchill*

'This royal bride we are all welcoming, who comes, like so many of the best things in England, from over the Border, is very much of an outdoor person. This Scottish princess-to-be does not like towns, crowds or publicity. There is nothing languishing or exotic about the beauty of that lovely head, and the big eyes with that faraway look seem more suited to scanning the wild purple distances of the Highlands than any formal elegancies of town vistas. A manner entirely natural and engagingly frank reveals an independence of character which is bound to make its mark.

Lady Alice is one of the finest horsewomen in the country, and on the question of clothes it is part of the bride's creed that life is easiest and most delightfully lived in jodhpurs and in the country. As the Duke of Gloucester's tastes match her own in this matter, one may surmise that the new royal household will spend as much time out of Town as their duties at Court will permit, and that in their establishment dogs and horses will have their own important place.

Lady Alice Montagu-Douglas-Scott will make a truly royal bride, but not a cut-to-pattern royal personage.' *October 1935*

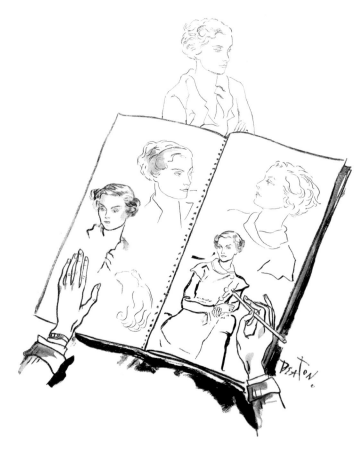

↑ **Drawing the Duchess: Lady Alice Montagu-Douglas-Scott, 1935, by Cecil Beaton.**
For the newly engaged Lady Alice, a sitting with the indefatigable Cecil Beaton was arranged, which resulted in this charming illustration of Beaton himself sketching his subject's preparatory likeness.

→ **Lady Alice Montagu-Douglas-Scott, 1935, by Cecil Beaton.**
By 1935, when the engagement of the King and Queen's third son, Prince Henry, Duke of Gloucester, to Lady Alice Montagu-Douglas-Scott was announced, it had become the custom for *Vogue* to be granted privileged pre-wedding access to royal brides.

# The Fabulous Mountbattens

In the 1920s and '30s, almost no couple – royal or otherwise – had a higher profile in *Vogue*'s society pages than Lord and Lady Louis Mountbatten. He was the handsome, dashing great-grandson of Queen Victoria and cousin to the King; she, formerly the Hon. Edwina Ashley, was the richest heiress in Britain, renowned not only for her wealth but also for her looks, personality and adventurous spirit. The Prince of Wales was best man at their royalty-packed wedding in 1922; on honeymoon they visited Hollywood and made a home movie with Charlie Chaplin. Thereafter, their lives were a much-publicized blend of royal grandeur and almost film-star glamour.

They were also, however, lives of service. In the royal seafaring tradition, Lord Louis was a dedicated naval officer, who would win accolades for his gallantry in World War II. In 1947, having presided (albeit controversially) over the Independence of India as Britain's last Viceroy, he would become Earl Mountbatten of Burma. Edwina, acclaimed as one of the most fashionable women in Britain, was also a self-proclaimed socialist who visited Soviet Russia in the 1930s, and later became committed to working for charitable causes.

**↑ Portraits In Passing, 1927–28, by Cecil Beaton.**
A highlight of *Vogue*'s social column was Cecil Beaton's witty, spiky (but always flattering) series of caricatures of well-known society figures. Edwina Mountbatten was a favourite subject for Beaton, who praised everything from her 'meticulous grooming' to her 'sagging stance' and 'taut toes', captioning one cartoon: 'The mode and manners of Lady Louis Mountbatten should be studied by the aspiring beauty.'

**→ Lord and Lady Louis Mountbatten on an ocean liner, 1922.**
Seen here on honeymoon, the couple loved travel, especially by sea.

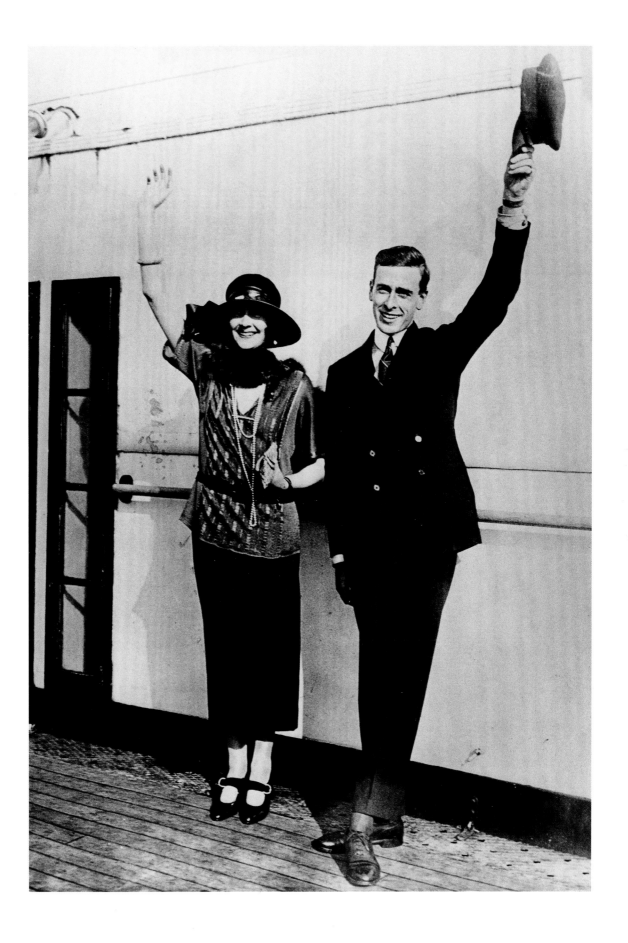

**← Edwina Mountbatten, 1931, by Cecil Beaton.**
Scintillating: Edwina sparkles in a classic studio portrait.

**↓ A Modern Frame, 1937, by Millar and Harris.**
With characteristic modernizing flair, in the late 1930s the Mountbattens created a stunning new London home for themselves, on the top floors of what had been a Victorian mansion on Park Lane, belonging to Edwina's banker grandfather. Remodelled in the latest Art Deco style, the penthouse was described admiringly in *Vogue* as 'a frame for Lady Louis' collection of pictures, jade and plate', and an ideal backdrop for their sophisticated lifestyle.

# The Silver Jubilee

*From* **Jubilee Letter** *by John McMullin*

'The sixth of May in London was the most thrilling day, so far, in the whole of my life. Weeks ago, London started to prepare for this great day. Then, London became sceptical. "The taste is appalling," we heard. "Why hang out of a window for hours to see a procession that passes in two minutes?" It was said that the King would permit of no great cavalcade of pomp and splendour; that it was his desire that this should be an occasion solely between himself and his people, and not a Roman holiday. So, people began to refuse Jubilee invitations. But how wrong they all were! Little by little London began to emerge into something glamorously beautiful. Selfridges spent ten thousand pounds on decorations, which culminated into a great gilded statue towering high above Oxford Street, and a million people came to look. And excitement became contagious.

I had planned to see the procession from the Carlton, where I was to breakfast with Elsa Schiaparelli. It was a marvellous place from which to see it, for we had a view of Pall Mall from St James's Palace to the National Gallery in Trafalgar Square. The street was thrilling – the people all mixed up with bunting, streamers, and uniformed figures, moving to the sound of music in the air from the loud-speakers at every corner. The time passed so quickly that we did not realize the procession was almost upon us.

In the first carriage sat the Duke and Duchess of York and opposite to them the two tiny Princesses, and this carriage brought down the crowd. The Duchess looked very proud and sweet, and the two little girls raised their tiny hands in that lovely royal gesture that is at once languid and shy – and in which the Princess Marina is so proficient. She and the Duke followed alone in the second carriage. A dream in pale grey, she was the last word in chic.

And then the great moment was upon us – the appearance of the King and Queen. Six grey horses with postilions and outriders swept the

**All The King's Men:** *Vogue*'s **cover for King George's Silver Jubilee, 1935, by Paul Maze.** One of the foremost artists of his generation, the Anglo-French painter Paul Maze was commissioned to create this vivid cover in his characteristic post-Impressionist style.

VOGUE

MAY·1·1935 (9)

ROYAL
JUBILEE NUMBER

2/-

**Scenes of Celebration, 1935, by Roger Schall.**
On 6 May 1935, King George V celebrated his Silver Jubilee and London went wild. Crowds lined the streets, singing, dancing and holding street parties. Everyone was there, from the soldiers and sailors on duty – such as the band of the Royal Marines (*far left*) – to 'Pearly Kings' and costermongers (*centre left*), along with hundreds of thousands of ordinary people, some bringing their children (*centre right*) to share in the fun (*far right*). One of *Vogue*'s most sophisticated American contributors, John McMullin, watched the spectacle with the designer Elsa Schiaparelli at a glamorous breakfast party and was entranced by it all, as he reported for *Vogue* in his Jubilee Letter, below.

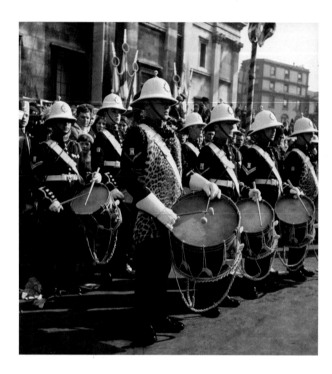

royal state landau along at a lively pace. The King, in a scarlet Field-Marshal's uniform, sat on the left, and the Queen, in white, on his right. All eyes were on the Queen, who, at that moment, was not only the great Queen of England, the most glamorous woman in the world, a demi-goddess, a legendary figure, the idol of all ordinary mortals, but also the woman about whom we have all heard such lovely, homely stories – who never forgets anyone; who sends presents and messages to the sick; who has her clothes made over and frowns on extravagance – who is herself a model housekeeper – and who is a real person. It was difficult to hold back the tears.

We all wondered how she would dress for this great occasion. And when I saw her I wondered how anyone could have been better dressed. She wore a long cape of white satin lamé with a great white fox collar, and elbow-length gloves. Her hat was made like a turban, of the palest pink lamé, with one small egret in the same colour. I had no impression of jewels, except of two enormous pearls in her ears, and I thought the lack of jewels elegant and distinguished.

*Little by little London began to emerge into something glamorously beautiful... And excitement became contagious.*

The carriage passed swiftly and swept on past the National Gallery on its way to St Paul's, but for me it will always remain stationary there, at the corner of Pall Mall and Haymarket. Until I die, I shall be able to close my eyes and see those two wonderful human beings – those very, very human beings – sitting there in their scarlet-lined gilded landau, a vision of simplicity that triumphed over the blinding glitter surrounding them. It was thrilling, thrilling, thrilling.'
*American* Vogue, *June 1935*

# Golden Sovereign

**George V, 1935, by Howard Coster (photograph) and Lesley Blanch (illustrations).**

Less than a year after his triumphant Silver Jubilee, George V died. 'When thrones were falling on every hand,' *Vogue* wrote, 'he left the British monarchy more secure in the affection of its people, and higher in the admiration of the world than ever before. He was a true father to his people.' The tribute ended, 'Very proudly we remember King George, whom in various ways we have been privileged to serve.'

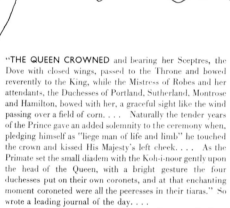

"THE QUEEN CROWNED and bearing her Sceptres, the Dove with closed wings, passed to the Throne and bowed reverently to the King, while the Mistress of Robes and her attendants, the Duchesses of Portland, Sutherland, Montrose and Hamilton, bowed with her, a graceful sight like the wind passing over a field of corn. . . . Naturally the tender years of the Prince gave an added solemnity to the ceremony when, pledging himself as "liege man of life and limb" he touched the crown and kissed His Majesty's left cheek. . . . As the Primate set the small diadem with the Koh-i-noor gently upon the head of the Queen, with a bright gesture the four duchesses put on their own coronets, and at that enchanting moment coroneted were all the peeresses in their tiaras." So wrote a leading journal of the day. . . .

"The pageant of colour was lit by a single moment's gleam of sunlight," while the dramatic setting of the Abbey, with the ceremonial so much better rehearsed than in 1902, provided a spectacle that has not been equalled since. It was all very feudal—the Prime Minister and Cabinet had no important part in it—and very beautiful and touching. . . .

We look back on that mediæval dream, separated from our times by such fantastic events and changes, with some bewilderment but more encouragement, mixed with a deep and real affection for the Royal pair who have been through it all with us. . . .

In a few pages we will take you back those many years to the opening of modern times, the new Georgian era. . . .

SOCIETY IN CORONATION YEAR celebrated the new reign with magnificent entertainment—in houses now gone—that combined the older traditions with the modern spirit.

A gay season for everyone, with the shop windows displaying coronets and robes of peeresses to large crowds discussing the rank a wearer would hold. It was a question of the width of fur on the sleeves, while the length of the train grew from a yard for a baroness with two bars of ermine to six yards for Her Majesty with many inches of miniver. . . . Every day foreign Royalties arrived, driving slowly in carriages through the Park, quite the prettiest of them being Queen Marie of Roumania. . . .

Our present-day Princess Royal caused much surprise in the Abbey when, though of schoolgirl age, she wore with her ankle-length dress a long velvet train and on her flowing hair, tied up with white ribbon, her Princess's crown. And tales were told of a rough-and-tumble (Continued on page 146)

EXCLUSIVE · PHOTOGRAPH · OF · HIS · MAJESTY · THE · KING

BY HOWARD COSTER

# Vogue

FEBRUARY 5·1936 (8)

PRICE ONE SHILLING

# 2.

# *The Crown in Conflict*

*Vogue* **cover, 1936.**
*Vogue*'s iconic plain purple cover was an innovative and moving tribute to a dead King-Emperor and the advent of his successor.

Few reigns in British history were more eagerly anticipated than that of King Edward VIII – or would end more disastrously. Idolized as Prince of Wales for his good looks, charm and apparent sense of duty, as King he was confidently expected to ensure the survival of Britain's monarchy, at a time when other thrones were falling and the spectre of republicanism rising.

Within a year of his accession, such hopes were dashed. In a historic broadcast on 11 December 1936, Edward announced his abdication, to marry 'the woman I love': a twice-divorced American named Wallis Simpson who, with two ex-husbands living, could not become Queen. The nation was aghast – as was his reluctant successor, the Duke of York. Shy, uncharismatic and burdened with a stammer, the new King George VI seemed ill-equipped to rule. But he had a matchless asset in his popular, forceful consort, Queen Elizabeth. Together with their daughters, Elizabeth and Margaret, they were glowingly depicted in *Vogue* as the model of a modern Royal Family – uniting majesty with domestic affection and virtue.

The magazine continued to provide exclusive coverage of the glamorous Duke and Duchess of Windsor (as Edward and Mrs Simpson had become). However, as events unfolded at home and abroad, *Vogue*'s emphasis would increasingly be on what one contributor, Evelyn Waugh, termed the 'accessible and human' aspects of the Crown.

# The Uncrowned King

*From* **The Reign Begins** *by Seymour Leslie*

'All things new – except the old affectionate loyalty. A new age, a great rejuvenating change ... Impossible not to be deeply moved by its dramatic significance. Our thoughts turn with confidence to the happy times ahead and perhaps we may already reflect on the new year and the new reign that stretches before us.

New precedents are probable, because everything we know about the new occupant of the Throne suggests a keen, alert mind. Edward the Eighth has led that quick, nervous, staccato life of our time, but has, one suspects, deep reserves of resource and initiative in an age when the world tempo quickens yearly.

The new reign will be influenced by a King whose natural qualities are his tremendous courage, his untiring ability to see, hear and understand quickly, and his readiness to fill his day with the utmost efficiency. It is well known that golf, gardening, motoring, flying and the art of the film deeply interest him. He loves the sun and delights in swimming. He is very efficient, business-like and types his own letters – what human picture could one create in fiction more completely contemporary and so qualified to understand – and to lead?

And the first summer of the new reign? Already one can fairly anticipate a desire that Americans and our other friends abroad should visit London this summer of 1936, for our social quiet will not interfere with their enjoyment. The immediate future socially presents no real problem as our own sad feelings and good taste indicate the right course. Small intimate gatherings at home, at the theatre and in restaurants are indicated, and mothers can do a great deal for their debutante daughters, even though there are no Courts. So, on these lines, we can and should carry on...'
*February 1936*

**Edward VIII, 1936, by Hugh Cecil.**
Still boyishly handsome at 41, King Edward VIII was expected to bring an unstuffy new spirit to the monarchy while upholding its ancient traditions. Publicly, along with his glamorous image, he was admired for his service in World War I, his gruelling royal tours, and his apparent sympathy for Britain's unemployed during the 1930s Depression ('Something must be done!' he famously declared). In private, however, as King, he would prove self-indulgent, pleasure-loving – and neglectful of his State duties. Although his abdication would cause a constitutional crisis, with hindsight it was to prove a blessing, passing the Crown to the steadfast King George VI at a critical period in British – and world – history.

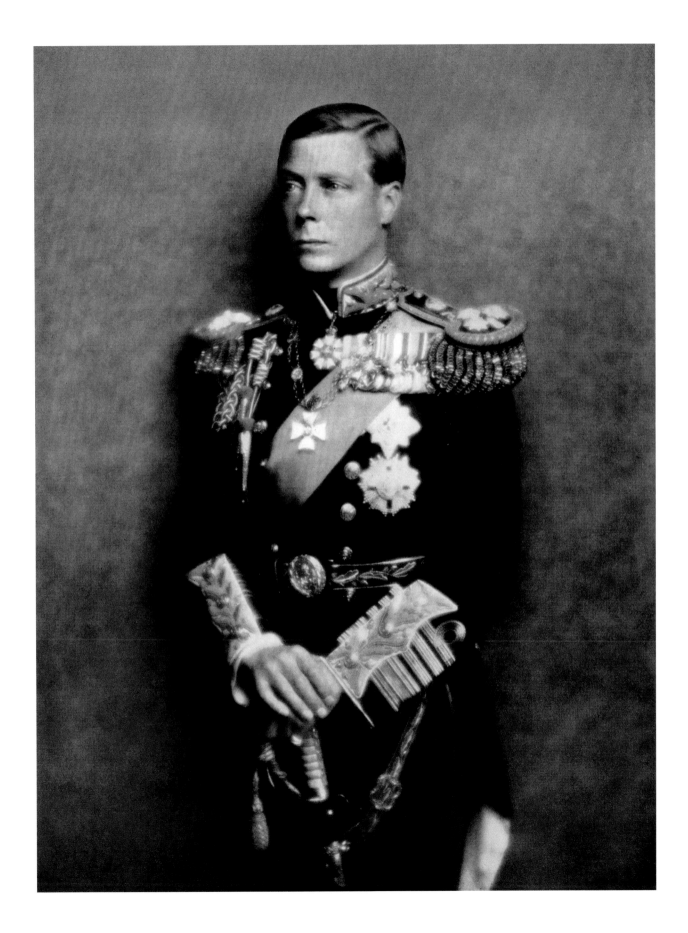

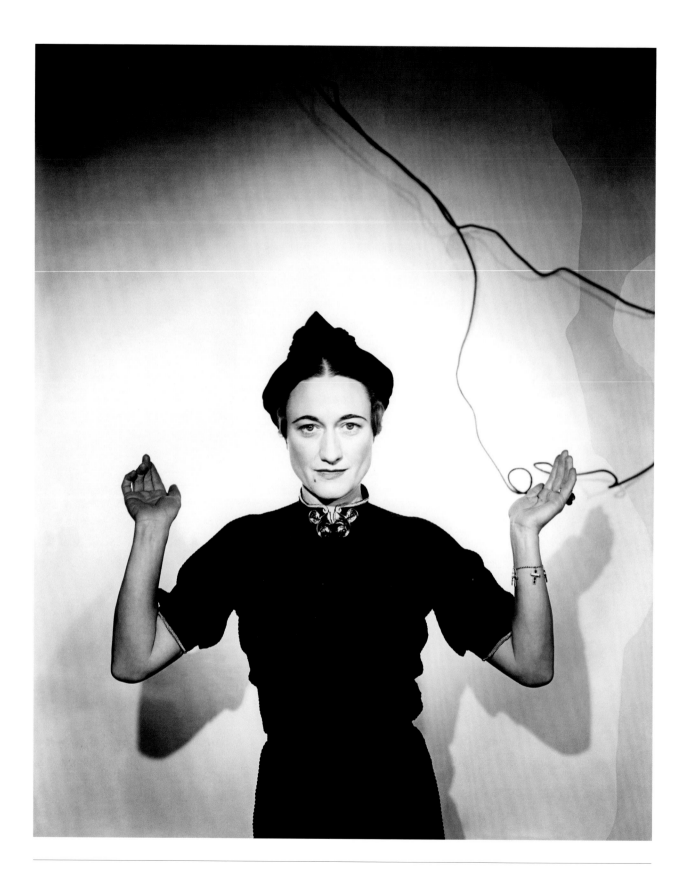

# The Woman He Loved

In the mid-1930s, an intriguing new name began to appear in *Vogue* – that of the chic, American-born wife of a London businessman: Mrs Ernest Simpson. Although no beauty, Wallis Simpson had personality, charm and immaculate dress-sense; as *Vogue*'s staff, and more sophisticated readers, were aware, she also had the besotted love of the heir to the Crown and Empire: the future King Edward VIII.

Unable, as head of the Church of England, to wed a divorcee, in December 1936 Edward sensationally abdicated to marry Wallis. Always in the know ahead of royal developments, *Vogue* had already secured a major scoop: an exclusive interview and portrait-sitting with Mrs Simpson, by Cecil Beaton, published just weeks after the dramatic news broke. When the couple, created Duke and Duchess of Windsor, married in June 1937, it was Beaton who took the official photographs – and provided *Vogue*'s readers with an insider's account of the wedding, and shots of the Duchess modelling her fabulous trousseau.

Although the magazine's focus was now firmly on the new King George VI and Royal Family, a relationship between *Vogue* and the Duke and Duchess of Windsor had been established which would yield publishing dividends.

**↑ Profile of a Socialite: Mrs Ernest Simpson, 1935, by Man Ray.**
'Mrs Ernest Simpson is shown wearing an outfit of great simplicity and elegance, a favourite of hers for luncheons and afternoon occasions. Her charming profile is thrown into relief by the cartwheel lines of her big navy straw hat.'

**← A Picture of Elegance: Mrs Ernest Simpson, 1936, by Cecil Beaton.**
Praising 'the elegance of her dress', American *Vogue* noted: 'Mrs Simpson has the French, the American passionate care for detail (English women are acquiring it too).' A particularly flattering mention in British *Vogue*'s society column admiringly revealed her tips for cocktail snacks: 'Of course it would be Mrs Ernest Simpson who first thought up the wonderful combination of seedless white grapes with little cubes of Dutch cheese, stuck through with wooden cocktail sticks.'

# A Sitting with Mrs Simpson

*From* **Mrs Simpson** *by Cecil Beaton*

'There is a lot to draw in Mrs Simpson's face, no short cuts to getting a likeness. No feature is less important than another. As important as the design of her face are the contours. Noble brow and high cheekbones are as salient features as the rugged mouth and excessively bright, humorous eyes. She is difficult to draw. It is not easy to concentrate on the pencil, for it is almost impossible not to talk too much. The afternoon was so amusing; she has the capacity for making afternoons amusing.

The room in which I drew her in late November in London looks over Regent's Park. I see it still – a charming feminine setting, with walls, carpets, curtains and upholstery the colour of bleached olives. The only colours in the room are the mauve orchids and crimson roses on an occasional table, and the pink in Mrs Simpson's

**↑→ Mrs Simpson, 1937, by Cecil Beaton.**
When Cecil Beaton first met Wallis Simpson in the early 1930s, before her royal liaison began, he privately thought her deeply unattractive: 'awful, common, vulgar, strident,' with a raucous voice and even bad breath. However, by the time he came to draw her for *Vogue* in late 1936, the King had become infatuated with Mrs Simpson and Beaton found her transformed. The future Duchess of Windsor was now not only dressed with exquisite taste and immaculately groomed, but slim, amusing, attractive, and 'alluring'. She was also covered in fabulous jewellery, bestowed on her by the King. This drawing shows her wearing one of her famous pieces, a ruby and diamond collar by Van Cleef and Arpels and the 'bracelet of little crosses' by Cartier, which the King designed for her, with each cross commemorating a special event in their lives.

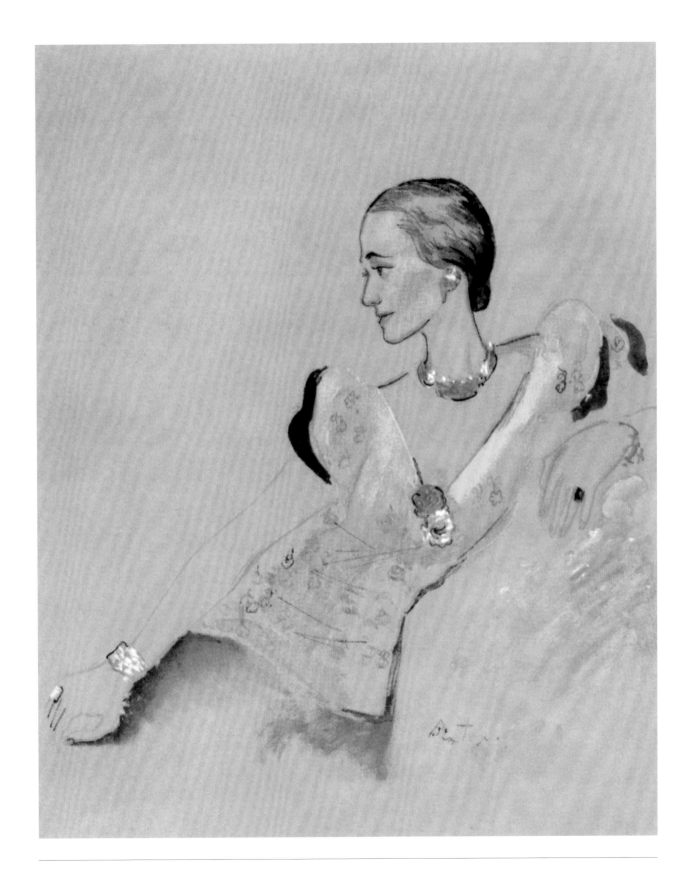

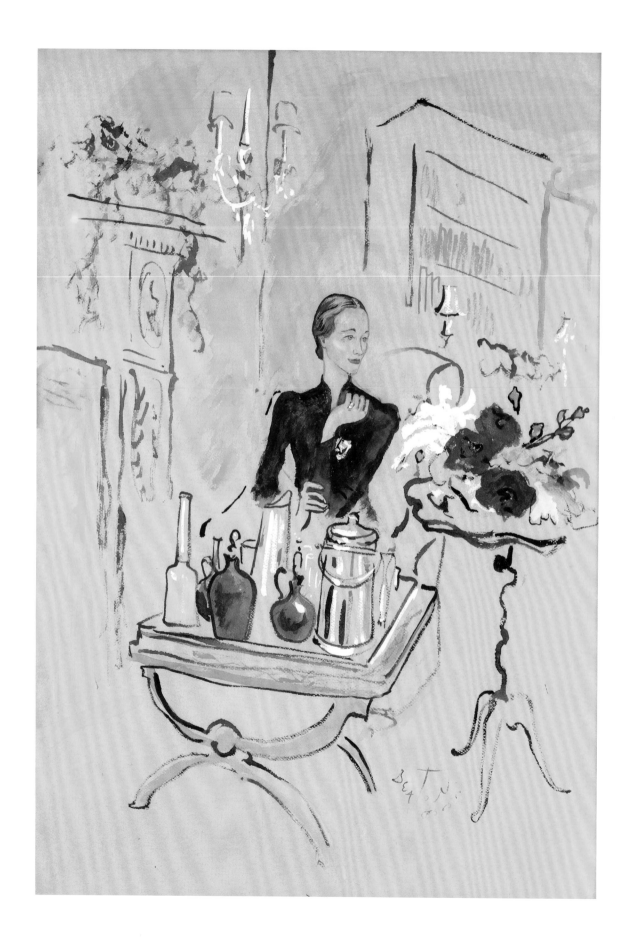

cheeks. The lighting is becoming and my sitter is at her best, in a nondescript black dress that she makes smart by wearing.

Hers is the figure that is admired now. The elongated curves are a slender variation on the Edwardian figure, and her posterior subtly invites a bustle. She reminds me of the neatest, newest luggage and is as compact as a Vuitton travelling case. Her appearance is made up of paradoxes: the wide jaw, the smoothly parted hair, the strong

## *Of late, her general appearance has become infinitely more distinguished.*

enamel-less hands give her the appearance of an early Flemish master, but the grave effect is shattered by the sudden explosion of a broad firework laughter.

Of late, her general appearance has become infinitely more distinguished. Not only is she thinner, but her features have acquired a refined fineness. She is unspoiled: she is like an ugly child who wakes up one day to find that it has become a beauty, but she herself has created this beauty by instinctively doing the right things. Her gestures are simple and compact; she occupies a small amount of cubic space in the room, standing on

one foot, her arms folded, or she folds herself up on the floor. Her taste in clothes shows always a preference for bold simplicity, and her jewellery, especially for day, is extremely modern, though the bracelet of little crosses is a surprise. She is the antithesis of pernicketiness, but she is tidy, neat, immaculate; her hair, like a Japanese lady's hair, is brushed so that a fly would slip off it. She is conscious of the corners of her mouth and frequently reassures herself that they are there. She has a little brush in her bag for her carefully shaped eyebrows. She has a mole at the right side of her mouth which, typically, she converts into a beauty spot.

My sketch is nearly finished. The beige-coloured Cairn wakes up; a variety of fastidiously presented *hors d'oeuvres*, grapes stuffed with cream cheese, diminutive *chipolatas* and such, appears and disappears as quickly. The floor is strewn with unsuccessful sketches. There is so much that should be suggested in the painting, so much of her "personal touch", neatness, practicality and logic. The artist would be in despair were it not that one of Mrs Simpson's greatest gifts is her capability of creating a carefree gaiety.'
*American* Vogue, *February 1937*

# 'We Have a New King'

HIS MAJESTY KING GEORGE VI

**← George VI, 1937, by Peter North.**
'The continuity of English kingship is the symbol of the continuity of life, which cannot be suspended by any catastrophe,' *Vogue* had written on the accession of Edward VIII. Within the year, the Crown had suffered the catastrophe of Edward's abdication – but the continuity of kingship remained, as his brother Albert took his place. Although widely respected for his naval career and public service, 'Bertie', with his shyness and stammer, seemed an unlikely saviour for a monarchy in crisis. Loyal press support was needed.

**→ Coronation Issue cover, 1937, by Pierre Roy.**
*Vogue*'s Coronation issue made much of the unchanging nature of the Crown. With a cover by the Surrealist Pierre Roy, the emphasis was on golden coaches, heraldic banners and time-honoured rituals, which combined theatrical glamour with reverent ceremonial. George VI was a modest King was *Vogue*'s message – but like the father whose name he had taken for continuity, he would be a no less majestic one.

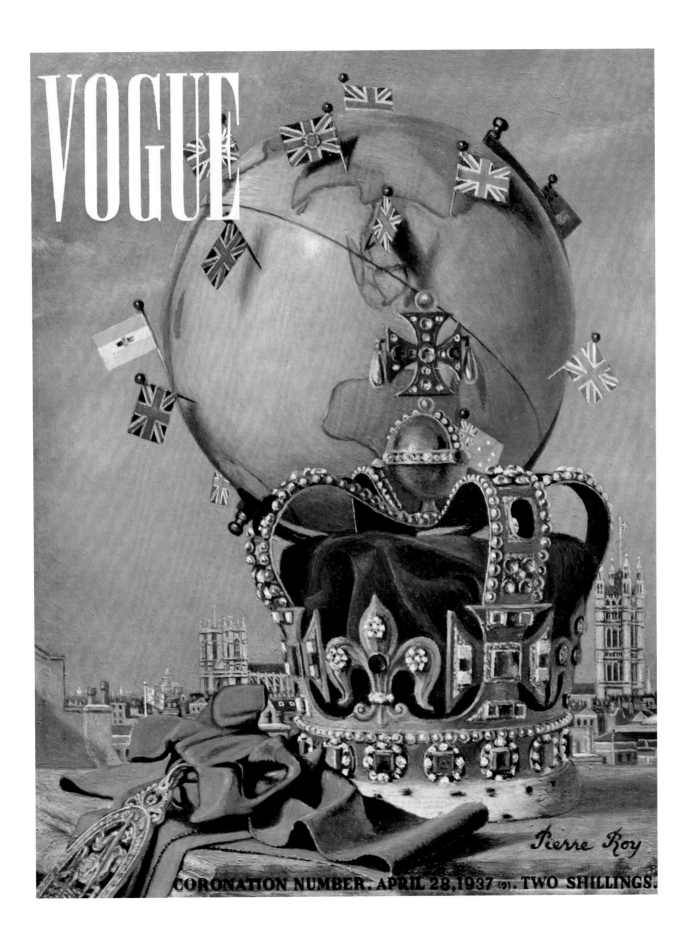

# The Coronation of George VI

*From* **Coronation Day** *by Sacheverell Sitwell*

'Our subject is Coronation Day, 1937. The Coronation Coach, going slowly on its way, will be taking with it all the history and tradition of England and the Empire. Queen Victoria, it will be recalled, had seen and known King George VI, who was a little boy of five or six years old at the time of her death. She would certainly know the little Princesses for who they are. The likeness of Princess Elizabeth, especially, to her grandmother Queen Mary is so decided as hardly to call for comment. And there could be no more happy augury.

King George VI comes to the throne in the pattern of his great father. He has this wonderful precedent to follow, with just those inherited attributes that may be counted on to repeat its success. His qualities of duty and common sense are safer in their application to the public good than the risks of genius.

It is perhaps almost impossible to realize the emotional strain of such a day as this upon the King and Queen, the ordeal of the religious service and the fatigue of all this relentless cheering. It must be the more trying in view of the King's known preference for a quiet life and no ostentation.

It is a happy chance to one like myself, who has no chance of seeing the service in Westminster Abbey, that he should much prefer watching the procession.

The time approaches... The roar of cheering spreads like a slow fire – and now at last we see the cause of it, proceeding in ineffable slowness and dignity towards us...' *April 1937*

**← The Garlanded Crown, 1937, by Rex Whistler.** An exquisite cartouche by a favourite royal artist.

**→ Ceremony of the Coronet, 1937, by Horst.** After the coronation of the King, his Queen Consort, Elizabeth, would also be crowned. 'In all the historic houses of England,' wrote *Vogue*, 'peeresses of the realm are rehearsing this gesture – rehearsing for that impressive moment when the Archbishop places the crown on the Queen's head, and the peeresses simultaneously raise their own coronets, sending a flash of gold through the vaulted Abbey.' Here, a model re-enacts the moment for *Vogue*.

# The Stuff
of Magic

**Cutting a Dash, 1937.**
Among *Vogue*'s regular
highlights were the previews
of the latest spring and
autumn dress materials.
Celebrating the Coronation
in charmingly whimsical
style was this golden coach
conveying the current
season's selection of the
most fashionable new fabrics.

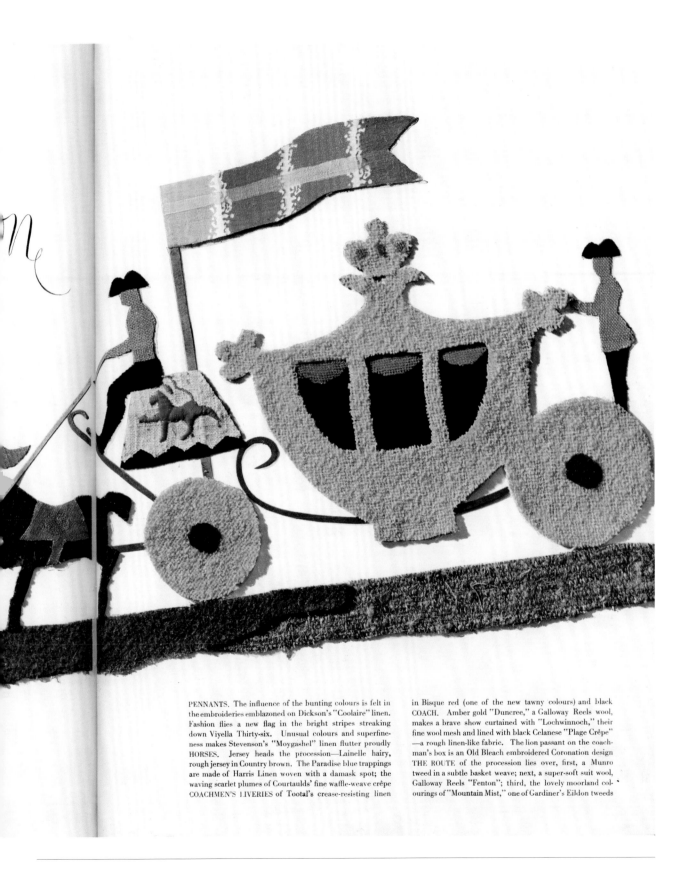

PENNANTS. The influence of the bunting colours is felt in the embroideries emblazoned on Dickson's "Coolaire" linen. Fashion flies a new flag in the bright stripes streaking down Viyella Thirty-six. Unusual colours and superfineness makes Stevenson's "Moygashel" linen flutter proudly HORSES. Jersey heads the procession—Lainelle hairy, rough jersey in Country brown. The Paradise blue trappings are made of Harris Linen woven with a damask spot; the waving scarlet plumes of Courtaulds' fine waffle-weave crêpe COACHMEN'S LIVERIES of Tootal's crease-resisting linen

in Bisque red (one of the new tawny colours) and black COACH. Amber gold "Duncree," a Galloway Reels wool, makes a brave show curtained with "Lochwinnoch," their fine wool mesh and lined with black Celanese "Plage Crêpe" —a rough linen-like fabric. The lion passant on the coachman's box is an Old Bleach embroidered Coronation design THE ROUTE of the procession lies over, first, a Munro tweed in a subtle basket weave; next, a super-soft suit wool, Galloway Reels "Fenton"; third, the lovely moorland colourings of "Mountain Mist," one of Gardiner's Eildon tweeds

# United Kingdoms

*From* **Scottish Season**

'Much has been written about the Coronation ceremony, but comparatively few people seem to remember that it actually takes place on Scottish soil. The Stone of Scone, on which the throne rests, is a genuine bit of Scotland – symbolical, perhaps, of the Scottish influence that is likely to play such an important part during the new reign.

The person mainly responsible for this Scottish renaissance is Queen Elizabeth, gracious daughter of an ancient Highland family, with eyes the colour of the traditional Scottish bluebell, and a passion for the ways of her own country. It was she who determined that her second child (the hoped-for son and heir) should be born North of the Tweed. Her exquisite younger daughter, Margaret Rose, brought such charm and grace with her into the world that she more than made up for the momentary disappointment of her sex, and the gesture that Queen Elizabeth made when she decided that the child who might have been the nation's future king should be born in the Highlands will never be forgotten.'
*Unsigned, April 1937*

**The Queen and King George VI in Edinburgh, 1937.**
The newly crowned couple on one of their first official engagements, the Queen's pleasure on visiting her native country clearly reflected in her smile.

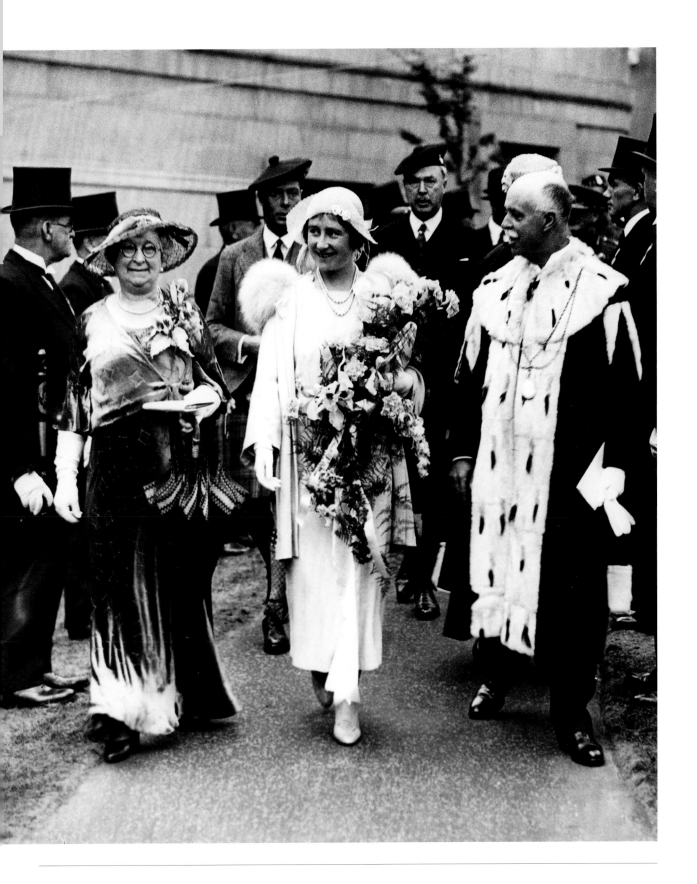

# The Education of a Princess

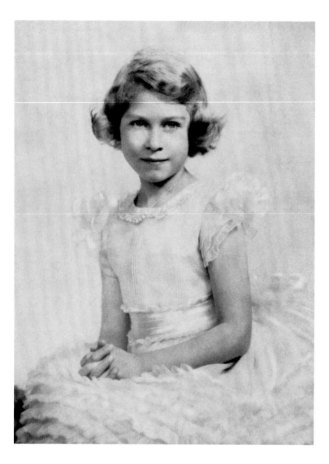

← **The 'Little Princess', Elizabeth, 1937, by Marcus Adams.**
*Vogue* said, 'How best shall a little girl be prepared to occupy the most exalted position in the world? The heir-presumptive to the throne of England, the Empire of India and the monarchy of all the British Dominions beyond the seas is today a princess and not a prince, and whatever may be said about that curious proposition, the equality of the sexes, it is obvious that the education of a prince to be a king is a far different thing from that of the education of a princess to be a queen. One thing is recognized that has never been acknowledged before in the schooling of an English Queen – that whatever state awaits her, she has a right to be happy as a child.

Princess Elizabeth's daily schooling is very like that of any privately educated little English girl – reading, writing, arithmetic, history, geography and French. Dancing and singing lessons are part of the weekly programme, and both princesses are learning to play the piano. Bedtime is early – at half-past six – a point about which the King and Queen are very strict.

For our Princess Elizabeth, who is to be happy before everything, formal lessons are only a small part of education, and for the rest what marvellous and unequalled opportunities will be hers of meeting the world's greatest people and seeing the world's wonders! For this reason her education promises to be unique, and to watch its development promises to be a matter of the greatest interest.'

→ **The Queen Consort and her daughter, aged 10, going to a pantomime, 1937.**
Popular entertainment was considered an important part of a rounded education – and happy childhood – for the future queen.

# Wedding of the Duke & Duchess of Windsor

From **The Windsors' Wedding** by *Cecil Beaton*

'The preparations for the wedding are reaching their final stage. In the office, five secretaries are dealing with the ever-increasing torrent of letters and telegrams. The presents, from all over the world, stand in stacks and range from gramophone records to a portrait of King George V made of over thirteen thousand stamps.

The butler, assisted by footmen in their shirt-sleeves, is presiding over the setting of the elongated dining-table for the festivities.

The parson is here – a genial man with a broad smile – and gives his suggestions for the placement and ornamentation of the altar. It is in the lime-coloured music-room – quite a small but sunny room, with sun-coloured curtains. The Duke, with the enthusiasm of a schoolboy home for the holidays, gives instructions on a thousand different issues and, himself, attends to the positions of the squashed-strawberry chairs for the thirty-two guests, and to the candlesticks and the draping of the curtains.

The guests are arriving, by car, train and air. Everyone gives a helping hand. Bells ring continuously, the telephone and the house bells.

"Where's the best man?"

Meanwhile, the towering vases of flowers become greater monuments to Mrs Spry's genius. The air is heavy with the scent of white peonies and lily-of-the-valley.

Upstairs, in readiness, hangs the grey-blue dress and slip that Mainbocher made, to give the bride-to-be the fluted lines of a Chinese statue. Downstairs, the bride-to-be, trim and smiling in yellow, with raised fingertips, is giving last-minute instructions and the first greetings to the organist. A large white carnation arrives for the duke's buttonhole, and the final touches have been given to the preparations for the marriage that has involved so much.'

*American* Vogue, *July 1937*

**The Duke and Duchess of Windsor, 1937, by Cecil Beaton.**
The now ex-King Edward VIII and Wallis Simpson were married on 3 June 1937, at the Château de Candé in France. Despite the elegance (and expense) of their carefully planned wedding, the day involved some deep disappointments for the new Duke and Duchess of Windsor. Cecil Beaton's report for *Vogue* – naturally – did not mention that, to the Duke's distress, none of the Royal Family chose to attend. Still more shocking for the couple was the revelation that, although he remained a Prince, with the style 'His Royal Highness', royal status had been denied to his adored wife, who would officially be called 'Her Grace', and who would not be curtsied to.

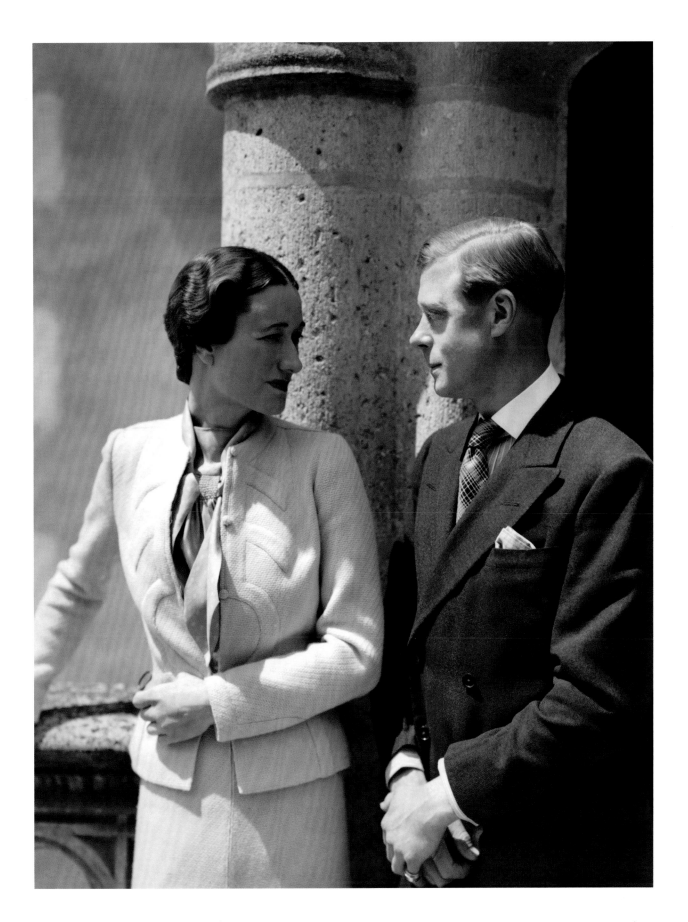

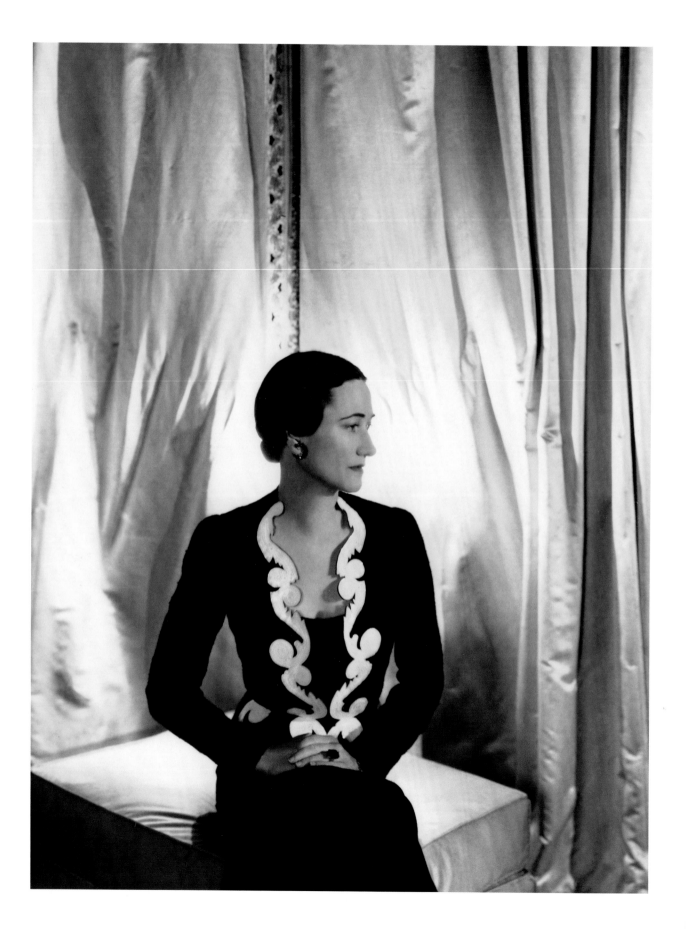

# The Duchess's Trousseau

**← The Duchess of Windsor, 1937, by Cecil Beaton.**
Before 'the marriage that has involved so much', Cecil Beaton was invited to stay with Mrs Simpson at the Château de Candé, where prior to the wedding he photographed her in her trousseau. Known for her hard-edged chic (in contrast to the 'feminine loveliness' of the new Queen Consort Elizabeth's style), Wallis favoured the sophisticated designs of Paris-based couturiers Mainbocher and Schiaparelli, in whose creations she now posed.

**→ The Duchess of Windsor, 1937, by Cecil Beaton.**
Beaton decided to change her image on this historic occasion for a softer, more romantic look. The resulting photographs, taken in and around the château and its sunlit, summery grounds show the future Duchess of Windsor in uncharacteristically wistful and reflective mood.

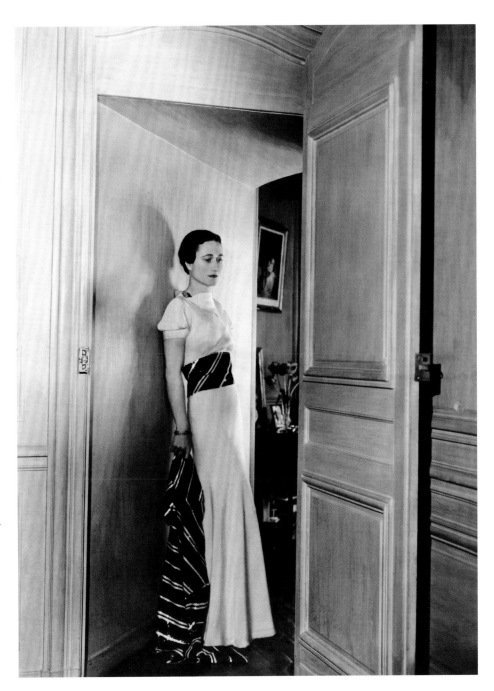

**↓ The Duchess of Windsor, 1937, by Cecil Beaton.** Wallis wrote to Beaton saying how delighted she was with the results of the shoot.

American *Vogue* published the photographs over many pages, and the issue sold out at once.

**→ The Duchess of Windsor, 1937, by Cecil Beaton.** The photographs of the Duchess were an immense success – notably this one

of her wearing Schiaparelli's famous organdie dress with a lobster design by the Surrealist artist Salvador Dalí.

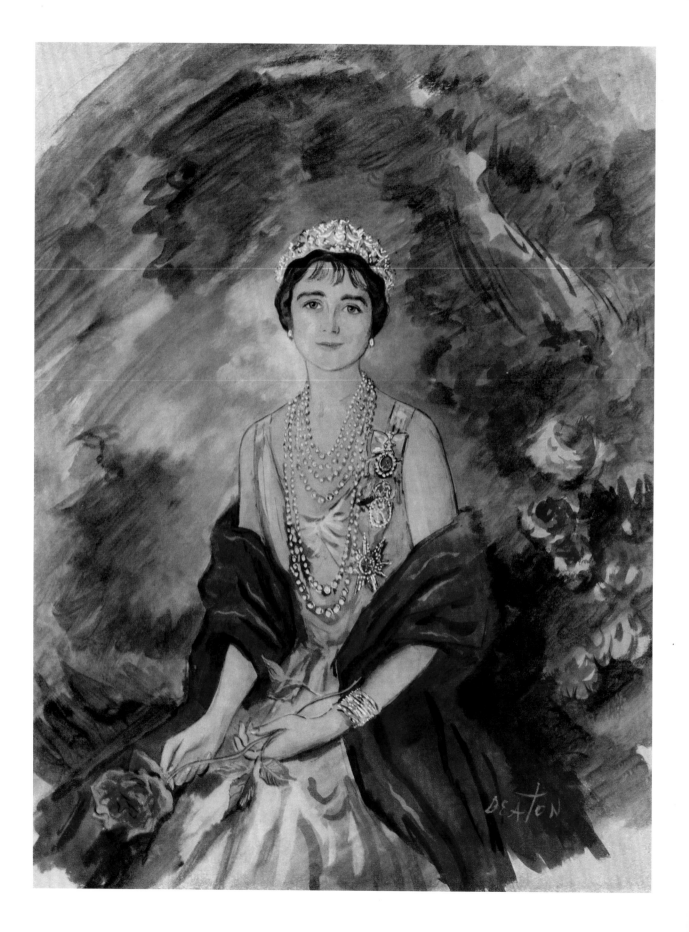

# Her Gracious Majesty

**← Her Majesty the Queen, 1937, by Cecil Beaton.**
*Vogue* said, 'We salute the First Lady in the Empire. She on whom so much of our social hopes are pinned is ... a graceful, gracious young woman of the world. Her friends, and she has many, quietly, confidently predict a happy, harmonious reign, for she herself has a happy, harmonious personality.

'The Queen has enjoyed the unusual advantage – obviously denied to the royal-born – of a training in the frank and real, not the fairy tale, world. Youngest but one of a family of ten, Her Majesty has had the best social training known to Woman – to be part of an enormous family enjoying a perpetual house party. On one occasion, she acted as hostess at home to a party that included His Majesty-to-be.'

**→ King George VI and Queen Elizabeth, 1937.**
The newly crowned couple meeting the public 'in their own atmosphere of happiness and youth', as *Vogue* wrote.

# Behind the Throne

*From* **To See the Queen** *by Evelyn Waugh*

'Most of us formed our first abiding impressions of the Queen from our nursery rhymes.

"Pussy-cat, pussy-cat, where have you been?
I've been up to London, to see the new Queen
Pussy-cat, pussy-cat, what did you there?
I frightened a little mouse under her chair."

And we pictured the Queen as someone accessible and human.

There is no uniform for a Queen. She can dress capriciously and imaginatively to suit the day and her mood. It used to be a great difficulty to draughtsmen in the old pre-camera days of the illustrated newspapers; they had to get their drawings sketched out before the event they were covering, and they never knew what the Queen was going to wear. The King, with his multifarious duties, is almost always dressed to represent one of them; his *levées* are august and business-like, thronged with diplomats and politicians and soldiers and ecclesiastics. But the Queen's Court is a party.

And it is not only on the state-regulated occasions that the glamour is felt. Sometimes, on driving through a provincial town, one notices an unusual sense of excitement; there is a little crowd collected on the pavement outside an antique shop; and inside is the Queen, choosing a wedding-present for a friend. Like the pussy-cat in the nursery-rhyme, they have come to see the Queen.

The King, to the child's imagination, is usually a soldier at the head of his troops. Later, he becomes the figure of the State – and as one gets older, the state comes more and more to mean the filling-up of forms and signing of cheques. *L'Etat c'est moi;* the "state is in his counting-house counting up his money". The King is the Law; the traffic-cop; the customs-house man; the Inland Revenue commissioner.

But the element of delight is one of the natural, spontaneous, inimitable functions of the Queens of England.' *May 1938*

**Conversation Piece, 1937, by Rex Whistler.** Commissioned from the artist Rex Whistler for British *Vogue*'s 1937 Coronation Issue, this 'Conversation Piece' is consciously informal in style, emphasizing the unpretentious image of the new King George VI and Royal Family. George's consort Queen Elizabeth became a noted collector of paintings by British artists; Whistler, one of her favourites, would be tragically killed in the coming World War II.

Drawn by Rex Whistler

The King and Queen
with the Princesses

# VOGUE

INCORPORATING VOGUE PATTERN BOOK, VOGUE BEAUTY BOOK, VOGUE HOUSE AND GARDEN BOOK

**SEPTEMBER 20, 1939 (19) · PRICE ONE SHILLING**

THE CONDÉ NAST PUBLICATIONS LTD. 1, NEW BOND STREET, LONDON, W.1

# 3.

# *The Windsors in Wartime*

**The first *Vogue* cover of World War II, 1939.**

In the first wartime issue, beneath a red-white-and-blue cover displaying the Royal Arms, *Vogue* sombrely wrote, 'At such a time we find example and encouragement in Their Majesties… In them we see courage, devotion and duty.'

With the outbreak of World War II, in September 1939, the role of the Crown came once again into sharp focus. The image of an unostentatious, hard-working Royal Family, to whom the public could look for leadership, yet to whom they could also relate as real people, had never been more important.

On the eve of war, as the King and Queen embarked on crucial foreign tours to secure international alliances, *Vogue* helped remodel the Queen's image as a vision of regally romantic femininity, impressing even the fashion-conscious (and republican) French. In the heat of war, however, the narrative changed again. *Vogue*'s spotlight was now on a down-to-earth, 'all-in-it-together' monarchy, with articles and photographs showing the Royal Family, old and young alike, stoically serving in uniform, reviewing troops and nurses, inspecting their own bomb damage, and preserving precarious family life, against the backdrop of all-out war.

It was with relief and gratitude that, after 1945, the magazine could turn once again to the happier peacetime coverage of royal weddings, fashion and future generations.

# The Eve of War

When the former Duchess of York became Britain's Queen Consort in 1936, no one would have guessed that she would ever create fashion history. Petite and plump, at a time when *Vogue's* pages were filled with taut-hipped women in sharply tailored suits and sleek, clinging gowns, the new Queen invariably favoured ensembles involving pastel colours, heavy fabrics and loose lines – reputedly earning her the nickname 'Cookie' from ex-King Edward and Mrs Simpson, who said she looked like a Scottish cook.

*Vogue* – ever loyal – praised the Queen's highly individual style as the essence of true taste, declaring, 'The chic, the severe, the statuesque would be quite wrong for her', and pointing out, 'It is a queen's place to follow, not fashion, but the grand tradition of royal dressing.'

In 1938, however, the grand tradition of royal dressing and fashion for once came together when, in order to secure support for the coming war in Europe, George VI and Queen Elizabeth made a State Visit to France. With all eyes on the Queen, for the sake of British prestige her wardrobe had to be spectacular, and the royal couturier, Norman Hartnell, surpassed himself. Taking inspiration from a Palace portrait of the French Empress Eugénie in Victorian dress, Hartnell made an asset of his royal client's fuller figure and 'gentle loveliness', producing floating, romantic, extravagantly full-skirted designs, which made the Queen into a 'fairy tale' vision, captivating the French and setting an instant new fashion for crinoline gowns.

↑ **Queen Elizabeth, 1938, by Norman Hartnell.** The death of the Queen's mother, shortly before the all-important royal visit to France in 1938, necessitated official mourning dress for Her Majesty (no bright colours to be worn), and set Hartnell an additional design challenge.

→ **Queen Elizabeth, 1939, by Cecil Beaton.** Hartnell's brilliant solution was an all-white wardrobe, with the famous snowy crinolines, and slimmer gowns, spangled with gold – all judged wonderfully appropriate and regally chic by the discerning French. It became her signature style.

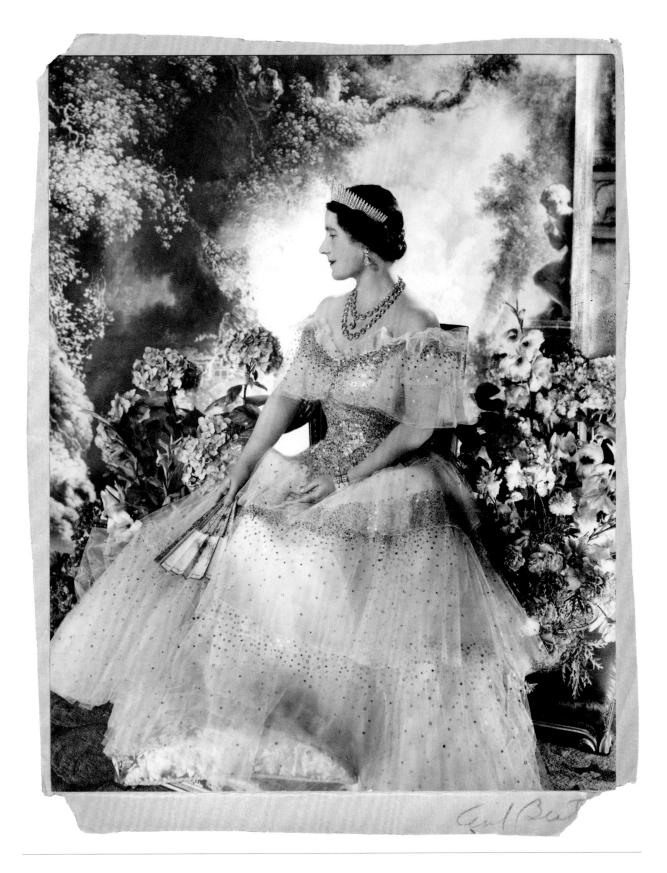

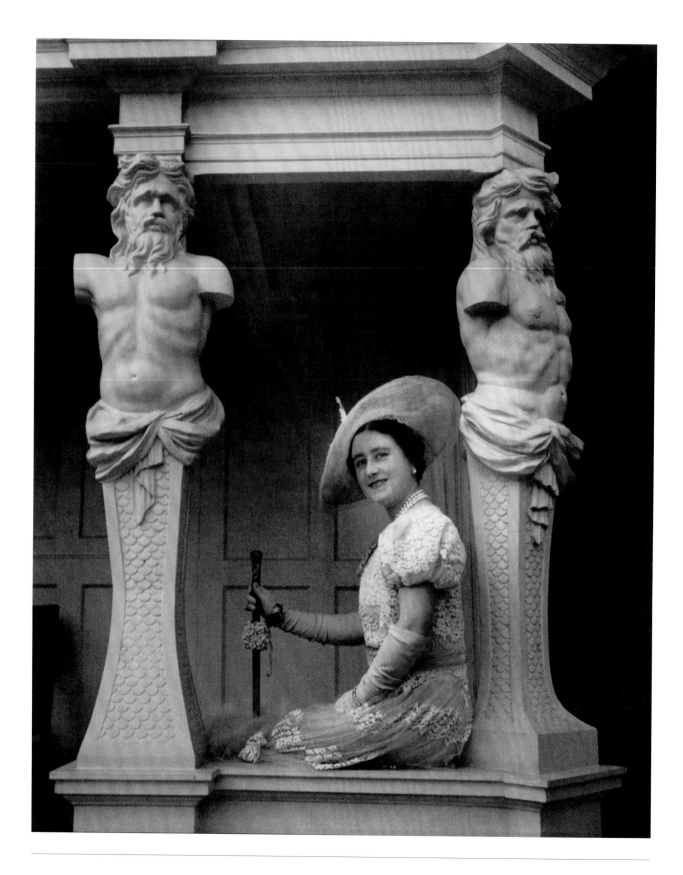

# The Faerie Queen

The invitation from Buckingham Palace to photograph Queen Elizabeth came as a surprise to Cecil Beaton, not least because he had photographed the wedding of ex-King Edward VIII, now the Duke of Windsor, and the inflexibly chic Wallis Simpson, both of whom the Queen had reason to dislike.

It went ahead, and it would be no exaggeration to claim that the photographs Beaton took that summer's day in 1939 changed the public's perception of the monarchy and revived the fortunes of the House of Windsor. Here was a Queen stepped out from a fairy tale, romantic and sun-blessed. In and around the Palace, he made not a 'likeness' of the new Queen, but instead the very image of what monarchy should be for a modern era: dazzling and remote but with a smiling, human face. Beaton's romanticization of the Royal Family ceased with the coming war – but only for the duration. He was obliged now to show the King, his wife and two teenage daughters as ordinary citizens enduring the depredations that were common to all their people.

The pomp and pageantry of the 1953 Coronation – for which he was official photographer – afforded Beaton fresh opportunities to root the monarchy in the full splendour of history, as a new Elizabethan age dawned. The next decades saw the Royal Family respond to prevailing social forces, becoming more open and relaxed, and Beaton's official sittings reflected this new democratic era. He would never forget who he was and who they were, however: 'The treatment he employs is imaginative but realistic,' observed his friend Peter Quennell. 'He shows his sitters just as they are, yet with a hint of the strangely transfiguring radiance that encircles those who occupy a throne.' Or as Queen Elizabeth, by then the Queen Mother, herself wrote to Beaton in 1963, 'I feel that, as a family, we must be deeply grateful to you for producing us as really quite nice and *real* people...'

**Queen Elizabeth at Buckingham Palace, 1939, by Cecil Beaton.** Although Beaton made extensive use of painted backdrops when photographing the Royal Family, not least for expediency, he also made a virtue of the architecture he found. Interior shots in the state apartments of Buckingham Palace gave a privileged glimpse into a private world, while those in the Palace grounds added scale and grandeur.

By the time his photographs of Queen Elizabeth were published, the nation was at war and Beaton was carving out another of his many roles, that of war photographer. When he returned to royal duties it was with a new sense of purpose.

# Forging Alliances

## *From* **Entente Cordiale**

'*Vogue*'s eye, as that of all the world today, is turned on Paris, where Their Britannic Majesties King George VI and Queen Elizabeth are to pay their State Visit to the President of the French Republic.

How fantastic, how splendid, that in this grim modern world there should still be all the pageantry, all the pomp and circumstance, and above all the tradition, of a Royal visit. The French nation understands both simplicity and splendour. Yet when Republican France plays host, the magnificence is dazzling, the preparations are lavish, and the ceremonial as impressive as that of any monarchy.

Now, barely a year after the last Coronation fanfare has died away on the summer air, Royalist England visits Republican France. There are more trumpets, more drums, more national anthems, bright bunting, and the sun glinting on uniforms, gold lace, and all the panoply of state.

Down the beautiful chestnut-lined boulevards of Paris comes the Royal procession. The King, with M Le Président. The Queen, with Mme Lebrun. Then the entourage, the household, the Lords and Ladies in Waiting, the ministers and officials of the Crown, the ambassadors and plenipotentiaries. *Vive le Roi*! *Vive la Reine*! It is another move on the great European chessboard, made by a real king and a real queen, who on this great and historic occasion, are fully aware of the national significance of their move – a move which proclaims that the *Entente* is still as *Cordiale* as ever.' *Unsigned, June 1938*

**Illustration, 1938, by Raymond de Lavererie.** A favourite *Vogue* illustrator, Raymond de Lavererie, produced a series of colourful cartoons showing the scenes awaiting the King and Queen on their all-important State Visit to France in 1938. King George VI and the French President, M. Lebrun, are depicted with 'all the panoply of banners and bunting', cheering crowds and an escort of exotic 'Spahi' horsemen, from the French colonies.

# Allied Interests

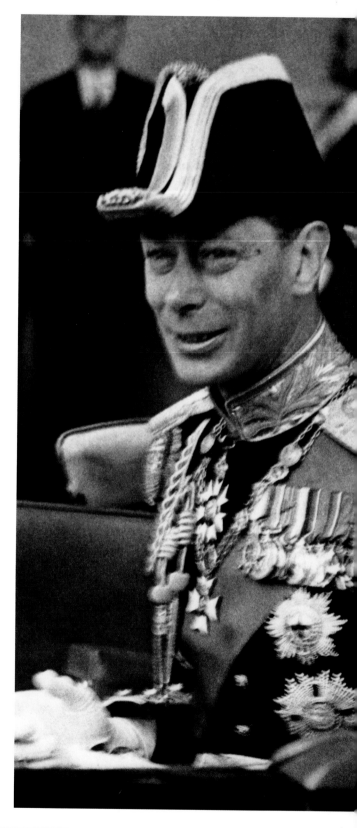

**King George VI and President Roosevelt, 1939.** This photograph was taken during the royal visit to the United States, with host and soon-to-be wartime ally, President Roosevelt. 'Canada and America are standing proof of the possibility of peace,' wrote *Vogue*. 'We salute them as they prepare, with legendary hospitality, to welcome our King and Queen!'

After the triumph of the French State Visit, King George VI and Queen Elizabeth embarked, in the spring of 1939, on an official tour of potentially still greater importance, to Canada and the United States. The loyalty of the great British dominion of Canada, with its resources and manpower, would be vital in the coming conflict – but there was no guarantee that an increasingly independent-minded population, in the twilight of Empire, would automatically support a second devastating war in Europe, as it had the last. Much less certain was America's position in a second Great War on faraway foreign soil. In pursuit of both potential partners and allies, every element of historic goodwill and belief in common interests and ideals that could be called upon now had to be enlisted – with the aid (it was hoped) of what *Vogue* called the 'gala performance' that was this royal tour.

# Working Royals

**↑ Princess Marina, Duchess of Kent – 'Head of Navy Women', 1939.**
All members of the Royal Family, young and old, had to be seen to be 'doing their bit' as an example to the nation. Here the Duchess inspects air defence and ambulance men.

**→ The Duchess of Gloucester 'leads the WAAF legions', 1939.**
The Duchess was one of the hardest-working members of the wartime Royal Family. She was Senior Controller in the WAAF before becoming Senior Commandant in 1940, and then Air Chief Commandant in 1943.

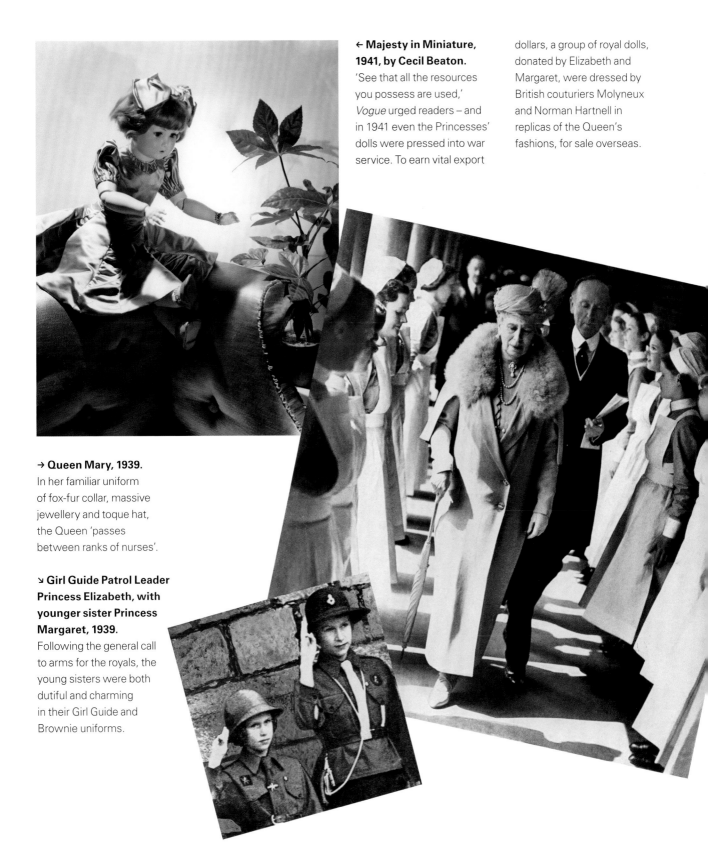

**← Majesty in Miniature, 1941, by Cecil Beaton.** 'See that all the resources you possess are used,' *Vogue* urged readers – and in 1941 even the Princesses' dolls were pressed into war service. To earn vital export dollars, a group of royal dolls, donated by Elizabeth and Margaret, were dressed by British couturiers Molyneux and Norman Hartnell in replicas of the Queen's fashions, for sale overseas.

**→ Queen Mary, 1939.** In her familiar uniform of fox-fur collar, massive jewellery and toque hat, the Queen 'passes between ranks of nurses'.

**↘ Girl Guide Patrol Leader Princess Elizabeth, with younger sister Princess Margaret, 1939.** Following the general call to arms for the royals, the young sisters were both dutiful and charming in their Girl Guide and Brownie uniforms.

# Wallis's War

From **Jotted Down** *by Wallis Windsor*

'Like everybody else, we live from hand to mouth. Government House at Nassau is on a completely wartime schedule. The Duke spends all day at his office; I spend mine at the United Services Canteen, the Negro Canteen, the Red Cross and the two Infant Welfare clinics that we founded.

I enjoy housekeeping. Food rationing is stringent in Nassau, and grumbling about war's adjustments, about any kind of rationing, bores me, infuriates me. The Duke has for his luncheon, all year round, a hot green vegetable, fruit compote, and maté. I never diet, but I do keep my weight around 112, just by being careful.

In wartime, especially, my clothes philosophy on the Island as everywhere, is simply to look neat, appropriate and inconspicuous. I don't give much time to clothes, as mine are just correct, well-cut and of good materials.

Since I can't be pretty, I try to look sophisticated, but unfortunately, I always want to be dressed like everybody else. When I am out I always feel dowdy, and wish that I had thought of getting THAT dress, and wearing it THAT way.'
*American* Vogue, *July 1943*

↑ **The Duchess of Windsor, 1941, by John Rawlings.** In Red Cross uniform overseeing plans for renovations to Government House.

↗ **The Duke of Windsor, 1941, by John Rawlings.** On duty addressing the Bahamas Labour Union.

→ **The Duke and Duchess of Windsor, 1941, by John Rawlings.** As Governor and Governor's Lady, diligently performing their wartime roles.

Finding an official wartime role for the Duke of Windsor that would reflect his royal status, but distance him from strategic affairs, was a matter of some importance. Although his embarrassingly friendly private visit to Hitler, with the Duchess in 1937, was put down to would-be peace-making naivety, there was every reason to doubt the former King Edward VIII's absolute commitment to Allied victory.

The solution found – creating him Governor of the Bahamas – was far from satisfactory. The Duke and Duchess resented what they considered the rather ignominious posting, and they did little to endear themselves to the local people. The Duchess devoted much of her time on arrival to overseeing improvements to Government House, and thereafter the couple took frequent trips away from the island.

Nevertheless, the appearance of loyal service to the Crown was maintained. For *Vogue*, the Duchess wrote a vivid account of their busy daily lives and duties.

# The Family Front

**↑ Prince Edward of Kent, 1941, by Cecil Beaton.** *Vogue*'s unique access to the private lives of the Royal Family resulted in one especially poignant set of wartime images – informal photographs, taken in 1941 by their friend Cecil Beaton, of the Duke and Duchess of Kent and family at home in the country, while the Duke was on leave from the RAF. *Vogue* stressed the normality of the Kents' 'healthy, Spartan, outdoor' lives, with a minimum of servants and ceremony.

**→ Prince Edward of Kent and Princess Alexandra plane-spotting with their father, 1941, by Cecil Beaton.** A year later, in August 1942, their father the Duke of Kent would be killed in a flying accident over Scotland, leaving the Duchess a war widow, now with a third child, Prince Michael of Kent, born just seven weeks before the Duke's tragic death.

# In Which They Serve

*From* **Headline Family – The Mountbattens**
*by Lesley Blanch*

'As Supreme Allied Commander, South East Asia, Lord Louis Mountbatten is the man of the hour. He is a magnetic and glittering figure, but no figure-head.

Until the war, only his closest friends, and perhaps the Admiralty, knew that the navy was the real passion of his life. He prefers the seamanship and personal qualities involved in handling destroyers to the more static immensity of bigger ships. He loves a seagoing life, and it is no secret that his new appointment cost him much to accept. He is an arrogant, vain, impulsive and dashing Captain, who, had he not such magnificent seamanship, might be dubbed slapdash by the diehards. His men adore him.

No need to recall here the many anecdotes of his furious fighting record, commanding the HMS *Kelly*, commanding the aircraft carrier HMS *Illustrious*, and then becoming "Commando-in-Chief". His every move is history now. As Supreme Allied Commander, South East Asia, he will be in supreme control over operations which he not only first envisaged, but also perfected by long months of experiment, rebuff, innovation and rehearsal.

And Lady Louis? She too has met the challenge of reality with purpose and individuality. "Just the wife of a Commando" is how she described herself in a recent speech. Actually, she is something more. She is Superintendent-in-Chief of the Joint Red Cross and St John Organisation. During the worst of the Blitz she worked in the shelters – the real ones: the fetid, lousy, damp, overcrowded shelters of the East End. She is as avid for work now as she used to be for play. She will switch her energies, after the war, to fighting for a better way of living, she says. She will expect, and want, to work just as hard. But NOT in uniform, please, she adds, with her quizzical, wry smile.' *November 1943*

**The Mountbatten family, 1943, by Cecil Beaton.** The Mountbattens were never shy of publicity, and their celebrity status was put to good use during World War II. Besides press coverage showing the whole family in uniform (their teenage daughters Patricia and Pamela were in the WRNS and the Girl Guides), a barely fictionalized film based on Lord Louis' naval exploits, *In Which We Serve* (1942), became one of the major box-office hits of the era – boosting both national morale and the wartime royal image.

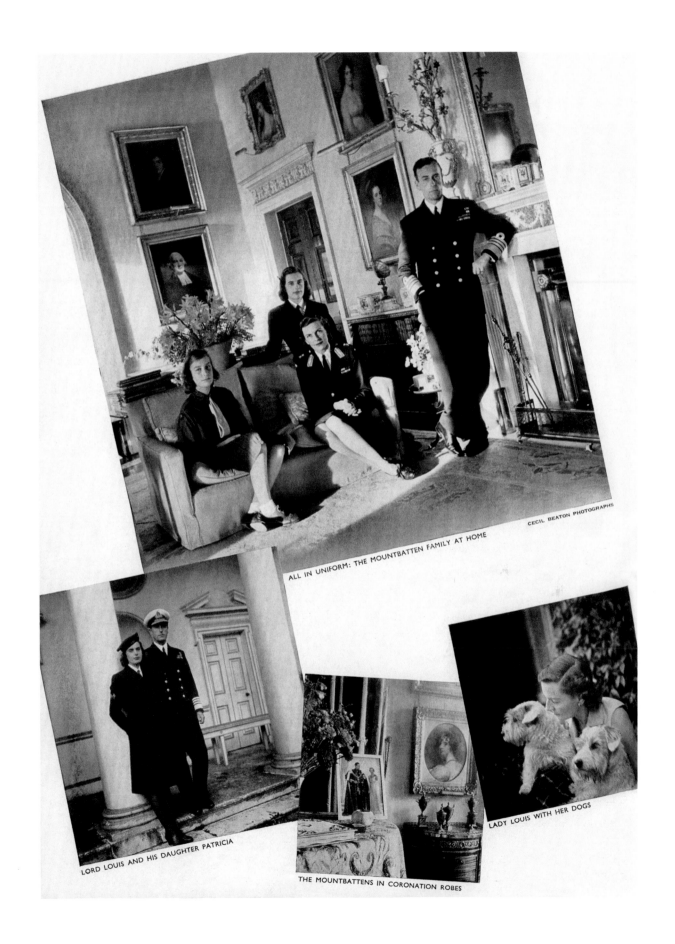

ALL IN UNIFORM: THE MOUNTBATTEN FAMILY AT HOME

CECIL BEATON PHOTOGRAPHS

LORD LOUIS AND HIS DAUGHTER PATRICIA

THE MOUNTBATTENS IN CORONATION ROBES

LADY LOUIS WITH HER DOGS

# Royalty Resilient

Sharing the hardships of ordinary people was an essential aspect of the King and Queen's wartime image. *Vogue* wrote that, like everyone else, Their Majesties had to abide by food rationing, and eke out their clothes coupons. Famously, they stayed in London during the devastating bombardments of the Blitz (although their daughters were based in the safer surroundings of stout-walled Windsor Castle, 20 miles away).

The Queen made a point of visiting the victims of air raids in the poorer parts of London – to some initial criticism that her appearances, wearing pre-war furs and finery, were out of touch with ordinary people's lives. Her reported response – with her usual gift for public relations – was that others wore their best clothes to see her, and she wished to return the compliment. The resentment did not last, especially after Buckingham Palace was itself hit in 1940, and the Queen declared boldly, 'I'm glad we've been bombed – it makes me feel I can look the East End in the face.'

**The King and Queen inspect the bomb damage at Buckingham Palace, 1941, by Cecil Beaton.** Even the bombing of Buckingham Palace at the height of the air raids on London provided a royal photo opportunity. The King and Queen posed cheerfully for Beaton, smiling amid the tidied-up debris.

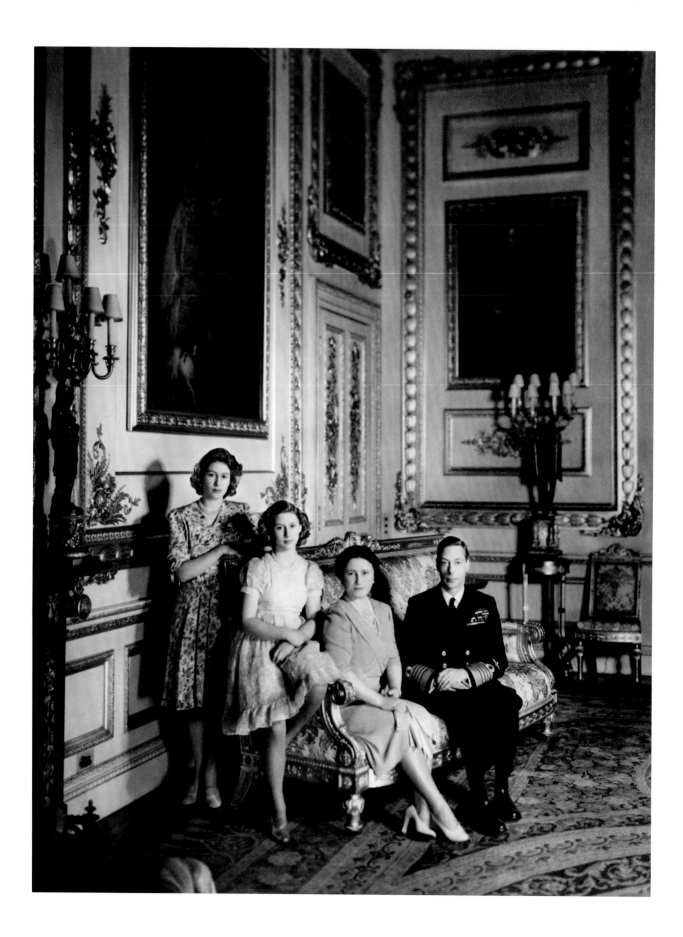

← Rationed Royals:
**The Royal Family at
Windsor Castle, 1943,
by Cecil Beaton.**
'During the bombing of
London,' Cecil Beaton
recalled in an article for
*Vogue*, 'we photographed
in the Palace's ground-floor
living rooms, where many
of the possessions had been
taken into hiding.' Keeping
up appearances – essential
to the war effort – meant
that an aura of stately dignity
for the Royal Family still had
to be maintained.

**→ Princesses Elizabeth
and Margaret, 1945,
by Cecil Beaton.**
While royal treasures were
locked away, and clothes
– for princesses as well
as the public – subject to
the Government policy
of 'Make Do and Mend',
Beaton photographed the
heir-presumptive to the
Crown, the teenage Princess
Elizabeth, in one of her
mother's pre-war evening
dresses, cut down to fit her.

# Eyes Forward

**_From_ HRH Princess Elizabeth**

'Princess Elizabeth, tall, natural and charming, approaches her 17th birthday with a great sense of the responsibility of her position and its duties. Her gentle smile, delicate complexion and long, sensitive fingers belie the fact that she can handle a light sixteen-bore gun. She is a wonderful swimmer, too, and was the first candidate to gain the Royal Life-Saving Junior Artificial Respiration award under war conditions. She can handle a stirrup-pump, too.

Her breadth of social instinct has been enhanced by meeting, with the King and Queen, people of all ranks and professions (cabinet ministers, diplomats, generals, artists, admirals, airmen, ratings and musicians); by helping her parents at receptions for the Allies; by tours to aerodromes, and centres of industry; and by close contact with her contemporaries in the Guides. Her broadcasts have radiated her presence to all corners of the country and Empire.

The familiar ease and charm of her family life have given her more freedom of upbringing than any former heir-presumptive to the throne has had. And her constant companionship with the king has done much to mould and direct her character.' _Unsigned, January 1943_

**↑ Portrait of Princess Elizabeth, 1943, by Princess Marina, Duchess of Kent.** The beautiful Duchess was a talented artist and this sensitive portrait of her niece, the future Queen, depicts a young woman of poise and dignity.

**→ Princess Elizabeth, Colonel-in-Chief of the Grenadier Guards, 1943, by Cecil Beaton.** Despite the sentimentality of some of _Vogue_'s wartime coverage of the future Queen, there was real respect for her evident dedication to her present responsibilities and future role. Beginning the war (aged 13) in Girl Guide uniform, Princess Elizabeth ended it in military overalls, serving with the ATS. There was no position more significant of her life to come than her appointment, before her 16th birthday, as Colonel-in-Chief of the Grenadier Guards, whose cap-badge she proudly wore in her hat for this photograph.

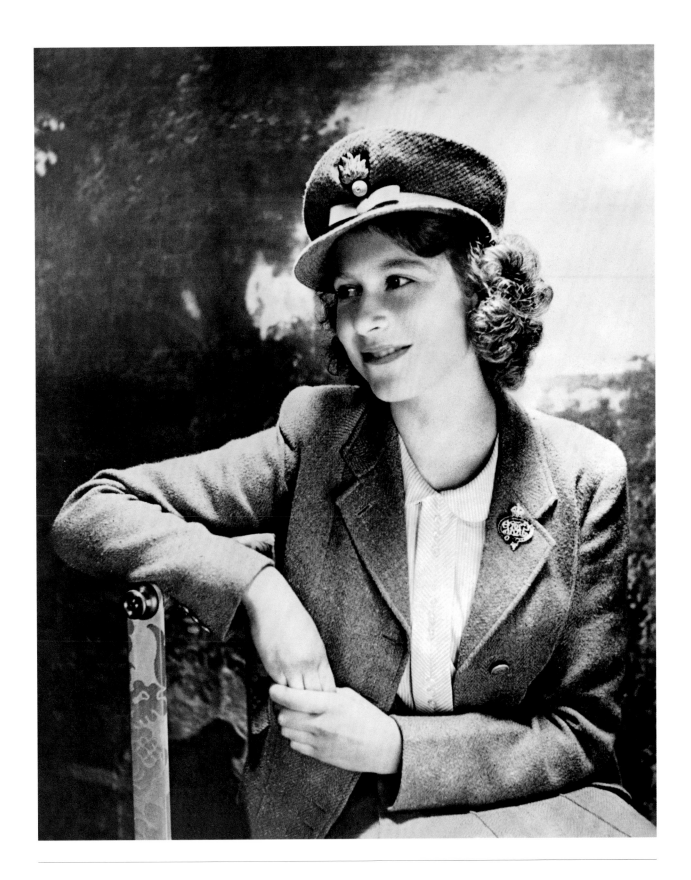

# Peace & Happiness

*From* **The Royal Wedding**

*by Lady Antonia Fraser*

'As I remember it, the whole wonderful occasion of the Royal Wedding, two years after the end of World War II, had an aura of popular enthusiasm surrounding it. It was Austerity Britain all right, clothes rationed and a stingy supply of coupons. Everything was rationed, but we learned not to complain.

And now into this severe, dutiful world came a real-life fairy story. The bride was a princess, but she had dressed up as a soldier in the war; an ordinary ATS uniform being the modern equivalent of a goose girl's get-up. The bridegroom, tall, fair and handsome, was a sailor and a commoner, but he too was a prince in disguise, of royal stock. In fact, on the wedding programme, Prince Philip was still listed as Lieutenant Philip Mountbatten RN, being created Duke of Edinburgh on the very morning of the wedding, too late for the rewrite.

It was the sheer glamorous fact of a wedding, a full white wedding, with bridesmaids, pages, presents and the lot, which was so glorious. We all knew that Princess Elizabeth had been saving her own coupons for the sacred event, and under no circumstances was there going to be any cheating: kindly women who tried to donate their own coupons had them returned.

The Archbishop of Canterbury in his address referred to the wedding unblushingly as "essentially the same as it would be for any cottager who might be married this afternoon at some remote country church in a remote village." All I can comment on this noble sentiment, 63-odd years later, is "Long Live the difference!"' *May 2011*

↗ **Wedding shoe, 1947, drawing by John Ward.**
*Vogue* supplied readers with details of the bride's outfit, including the design of her strappy satin wedding shoes, by Rayne, 'specially drawn for *Vogue*' by the artist John Ward.

→ *Vogue*'s **Royal Wedding cover, 1947, by Carl Erickson ('Eric').**
Princess Elizabeth and Prince Philip were said to have wanted a relatively quiet, simple wedding, but were persuaded by the Government that the nation, dispirited by rationing, shortages and post-war gloom, would be cheered and inspired by the spectacle of a traditional, full-scale royal wedding.

# VOGUE

## The Royal Wedding

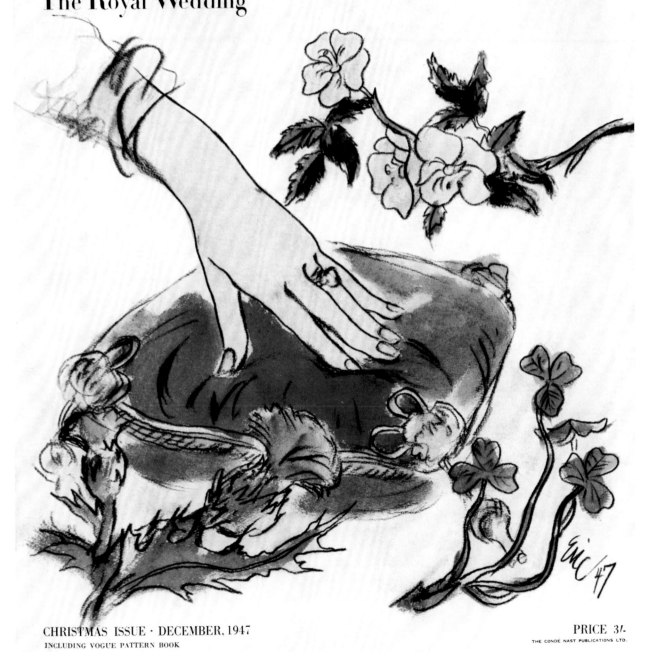

CHRISTMAS ISSUE · DECEMBER, 1947
INCLUDING VOGUE PATTERN BOOK

PRICE 3/-
THE CONDE NAST PUBLICATIONS LTD.

# Wedding of Princess Elizabeth

**↑ The future Prince Philip attends a reception, 1947, by Feliks Topolski.**
Hungarian-born Topolski, a former official War Artist, became a close friend of Philip. A fellow member of the all-male dining society 'The Thursday Club', at which the future Prince liked to unwind, Topolski helped to organize Philip's unofficial stag night in 1947, and drew the wedding. Five years later, he was commissioned by Philip to create a 95-ft-long panorama of Elizabeth II's Coronation, to hang in the state apartments at Buckingham Palace. He would continue, in his unique style, to record royal events, including the weddings of both Princess Margaret and Prince Charles.

**→ Princess Elizabeth and her husband after their wedding, 1947.**
Another fairy tale royal bride in her coach, returning from Westminster Abbey with the newly created Duke of Edinburgh. Her satin dress, by Norman Hartnell, was richly embroidered with stars and she wore the Diamond Fringe Tiara, lent by her grandmother Queen Mary.

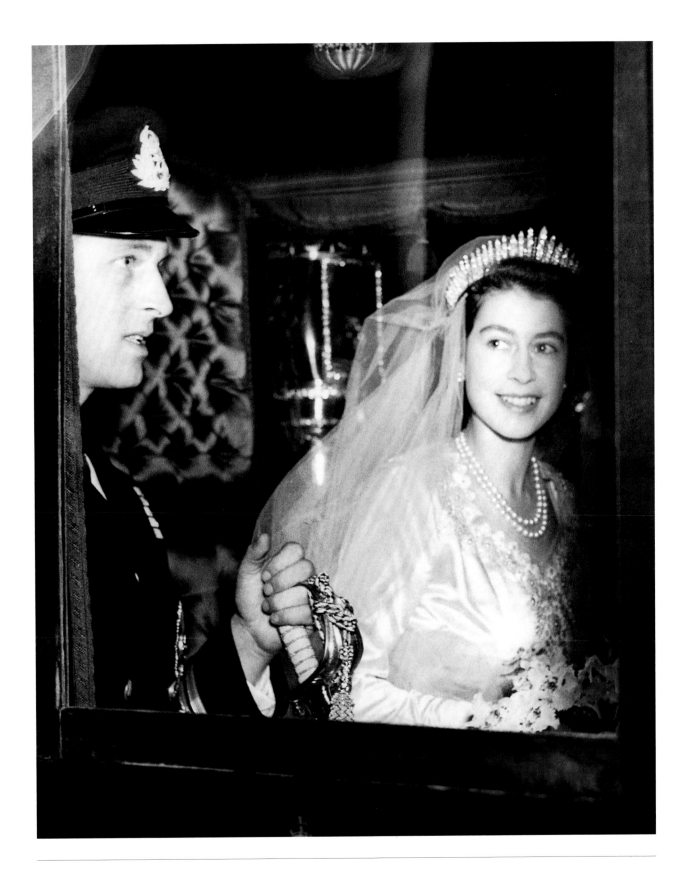

# The Making of a Monarch

When the first picture of the future Queen Elizabeth II appeared in *Vogue*, in January 1927, no one could have foreseen that this baby, born third-in-line to the throne, would grow up to become Britain's longest-serving monarch, and the most famous, and most photographed, woman in the world.

Her uncle, the future King Edward VIII, was then still single; it was assumed that he would marry and produce heirs to replace her in the line of succession to the Crown. But after his historic abdication in 1936, Princess Elizabeth's role changed dramatically. She was now the heir-presumptive to the throne and Empire – and with the stability of the monarchy under threat from the abdication, and soon the nation's very survival under threat from World War II, *Vogue* was called on to help shape the young Princess's public image.

The magazine's photographers and writers portrayed her emergence from charming child into a graceful, dignified and – above all – dutiful young woman, posing in evening dress amid the stately surroundings of Buckingham Palace, or in utility tweeds and uniform at her war work.

By the time of her marriage to naval hero Philip Mountbatten in 1947, Princess Elizabeth had become the focus of deep affection, as well as pride and patriotism, in battle-scarred Britain, and the subject of intense interest abroad.

An article on 'The Monarchy' by the historian Arthur Bryant, commissioned by British *Vogue* to mark the birth of her first child Prince Charles in 1948, also appeared in American *Vogue*. The photograph of Princess Elizabeth (opposite), taken by Cecil Beaton to accompany it was originally unpublished, but Bryant's piece struck a chord with readers, who found in the young royal mother and future Queen the reassuring embodiment of what he defined as 'the steadying and unifying influence of the unchanging Throne' in a rapidly changing modern world.

↑ **Princess Elizabeth inspects the Grenadier Guards, 1947, by Carl Erickson ('Eric').** *Vogue*'s illustrator captures the future Queen's commitment to her military duties.

→ **Princess Elizabeth, 1948, by Cecil Beaton.** Unpublished at the time, a portrait of the serene young mother and future Queen.

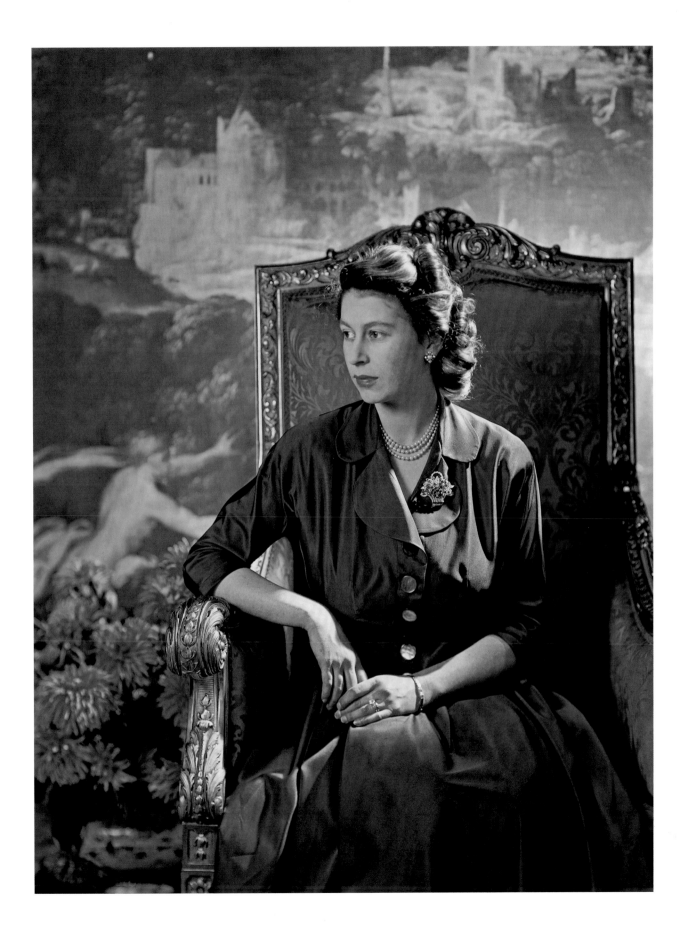

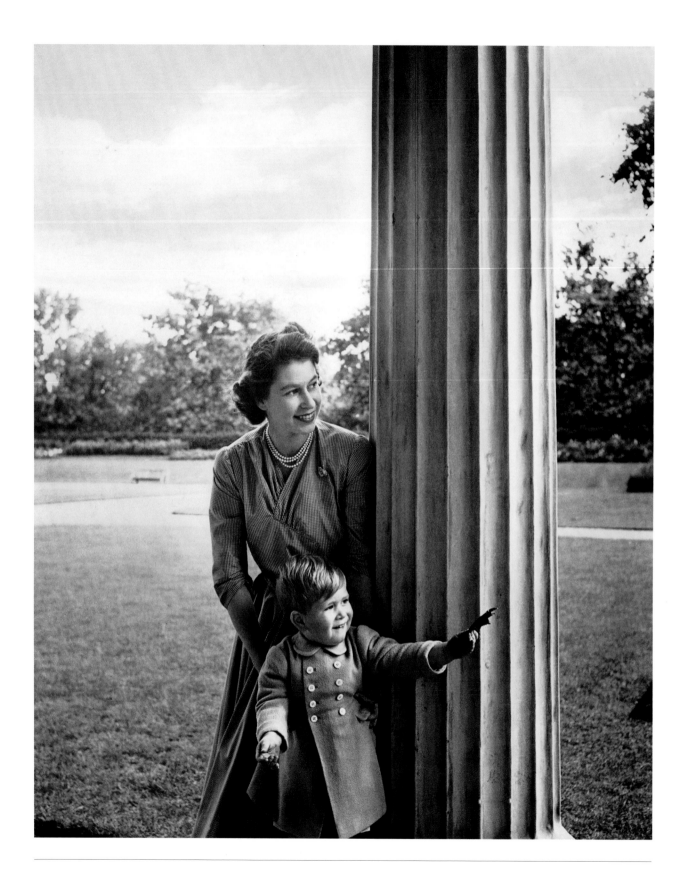

# A Growing Family

**← Princess Elizabeth with Prince Charles, 1950, by Cecil Beaton.**
The 'fairy story' element of Princess Elizabeth's wedding continued in true 'happy ever after' tradition, with the birth twelve months later of a baby son, Prince Charles.

**→ Princess Elizabeth with Princess Anne, 1950, by Cecil Beaton.**
Within two years of the heir, a daughter, Princess Anne was born. The succession to the Crown was now assured and the British public had once again a model Royal Family with charming children, to be followed in the press and increasingly through the new medium of television. 'Though I am not a child photographer,' as Cecil Beaton wrote, he was gratified to have taken the first official photographs of the infant Prince Charles and his baby sister.

# The Other Princess

**Princess Margaret, 1951, by Cecil Beaton.** 'Lilibet is my pride,' King George VI reputedly said of his two daughters, 'but Margaret is my joy,' and despite much sadness in her life, joy would be an enduring characteristic of the beautiful and fun-loving younger princess.

While Elizabeth ('Lilibet'), as heir-presumptive to the Crown, was expected from childhood to behave with exemplary decorum, Margaret – four years her junior – was indulgently allowed some naughtiness in the nursery, and some freedoms as a young adult, from smoking in public and visiting nightclubs to wearing the latest French fashions.

Her choice of a Christian Dior ballgown in which to sit for her 21st-birthday portrait might have raised some eyebrows in bleak post-war Britain, where clothes rationing had not long ended. Skirts with billowing yards of fabric were still a rarity for the privileged few and, as Beaton later wrote in *Vogue*, royalty was generally expected to 'encourage British dressmakers', rather than endorse French couturiers. But, Beaton reported, the Princess was 'very proud' of her Dior gown.

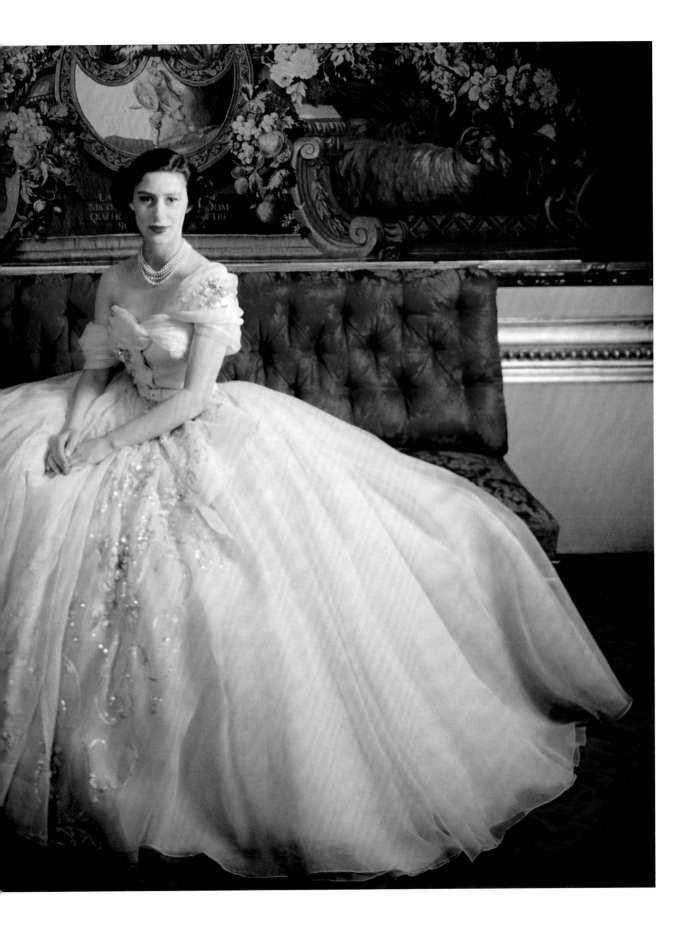

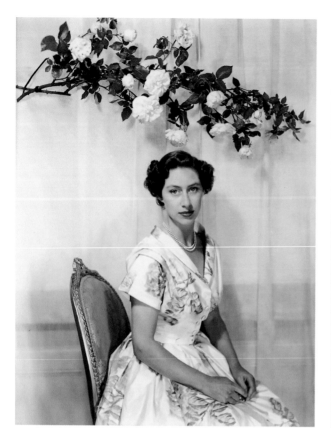

**A princess in bloom**
(*Above left*) A classic study of the Princess, christened Margaret Rose, photographed at Clarence House, 1954, by Cecil Beaton. (*Above right*) The Princess – who loved travel and sunshine – on tour in 1953. (*Left*) The small-waisted, wide-skirted styles of the late '40s and early '50s suited her hourglass figure.

→ **Princess Margaret, 1949, by Cecil Beaton.**
Exquisitely lovely, with (in the words of her photographer Cecil Beaton) 'ice-cream pink cheeks and intensely blue, cat-like eyes', the tiny, curvaceous Princess loved fashion. The embroidered butterflies on her gown symbolize her emergence as a beautiful young woman.

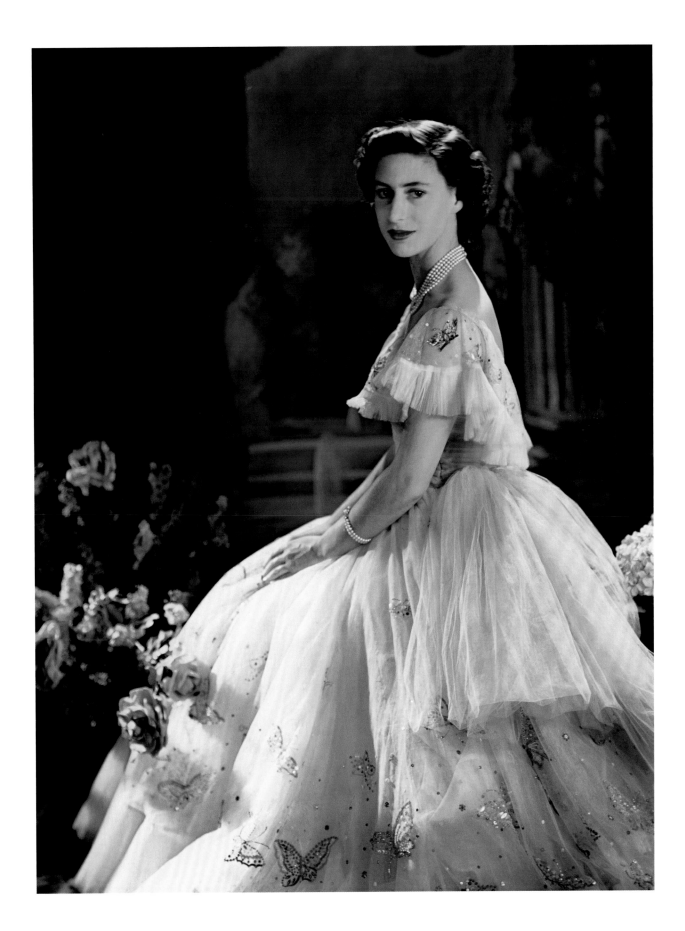

# Majesty...

*From* **The Monarchy** *by Arthur Bryant*

'A hundred and thirty years ago, it looked as if the British monarchy was doomed. Almost every progressive subscribed to the radical philosophy and believed that England, following the example of America, would become a Republic. Since then nearly the whole of the old world as well as the new has repudiated the conception of kingship. But, instead of growing weaker, the monarchy has grown stronger. When I was a boy, Socialist and Radical newspapers habitually attacked the Royal Family in the most insulting terms. Today they scarcely ever attack it at all. No newspaper with a popular circulation could maintain its sales if it did so.

This may seem curious, for since those days the people have grown progressively more Radical and Socialist. Yet we have come to think of our Throne as an essential part of the machinery of government; it seems as vital to us as our Parliament. It is indeed a PART of our Parliament. All legislation is enacted "by the King in Parliament". The King, who is an integral part of this ruling machinery, never opposes the popular will. In all political matters, he accepts the advice of his Ministers. Yet the hereditary King of England is no rubber-stamp; he is as much a personality as the elected President of the United States. The present Queen, and her daughter, the Princess Elizabeth, are the centre of every stage they occupy.

What has happened is that the British – a people with a genius for political evolution, rather than revolution – have resuscitated an ancient and elsewhere discarded institution, and adapted it to suit the needs of a new age. While almost every other nation in the Old World has been fatally rent, Britain has passed through war and change without civil bloodshed, and without disorder. And this has been due, I suggest, not so much to the boasted temperament of the race, as to the steadying and unifying influence of the unchanging Throne.' *April 1949*

**The Queen Mother as Queen Consort, 1949, by Cecil Beaton.**
'Her Majesty the Queen graciously consented to pose for Cecil Beaton in unaccustomed black against a backcloth of his origination, carried out by Martin Battersby,' ran *Vogue*'s caption to this majestic image. 'Her black velvet off-shoulder dress by Norman Hartnell is a wonderful setting for her clear colouring and magnificent diamonds.'

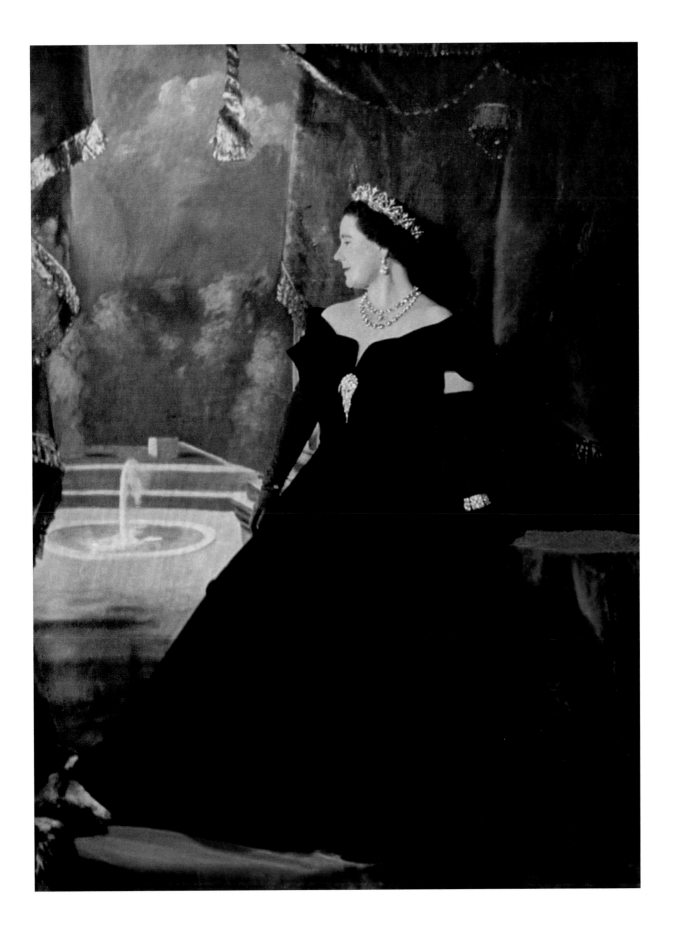

# ...Mourning

**← King George VI, 1952, by Studio Lisa.**
On 6 February 1952, aged 56, the King died suddenly in his sleep at his Norfolk home, Sandringham.

*Vogue* wrote: 'George VI was a loved and respected husband and father, and a deeply conscientious citizen. It is limitlessly to the late King's credit that throughout a reign of utmost personal demands, world crises, wars, vast changes abroad and at home and grave trials of his overtaxed strength, he put the demands of his country before everything.' The tribute ended, 'His people loved him as a gracious and courageous man, both their King and their friend. We mourn the death of a very dearly loved monarch.'

**→ The Three Veiled Queens, 1952.**
George VI's daughter, the new Queen Elizabeth; his mother Queen Mary; and his wife – now Queen Elizabeth the Queen Mother – mourn his death.

# VOGUE

## CORONATION NUMBER

JUNE 1953 • PRICE 3/6
THE CONDÉ NAST PUBLICATIONS LTD

# 4.

# *The New Elizabethan Age*

**Queen Elizabeth II Coronation Issue, 1953, by Norman Parkinson.** Celebrating the new egalitarian post-war age, this cover showed the Crown etched on the glass of a pub door.

Queen Elizabeth II came to the throne in February 1952 on a wave of popular affection, expectation and rejoicing. Despite the sadness of King George VI's sudden death, aged only 56, the accession of a young, beautiful, female monarch – at 25, the same age as her great namesake, the first Queen Elizabeth – seemed to represent the spirit of a bright new era for a post-war populace now looking ardently towards reconciliation abroad and reconstruction at home. The Empire had gone, succeeded by a Commonwealth of independent nations: potentially a still greater force – politically, culturally and ideologically – on the world stage. The scene was set (it seemed) for a new Elizabethan Age of peace and prosperity.

*Vogue* heralded the new reign with lavish coverage of the Coronation, by the doyen of royal chroniclers, Cecil Beaton. But as the decade progressed, readers would be kept abreast of a Royal Family that, along with the traditional glamour and ceremony, increasingly reflected the realities of a changing world, in which princesses could marry commoners, princes could scowl at photographers, and happy endings to fairy tale stories could not always be relied on.

Amid the challenges facing her world in the 1950s and '60s, however, the young Queen would continue steadfastly (as *Vogue* had written on her accession) 'to impose an ordered pattern on an otherwise confused assembly of events'.

# Year of Grace

## From **Her Majesty Queen Elizabeth II**
*by A. L. Rowse*

───────

'A look at our history suggests a very encouraging prospect for the role of a Queen. It can hardly be without significance that the three greatest epochs in English history are each associated with the rule of a woman: the Elizabethan Age; the rule of Queen Anne; the Victorian Age. To what can this be due? Can it be that the figure of a woman at the apex of society calls on greater reserves of loyalty and devotion, even of gallantry, among the men? As an historian I am sure that was certainly true of the first Elizabeth, and think it was pretty certainly true in the case of both Queen Anne and Queen Victoria.

There is no doubt that not merely the idea, but the experience of the English monarchy appeals to the deeper levels of our consciousness. There is something of the nature of a sacrament in it: it is religious in character – even in the literal sense of the word, for "religion" means a bringing together. And our society is bound together by this symbol and by the person of the monarch set apart – bound together in common memories and common experiences of trial and rejoicing; of being bombed together in wartime London, of losses shared, the Royal Family losing a beloved member, like so many thousands of English families. And then the memories of so many great days and rejoicing: VE Day and the throngs round Buckingham Palace calling out the King and Queen, coronations and weddings in the Abbey; state visits in the City, to St Paul's or the Guildhall.

All this is summed up and expressed in the Rite of Coronation, going back unbroken for more than a thousand years to the crowning of the Anglo-Saxon kings – Queen Elizabeth's faraway but undoubted ancestors – in the early days of the English people on this island.

We who live here are apt to take these things for granted, the sense of history is so much part of the air we breathe.' *March 1952*

**Princess Elizabeth, 1951.** In the year between her Accession and Coronation, the young monarch impressed her subjects at home and onlookers abroad with her combination of youthful grace and queenly dignity. Here, before her Accession, she attends the premiere of the film *The Lady With a Lamp*.

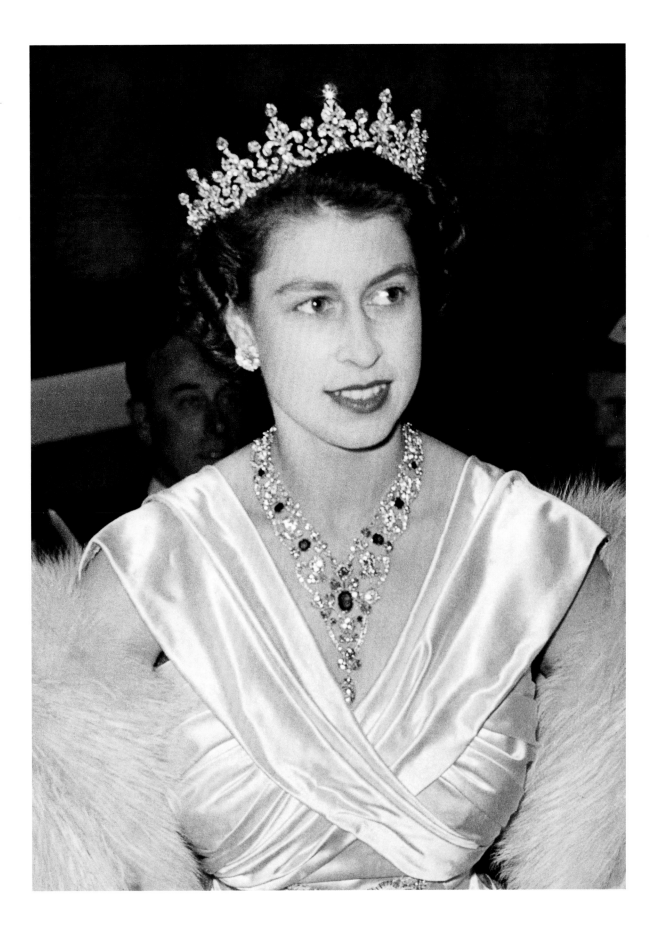

# In Fashion

**The Queen and Princess Margaret at a private British fashion show, 1952, by Carl Erickson ('Eric').**
Asked as a girl what she would like to be when she grew up, Queen Elizabeth reportedly said, 'A lady living in the country with a lot of horses and dogs', and her preferred style of dressing was always that of an upper-class countrywoman – Hermès headscarves, tweed skirts and sensible shoes.

Nevertheless, the fashion industry was of enormous importance to Britain's post-war economy, and the young Queen promoted it loyally. Apart from her French scarves, her accessories were British-made (shoes by Rayne, handbags by Launer) and her wardrobe, for years, was almost exclusively by London designers Norman Hartnell and Hardy Amies, who understood the demands of her role. The look she established as a young Queen, with bold colours and off-the-face hats, so she could be clearly seen by the public, has varied little – although in the mid-1960s, when even her sister and daughter appeared in mini skirts, Her Majesty's hemlines were permitted to rise a decorous inch or so.

H.M. THE

86

**EN AND** **H.R.H. PRINCESS MARGARET** attended a private showing, on November 12,

of clothes by members of the Incorporated Society of London Fashion Designers, and of new fabrics from British textile mills.

Vogue's artist, Carl Erickson, flew from Paris for the occasion, and sketched them

watching the parade with Lady Clark, the President, and John Cavanagh, who, like each of the designers in turn,

took his place beside the Queen while his own models were shown. This Royal interest

is a most welcome encouragement to the whole fashion and textile trade.

87

# The Coronation of Elizabeth II

← **The Ancient Abbey: Westminster Abbey's Rose Window and North Transept sketched during the Coronation, 1953, by Cecil Beaton.**
On 2 June 1953, Elizabeth II became the sixth female monarch to be crowned Queen in the magnificent, thousand-year-old setting of Westminster Abbey. It was a moment when the past met the present – and, above all, the future. 'Imperceptibly,' wrote *Vogue*, 'we have moved into what future historians will recognize as a new age.'

→ **The Anointed Queen, 1953, by Cecil Beaton.**
Beaton described the Queen as looking 'minute' beneath the heavy crown and robes of state in this official photograph. 'Queen Elizabeth is young, ardent, with a shining sincerity of character and deep reserves of faith to give her strength for a task to which she is not only called by history, but to which she has expressly dedicated herself,' commented *Vogue*.

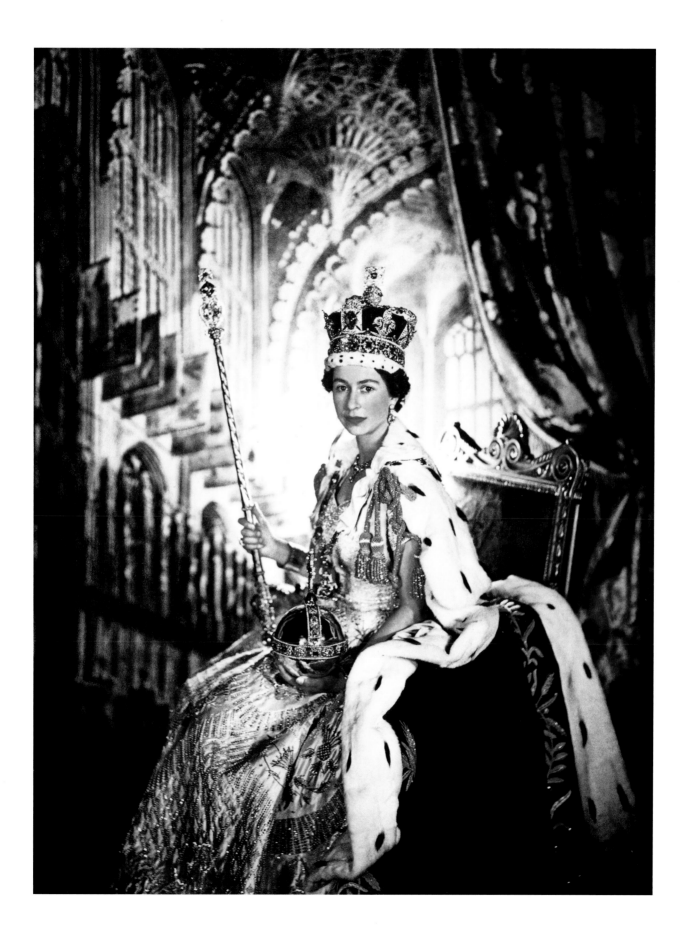

### From **Notes in the Abbey** *by Cecil Beaton*

'This wonderful ceremony takes one back through a thousand years, yet it is as fresh and inspiring as some great histrionic ritual, enacted upon a spontaneous impulse of genius. The movements, the gestures, the weaving in and out of the robed figures, using first one portion of the Abbey and then moving, for contrast, to another. The supreme nobility of the words of the service has the double impact of surprise and familiarity that greets the mark of real inspiration. ... Each incident in the long ritual is in itself a symbol of what is noblest in us.

Always one's eye is beguiled by the unexpected effect. A page, wearing a turquoise uniform, comes forward to receive a coronet. A mote of light catches a gold sequin fallen on the floor or a jewel in a bishop's ring. ... The sun comes down, and lights up the massed treasure of gold plate on the High Altar.

This is history, but it is of today, living and new. There is nothing ponderous; it is almost gay! The service following its course with the easy flow of the River Thames, yet nothing is hurried, it is in the dream world of slow motion; there's no pretence or make-believe about this great display. These people have been born to perform these offices – to present a glove, an orb or a sword to the Queen. They have been rehearsing their roles since their birth; as children they heard their grandfathers talk of coronations. Perhaps in other countries such men as these might seem to be in fancy dress, but here they wear their gold

thread embroideries with the insouciance born of total conviction. The ultimate in manners, these people are on terms with each other, never surprised or impressed, everything regulated and dignified. Sir Winston Churchill – a stolid figure, lurching forward in the aura of arabesques of white ribbons on his Garter cloak and fronds of his plumed hat... The Pages, an integral part of the ceremony, always surprising with their miracle quality of youth, the promise of the unknown before them, touching the heart with their good behaviour, their bows, their obeisance, or their casualness, their fidgeting and yawning, with

their spruce white silk stockings, the elusive lock of flaxen hair... One page has a black eye with a patch all over it. They are extraordinary contrasts to the venerable old men they serve, and their uniforms of surprising colours, grey, dark blue, orange, white, green...

The young ladies, the trainbearers, all slender and tall with the pallor of winter flowers, an exquisite foil in their satin dresses of celery or certain other root vegetables, spangled with gold, which compete successfully with the uniforms of the high officers of state...

The ubiquitous, ministering presence of the Mistress of the Robes... Princess Margaret's poise when receiving her train from her bearer... The Duke of Edinburgh, his head cocked with intense interest as he follows every detail of the ritual...

The Queen has not a definite smile, but the suggestion of a smile which lightens the corners of her mouth. She looks at everyone with a dedicated look – an expression of enlightenment... The erect stance – the rigid little head, with the hair so well curled around her Crown. ... Her touching beauty at the Anointing, without her Crown, like a child in a simple white dress...

Then her Byzantine magnificence. ... The poignant, youthful voice making a Sovereign's responses with an absolute and natural authority.'
*July 1953*

# The Last Empress

**← Mother of the Queen, 1953, by Cecil Beaton.**
For all her joy and pride at seeing her daughter crowned Queen Elizabeth II, the Coronation Day must have been a bittersweet one for the woman who, as King George VI's consort, had once been crowned in the Abbey herself, as Queen Elizabeth and the last Empress of India. Now, to differentiate her from the reigning monarch, she was styled Queen Elizabeth The Queen Mother – a title apparently chosen in preference to the 'Dowager' alternatives. Still mourning her husband, and aged only 52, the Queen Mother had to face immense changes in her status and lifestyle.

**→ The Queen Mother, 1959.**
With apparent reluctance, only weeks before the Coronation, she moved out of the apartments she had shared with the King in Buckingham Palace, now the official home of the new Queen and her family. But once established, with Princess Margaret, at nearby Clarence House, the Queen Mother began a new phase of her life, in which she would become more popular than ever.

# Monarch & Mother

For an upper-class married woman to be a full-time working mother was something of a rarity in Britain in 1952, when the young Queen Elizabeth II came to the throne with a son and daughter, Prince Charles and Princess Anne, then aged three and one. However, as hereditary monarch, it was a situation in which she had of course no choice. In a broadcast to her future people, made when she came of age in 1947, the then Princess Elizabeth had solemnly vowed, 'I declare that my whole life, whether it be long or short, shall be devoted to your service'; and that was a promise she would keep, at all costs.

And, with hindsight, there were some costs to her private life – though never to her public service. For the royal children, nursery routine, in the care of nannies, had to be strict, with limited parental playtime. In this, their lives were not unlike those of many of their aristocratic peers, but more unusually there would be times, during the Queen's exhaustive tours of the Commonwealth and other nations, when the young family were separated for months – a situation that, as adults, her children were determined not to repeat. For their tour of Australia in 1983, Prince Charles and his wife Diana, as Prince and Princess of Wales, insisted on taking their baby son, Prince William, with them – and set a happy precedent that young royal parents continue to follow.

**A Working Mother, 1953.** Queen Elizabeth II: Commander-in-Chief of the Armed Forces, Sovereign of the British Isles and Dominions, Supreme Governor of the Church of England and elected Head of the Commonwealth (as well as mother of two) about to present new Colours to the Grenadier Guards at Buckingham Palace.

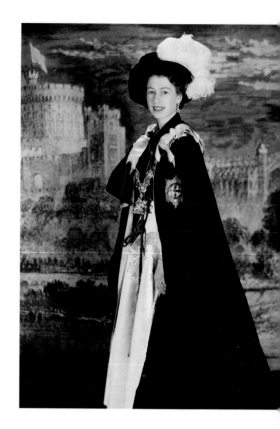

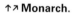 **Monarch.**
Night and day, the Queen
was rarely off duty. (*Above*)
Attending a gala at the Royal
Opera House, with The Duke
of Edinburgh, 1953. (*Above
right*) 'In the grave beauty of
the Garter robes', 1955, by
Cecil Beaton.

→ **Queen Elizabeth, 1953,
by Carl Erickson ('Eric').**
A pensive profile of the
newly crowned Queen.

**→ Mother: The Queen and Princess Anne, 1959.**
Family holidays at their country residences, Sandringham in Norfolk and Balmoral in Scotland, allowed the Royal Family some treasured leisure time together. Princess Anne, intrepid and outdoor-loving from childhood, shared both her father Prince Philip's love of boats and her mother's passion for all things equestrian.

**↘ Prince Charles at Windsor Great Park, 1952.**
A more sensitive and introspective personality than the royal lifestyle always allowed for, here on an engagement with his mother the Queen and grandmother the Queen Mother, Prince Charles flinches from press cameras.

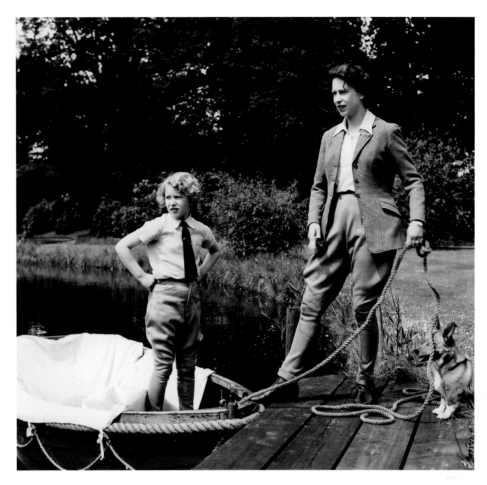

# Coronet
# & Camera

**Princess Margaret and Antony Armstrong Jones, 1960, by Denis Manton.**

Tony Armstrong Jones had been with *Vogue* since 1956. He was sure-footed as a photographer and *Vogue*'s editor Audrey Withers was equally impressed that 'he knows everybody' and would add 'a much-needed social element to our coverage, which has not been strong for many years'. She was further impressed that he had taken the Duke of Kent's coming-of-age portraits and, at the Queen's invitation, those of the royal children.

In early 1960, Armstrong Jones's engagement to the Queen's sister, Princess Margaret was announced. A delighted *Vogue* saw an opportunity to celebrate the good fortune of one of its own, and marshalled its photographers and illustrators to record the auspicious day. Behind the scenes, Withers considered a wedding gift – with one eye to the future: 'it would be very valuable to have as much as possible of his goodwill in the years to come. Do you think that this would be an investment worth making?' In the end, *Vogue* invested in a small drawing by Gwen John.

*Vogue arti...
Margaret and his...
their weddin...
sincerity, we send our loy...*

# wish them well

*...is Manton* *made these drawings of Princess*

*...er colleague* *Antony Armstrong Jones to mark*

*...on May 6,* *now only a week away. With warm*

*...affectionate* *good wishes for their happiness*

121

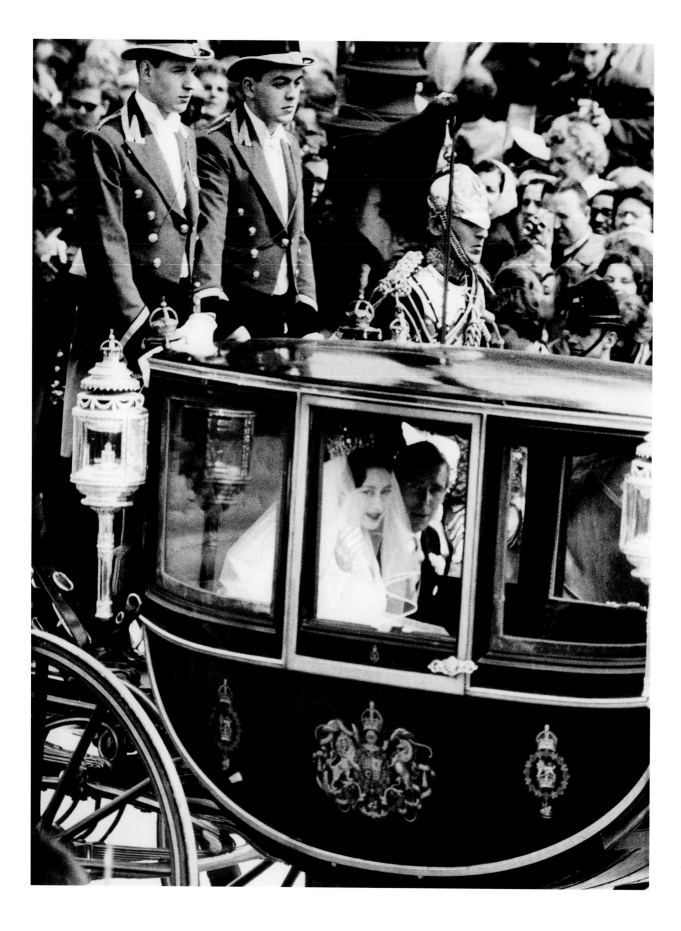

# Wedding of Princess Margaret

**←→ Princess Margaret's Wedding Day, 1960, by Brian Duffy.**

'Recollections of a lovely day,' wrote *Vogue*, 'when the sun shone, the trumpets sounded, the bells pealed, and tens of thousands of people packed the London streets to cheer their Princess and her husband, still – all honour to him – plain Mr Armstrong Jones.' The mood the more joyful, perhaps, after the Princess's well-documented attachment to Group Captain Peter Townsend, did not, as expected, lead to marriage. (*Left*) In the Glass Coach, having left Clarence House, Princess Margaret wears the Poltimore Tiara (acquired at auction the previous year) and a wedding dress of simple design by Norman Hartnell. Beaton was official photographer, but his attempts at less formal compositions, in step with the relaxed attitudes of the bride and groom, were frustrated by the Duke of Edinburgh's eagerness to get the whole procedure out of the way. (*Right*) 'Finally', exclaimed *Vogue*, 'a photograph for the national family album, a rousing send-off to the bride and bridegroom.'

# The Swinging Snowdons

**← Lord Snowdon, 1968, by Alexander Liberman.** Lord Snowdon and Princess Margaret positioned themselves as the least stuffy of royals – although the Princess was a stickler for the formal courtesies merited by rank. And the chicest, too. Aside from his royal duties, Snowdon had continued his career as a photographer, notably for *The Sunday Times Magazine*. He was also a product designer, writer and creator of theatre sets; he designed a line of ski-wear, made clocks, jewellery, furniture and motorized wheelchairs, and helped conceive the design for the aviary of London Zoo. In this year, his documentary on old age, *Don't Count the Candles,* won two Emmy awards.

**→ Princess Margaret, 1965, by Cecil Beaton.** Almost a snapshot in its studied ease, a portrait taken to mark an official visit to the United States. *Vogue* remarked that they recognize 'the wonderland qualities of their marriage but prefer to be known as a working couple,' concluding, 'The Snowdons hold on tenaciously to their private peace. They insist on the real, resist the sham.'

While *Vogue* was receptive to the new and the daring, it was always reassured by the traditional and the familiar. Its 1953 Coronation cover played to both, showing simply and effectively a pub window etched with the royal crown; a moment of social equality anticipating the 'classless' 1960s.

With the British Empire in decline and the nation enduring post-war austerity, among those exemplifying the new attitudes were the Queen's younger sister and the photographer Antony Armstrong Jones, who married in 1960. 'Call me Tony...': his instinctive lack of stuffiness gave the Royal Family by extension a different image for the decade to come. Disdainful of his wife's circle, inevitably drawn from the upper classes, he widened it to include a more bohemian crowd

of fashion designers, advertising whizz-kids, journalists, antique dealers and celebrities. The Earl of Snowdon's close ties ('Mr Jones' was granted an earldom in 1961) allowed him to subvert the traditional royal portrait to present the family with a new, relaxed face and – by his and Princess Margaret's own example – a contemporary relevance. In tune with the times, the royal couple shared a flair for conspicuous fashion, an absurdist sense of humour and an ambivalence towards official duties.

The end is well known. Snowdon chafed at the constraints of royal protocol; the more irascible he became, the more imperiously his wife behaved. Both embarked on extra-marital affairs. In 1976, the couple separated, divorcing in 1978.

**← Lord Snowdon, 1965, by David Bailey.**

Snowdon in his Aston Martin DB5 convertible (4.0 litre, straight-6 engine capable of 282bhp, with a top speed of 145 mph), probably the one presented to him by his close friend Peter Sellers. (The actor and comedian would own around 120 cars in his life, sometimes for as a little as a day.) Custom-painted in 'Caribbean Pearl Blue', a bold shade of azure, the Aston Martin boasted one of the world's first car phones. Snowdon and his sportscar appeared in David Bailey's celebrated book *Goodbye Baby and Amen* (1969). He had also featured in the earlier *David Bailey's Box of Pin-ups* (1965), a roll call of the decade's elite, high and low. In certain circles, there was unease at a member of the Royal Family rubbing shoulders with notorious London gangsters such as the Kray twins, albeit in a boxed book.

**↗→ Princess Margaret and family, 1967, by Norman Parkinson.**

These snapshots of Princess Margaret, her husband and their children, Viscount Linley and Lady Sarah Armstrong Jones, were taken in the grounds of Kensington Palace. Inconceivable a decade earlier, such a spontaneous glimpse was almost certainly down to a royal couple determined to live their lives in tune with modern times.

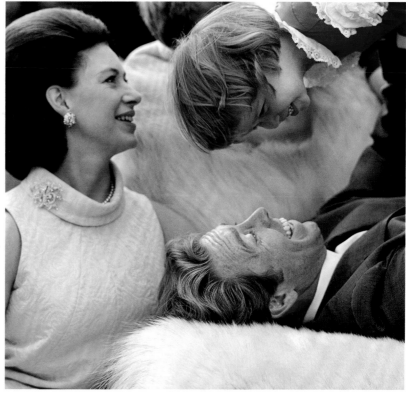

# Ancien Régime

*From* **The Duke and Duchess of Windsor in France** *by Valentine Lawford*

'The Duchess of Windsor never keeps anyone waiting. Her step is characteristic – a light but firm staccato – on the stairs. Seeing her after a lapse of years, one notes again the contrast underlining her expression: the mouth most prone to humour, and the enquiring, almost anxious kindness, of the eyes. As she moves, she gives her orders with a maximum of clarity and a minimum of words. Time has evidently not lessened her celebrated efficiency, nor lowered the high standards that she demands, above all from herself.

The Duke's step is less hurried, as he emerges a little later. In a world where men tend to look more and more alike, he seems more than ever endowed with the capacity to look like no one else. If anything, he seems today even more Royal than he did when he was Europe's most popular Prince. If there is perhaps any part of the well-known image that seems lacking today, it is the nervous, almost despairing, shyness that was such a familiar mark of his youth. Outwardly, the Duke is still as eager and solicitous, yet intangible and aloof as when Prince of Wales. His expression is still indefinably charming but indefinably sad. But he no longer looks as though, for all his exemplary training and authentic willingness to play his part in life, he were acutely frustrated by the inability to do so a little closer to the ordinary heart of things, in a less stylised manner, and as he conceived it, at a more modern pace.

On their honeymoon twenty-seven years ago the Duke and Duchess made a pact never to re-hash the past, or conduct a post-mortem on the events immediately leading to their marriage. It is safe to assume that they would have been glad if others had followed their example.'
*American* Vogue *April 1964*

**The Duke of Windsor, 1964, by Horst.**

For an ex-monarch who had famously rejected the demands of royal duty and ceremonial, as Duke of Windsor the former King Edward VIII retained a remarkable degree of stately style in his post-abdication life. A 12-page feature in American *Vogue* in 1964 showed the Duke and Duchess at home in France, waited on by liveried footmen and surrounded by reminders of the Duke's royal past, from his Garter banner hanging in the hall to the red despatch box marked 'The King' (*opposite*), which once brought him the daily state papers he had found it so tedious to study and sign.

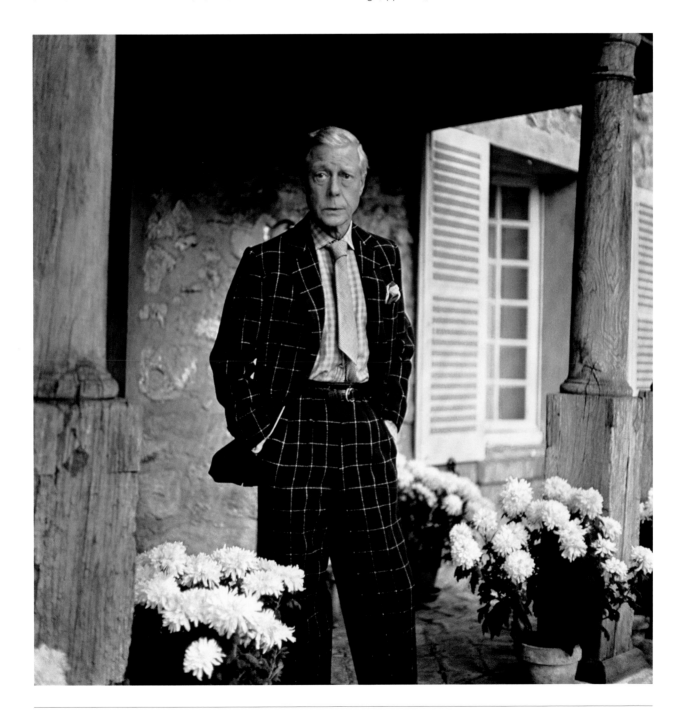

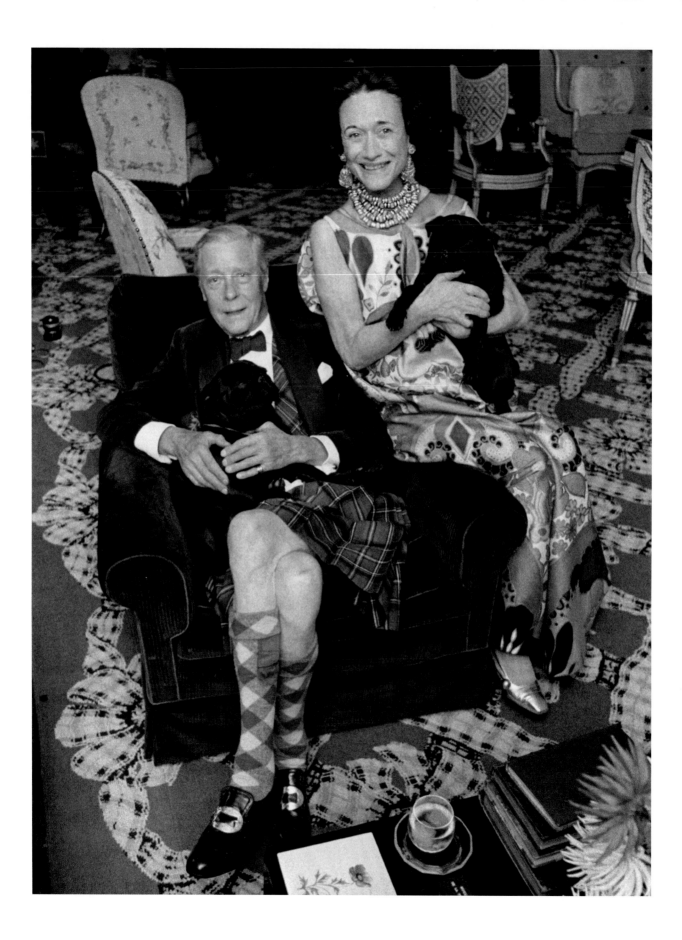

**←→ The Duke and Duchess of Windsor at home in France, 1967, by Lichfield.**
Along with pugs, jewellery and parties, a love of fashion was among the many tastes the Duke and Duchess of Windsor had in common. In his youth as Prince of Wales, the Duke had scandalized his father, King George V, by dressing (in the King's view) 'like a bounder'. Suede shoes, plaid socks, Fair Isle sweaters and the ultra-wide trousers known as 'Oxford bags' all featured prominently in the Prince's wardrobe, along with cummerbunds and gaudy evening dress. On holiday – like the rest of the 'Riviera Set' – he adopted peasant-style berets, Breton stripes and cotton drill sailor trousers.

  'He has always had his own manner of putting things together,' commented *Vogue* in a 1967 feature, admiring his 'incomparable elegance and grace' – and scotching the myth that the style of tying a tie known as the 'Windsor knot' was his invention. His ties, explained the caption to the photograph, *right*, were merely made 'with a thick inner lining, to make them appear fatter when tied'.

# The Next Generation

Born on Christmas Day, within two weeks of the abdication of her uncle Edward VIII, Princess Alexandra was the only daughter of the Duke and Duchess of Kent, and on her birth was sixth in line to the throne. That birth marked the last time the Home Secretary was required to be in attendance. She was five when her father died in a plane crash while serving in the Royal Air Force.

She was introduced to royal duties early. At 11, she was a bridesmaid at Princess Elizabeth's wedding to Prince Philip. It was thought that another princess, only a little younger than her first cousins, the Queen and Princess Margaret, might form a formidable and appealing trio. *Vogue* concurred: 'she has awareness, humour and concern'. The concern came with practicality, when in 1957 she joined what is now the Great Ormond Street Hospital as a trainee nurse. Her most perceptive observer was, as ever, Cecil Beaton, whose initial impressions were unfavourable: her coronation dress was 'far too fluffy and unimportant for the occasion'. At a ball at Windsor in late spring 1970, he was enchanted and scrutinized her in detail: 'Princess Alexandra looked ravishing, long tendril curls, a dark red satin dress and a sheen on her skin; the most adorable of human beings exuding beauty.'

↑ **Princess Alexandra, 1952, by Cecil Beaton.**
*Vogue* introduced the Queen's younger cousin: 'A new personality is emerging in the Royal Family circle. As the only girl among the Queen's first cousins, it is to her that we must look for the interest which a growing princess provides.' She was in her sixteenth year and at Heathfield, the first royal princess to attend boarding school.

→ **Princess Alexandra, 1967, by Cecil Beaton.**
A portrait made to mark her first official visit to the United States. 'She comes', American *Vogue* reported, 'as one of Britain's most admired and sought after public figures. For sound, non-legendary reasons.'

↑ **Prince Edward, Duke of Kent and Prince Michael of Kent, 1952, by Cecil Beaton.**
In 1942, a few weeks after the birth of Prince Michael, his younger son, the Duke of Kent left for Iceland aboard a Sunderland flying boat. It crashed shortly after take-off and he was posted as 'missing in action'. Here, Prince Edward, the present Duke of Kent, aged 17, and his brother Prince Michael, aged 10, pose beneath a portrait of their late father by Savely Sorine.

↗ **Prince William of Gloucester, 1962.**
A snapshot marking the Prince's coming of age. Dazzlingly handsome, of great charm and not a little singlemindedness, he refused to join the services, a path expected of a young prince (at birth fourth in line to the throne), preferring instead the Foreign Office. Killed at 30 in 1972, when the light aircraft he was piloting crashed into a tree, he remains one of the great might-have-beens of modern royal history. Years later, Prince Charles named his first-born son in honour of his adored older cousin.

**← Prince Richard of Gloucester, 1963.**
The second son of Prince Henry, Duke of Gloucester, Prince Richard was initially able to carve out a professional career. Having studied architecture at Cambridge, he entered practice in 1966. However, the unexpected death of his elder brother, Prince William, left him heir to the title and he retired to take up royal duties from then on.

**↑ Prince Charles at Tarasp, Switzerland, 1963.**
The world watched as 14-year-old Prince Charles took his first steps on the slopes at Tarasp, where he was lodging with his kinsman Prince Louis of Hesse. His winter sports holidays often caught the attention of the press, the more so perhaps since 1988 when, near Klosters, Switzerland, he emerged unscathed from a fatal avalanche. And it was at Klosters in 2005, a week before his second marriage, that the Prince vented his frustration with the press pack: 'I hate doing this,' he muttered *sotto voce* but seemingly unaware several microphones could pick up his words. 'Bloody people.'

# VOGUE

# ELIZABETH II
# THE SILVER JUBILEE

# 5.

# *The Firm & The Future*

'The Royal Family is just a family. Of course, one maintains one's respectful distance – one remembers not to give the Queen a thump of joyful friendliness or bite the Duke of Edinburgh in the calf – but the more you join in, the more they relax', remarked Norman Parkinson. In the years leading up to the Silver Jubilee, there was an increasing awareness on the part of the monarchy to be more approachable, more in tune with values shared with the majority of the nation. A ceremonial figurehead certainly, the Queen was a wife and mother, daughter and sister too, and vignettes of shared family life made her somehow more tangible.

Parkinson was the first photographer at *Vogue* to present readers with relaxed and intimate glimpses into the lives of those closest to the throne. Similarly, both Lord Snowdon's and Lord Lichfield's proximity to the Royal Family (the former married to the Queen's sister, the latter her first cousin once removed) allowed for a more personal perspective on family events, unaffected by protocol and official constraint.

The Silver Jubilee in 1977 afforded the perfect opportunity for closer engagement with the people – if the people wanted it. Britain's economy was in poor shape and the national mood might not have been well disposed. In the event, the British celebrations were rapturous. Novelist Rebecca West reminded *Vogue* readers that the Queen remained 'one third a constitutional monarch, one third a poetic myth and one third a woman.'

# God Bless the Prince of Wales!

*From* **'Wales: The Investiture'** *interview with Lord Snowdon*

"'If you accept any sort of position, you've got to take it seriously. When I was made Constable of Caernarvon Castle, I wanted to improve it in every way for the visiting public. The Investiture has helped to do this. Most of the improvements are lasting. I asked John Piper to do lithographs, which are very cheap and are on sale, and I tried to upgrade the souvenirs. Also the castle will be floodlit from now on. I wanted grandeur and simple elegance." Caernarvon Castle, Edward I's embattled pile of sandstone, is still as formidable as when it withstood Madog's rebellion in 1294, Owain Glyndwr in the 15th century, and the sieges of the Civil War. Now, however, it is to provide the setting for the greatest royalist pageant of Prince Charles's investiture.

Lord Snowdon has devised a plan that combines medieval associations with the best of modern methods and local materials.

"We tried to design the whole thing for television, not only for the people who will be there. After all 40 million will be watching on television, and only about 4000 will be there." This presented problems: the thrones in the centre of the castle's open courtyard had to be majestic, the centre of attention, yet a canopy would obscure them from the cameras. The designer found a perfect solution: on two concentric circles of Welsh slate, dark and riven, stand three simple, solid slate thrones. "It could be from Stonehenge, or modern because of the basic simplicity." From the dais rise four steel poles, dulled to look like medieval armour, holding up a clear Perspex canopy, scooped like a shell, on the front of which are emblazoned the feathers of the Prince of Wales.

"I am Welsh after all," says Lord Snowdon, "and I believe very strongly in the Investiture, that it can do a great deal of good for the country. Anyway, you try and do a television programme that lasts five hours on £55,000.'" *July 1969*

← **Lord Snowdon at Caernarvon Castle, 1969, by Norman Parkinson.** On the eve of the Investiture, Lord Snowdon, director of proceedings, on the shoreline below the castle with designer Carl Toms, engineer Robert Hancock and John Pound from the Ministry of Works.

↓ **The Prince of Wales dressed for his Investiture, 1969, by Norman Parkinson.** At Caernarvon Castle, Prince Charles took the oath of allegiance to his mother as Prince of Wales. His uncle Lord Snowdon oversaw the ceremony, modernizing the pageant of 1911, which presented Edward VIII to the Welsh people. Millions around the world marvelled via television at some newly minted 'traditions', such as the Prince addressing the assembled crowd in Welsh.

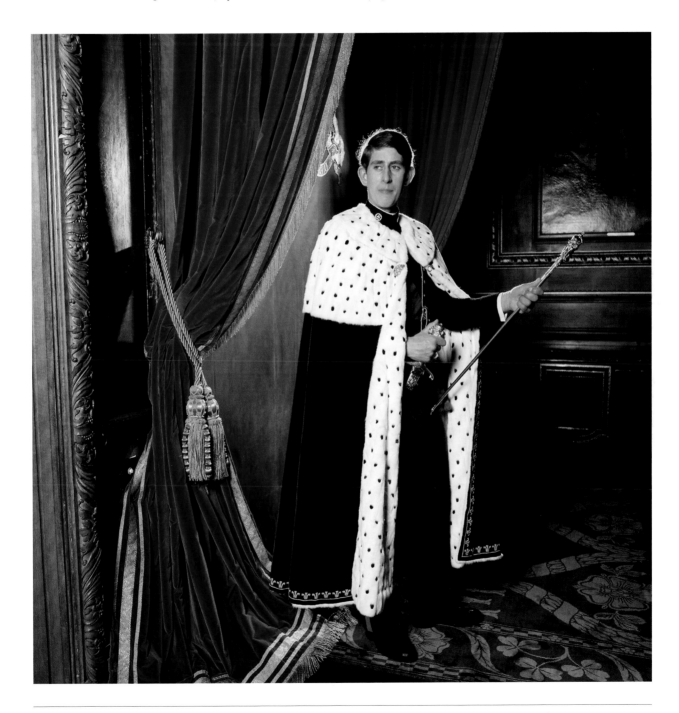

# Riding High

**← Princess Anne in Windsor Great Park, 1969, by Norman Parkinson.** At 19, Princess Anne was regarded as an expert on all things equestrian, here on the 14.2hh High Jinks. *Vogue* noted that of all the Royal Family, the Princess possessed a 'flippancy and an elastic expression that make her the most animated in photographs or on television'. In Vienna she had been invited to ride one of the Spanish Riding School's senior Lipizzaner stallions. She put him through a dressage move, a *piaffe*, which was as difficult, *Vogue* observed, as 'dancing a *pas de deux* with Nureyev'. Two years later she won gold in the European Eventing Championships at Burghley on Doublet, a home-grown gelding. She was also awarded the title 'BBC Sports Personality of the Year'.

**↓ Princess Anne, May 1973, by Brian Aris, and September 1971, by Norman Parkinson.** The Princess was the first member of the Royal Family to be photographed for a *Vogue* cover, the occasion being her 21st birthday. The later cover shot by Brian Aris was taken in Ethiopia on the Princess's African tour.

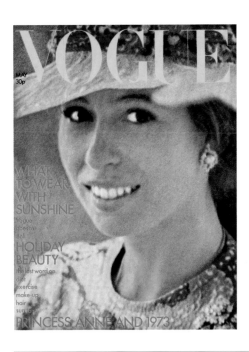

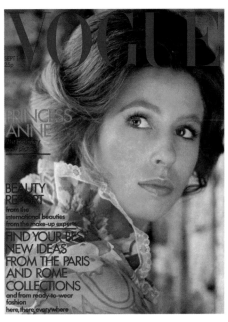

**↘ Princess Anne in Ethiopia, 1973.**

As patron of Save the Children, Princess Anne embraced her role with a remarkable energy, as if, *Vogue* once remarked, her own life depended on it. Visiting its projects across the world, she has been indefatigable for over 50 years. In 1990, Zambia's president Kenneth Kaunda nominated her for the Nobel Peace Prize.

**↑ Princess Anne, 1970, by Snowdon.**

Published for her 20th birthday in 1970, the year she made her first visit to the United States. American *Vogue* remarked: 'Direct, pretty, clever, H.R.H. Princess Anne whose straight-out job is being a princess is remarkably good at it.' British *Vogue* marvelled at the effortless way in which she kept pace with her escalating public role: 'At a dinner party recently, having just launched the biggest tanker in Europe, she talked knowledgeably about the mechanical problems involved in the construction of tankers...'

**→ Princess Anne, 1973.**

Photographed again on her African tour in a hat by John Boyd. *Vogue* further approved of the Princess's economical use of her clothes. This hat had been seen before and would be again, the crown bound with a colourful scarf.

**←↓ Princess Anne, 1971, by Norman Parkinson.**
Two portraits to mark the Princess's 21st birthday. (*Left*) By the early 19th-century 'ruin' at Frogmore House designed by James Wyatt, where Queen Victoria liked occasionally to breakfast; and (*below right*) wearing a diamond tiara and a dress, the 'Medici sleeves' of which *Vogue* greatly approved. The backdrop was painted for the occasion: the white horse is carrying the Princess's standard.

# Another Fairy Tale Princess

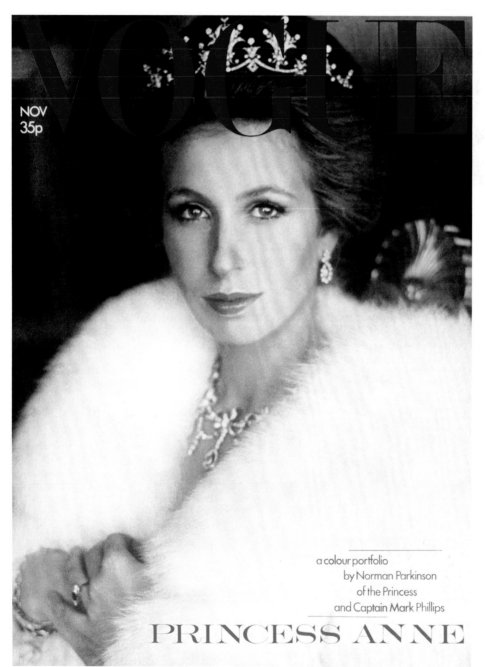

NOV
35p

a colour portfolio
by Norman Parkinson
of the Princess
and Captain Mark Phillips

PRINCESS ANNE

**← Princess Anne, 1973, by Norman Parkinson.** Norman Parkinson made a six-page portfolio to mark the marriage of the Princess to Mark Phillips, an acting captain in the 1st The Queen's Dragoon Guards (the regiment's Colonel-in-Chief was his wife-to-be's grandmother). This was a fresh and modern set of images for a modern and unstuffy princess. The cover, however, remained traditional, the Princess in a diamond tiara, necklace and earrings and showing her diamond and sapphire engagement ring by Garrard.

**→ Princess Anne and Captain Mark Phillips, 1973, by Norman Parkinson.** In the grounds of Frogmore House, the Princess in riding clothes and Captain Phillips in his no. 1 dress uniform. They shared an enthusiasm for equestrianism. Phillips was part of the three-day evening team that won gold at the summer Olympics in 1972, and in 1976 the Princess was a member of Britain's Olympic equestrian team.

# A Sporting Prince

**→ The Prince of Wales at Westminster Abbey, 1975.**
Prince Charles arrived at the Abbey to rehearse the ceremony at which the Queen would install him as Great Master of the Order of the Bath, succeeding his great-uncle Prince Henry, Duke of Gloucester. The Prince had grown a beard while on a recent tour of Canada. On that tour he made a dive under the ice at Resolute Bay, Nunavut, in precarious conditions. 'It all went swimmingly,' he said.

**← The Prince of Wales at Windsor Great Park, 1980, by Edward Bell.**
As a member of 'Les Diables Bleus' polo team, the Prince held a four-goal handicap. He played competitively until 1992, despite several serious accidents on the field. Without polo, he once said, he would go 'stark, staring mad'. It was widely, probably erroneously, believed that it was at a polo match in 1970 that he first met his future wife Camilla Shand.

# Dream Toppings

*From* **The 'T' Set or Where Have all the Tiaras Gone?**

'First worn by royal persons and the nobility in the early 19th century, tiaras are related to diadems, *ferronières* and crowns. They are variations on flower and leaf themes, circles and squares, intricate traceries with pendant jewels, as worn by Josephine and again by Eugénie in the Second Empire, and the Russian Imperial introduced them to the Edwardian court.

And today? Surprisingly, people are still buying them. At Sotheby's, jewellery expert Peter Hinks says that they often have tiaras for sale. So say Christie's, where the price might be anything from £250 to the £120,000 paid in Geneva last year. "We've got a tiara in our next sale brought in by a woman who already has one in the family." People think one is enough to share around. Those who have no tiara may well rush out and buy one for a royal wedding or coronation. In 1937 and 1953, crown jewellers Garrard sold lots.

The great jewellery houses go in for upkeep: "Our clients have family heirlooms and bring tiaras in because they cannot assemble them themselves or need new velvet to dress them up." Says Boucheron, "Repairs to tiaras yes, sale of tiaras definitely no." At Wartski, Mr Kenneth Snowman said, no, they had sold no Fabergé tiaras, the only known examples being illustrated in Mr Snowman's work on Fabergé. They do sell other sorts. At Collingwood, the tiara trade is humming. "We sold a spectacular one last November and we always have a couple in stock from about £5,000. We alter them so that they can be worn as necklaces."

If all this seems excessive, there is Moss Bros who do a brisk business in the hire of paste copies, mainly for brides and mainly a copy of Princess Anne's tiara, but also for investitures, functions, the Mansion House, things like that. A night out in a Moss Bros tiara costs from £2.75, probably less than a night's insurance on the genuine article.' *Unsigned, November 1974*

**The Duchess of Kent at Anmer Hall, 1975, by Norman Parkinson.** The Duchess with her younger son Lord Nicholas Windsor. She wears a sapphire and diamond necklace and tiara, part of a parure of her mother-in-law Princess Marina's. The Duchess and her husband Prince Edward, Duke of Kent, then a Lieutenant-Colonel in the Royal Scots Dragoon Guards, had recently returned from a State Visit to Iran. The Duke would leave the army the following year. In 2001, the Duchess decided to reduce her official duties and obligations and prefers now to be known as Katharine Kent. Anmer Hall, near Sandringham, has become the private country residence of the Duke and Duchess of Cambridge.

# The Kents:
# Public & Private

**← The Kent family at home, 1969.**

The Duke and Duchess and their then two children, seven-year-old George, Earl of St Andrews, and five-year-old Lady Helen Windsor, in the grounds of Coppins, Buckinghamshire. Their third child, Lord Nicholas Windsor, would be born the following year. Coppins had been the country home of two generations of Kents, bequeathed to the present Duke's father, Prince George, by his aunt Princess Victoria. The Duke of Edinburgh was a frequent guest at Coppins during his school holidays. Princess Marina of Greece and Denmark, wife of Prince George, Duke of Kent, was Prince Philip's first cousin.

**→ Lady Helen Windsor, 1975, by Norman Parkinson.**

The bright-eyed future fashion ambassador and muse of Italian designer Giorgio Armani, aged 11.

← **Prince and Princess Michael of Kent, 1978, by Snowdon.**
The second *Vogue* photograph of the couple that year. A determinedly informal shot by Snowdon found the Prince sporting a beard grown on honeymoon, which he was obliged to remove before returning to his regiment. The couple had married that summer in Vienna.

↓ **Prince and Princess Michael of Kent, 1978, by Norman Parkinson.**
The Prince and Princess had recently married in a civil ceremony when Parkinson took their joint portrait for *Vogue*. The Prince wears the No.1 Dress Uniform of the Royal Hussars (he was a major); the Princess's cream lace and chiffon dress is by Bellville Sassoon. This was the first time that hair and make-up credits were given for a royal sitting.

# Lives of Duty

*From* **The Royal Image** *by Roy Strong*

'Up until this century, few subjects ever actually saw their ruler. Few monarchs prior to the railway age went beyond Exeter in the south-west, Gloucester in the west, Norwich in the east and York in the north. Wales rarely got a look-in, while George IV's state visit to Scotland, after a century of downright neglect, was a *succès fou* to be followed by Victoria and Albert's colonization, on account of its resemblance to Germany. The British monarchy until our own age was strictly a London and Home Counties product, for these provided the background for its state appearances and its progresses from palace to country house. In 1979, we would think it inconceivable *not* to have seen the Queen. A century ago it would have been as inconceivable to *have* seen her. And that is the essential difference...

In 1979, royal portrait painting – *pace* the hysteria always let loose around Signor Annigoni – no longer is of central importance to the Crown. It is photographic and film images that matter. Today's heads of state and political leaders are, therefore, much more vulnerable than in the past. There is always a photographer waiting in the wings, anxious to snap in a trice any member of the Royal Family in an off moment, looking bored, or downright fed up.

**Princess Alice, Countess of Athlone, 1978, by Snowdon.**
Princess Alice at 95, the last surviving granddaughter of Queen Victoria, was then the oldest living member of the Royal Family. Photographed at Kensington Palace, she wears the Royal Family Orders and the sash and star of the GBE. Pinned to her shoulder are cameos of her grandparents Queen Victoria and Prince Albert. She died in 1981, aged 97, having lived through the reigns of six English monarchs.

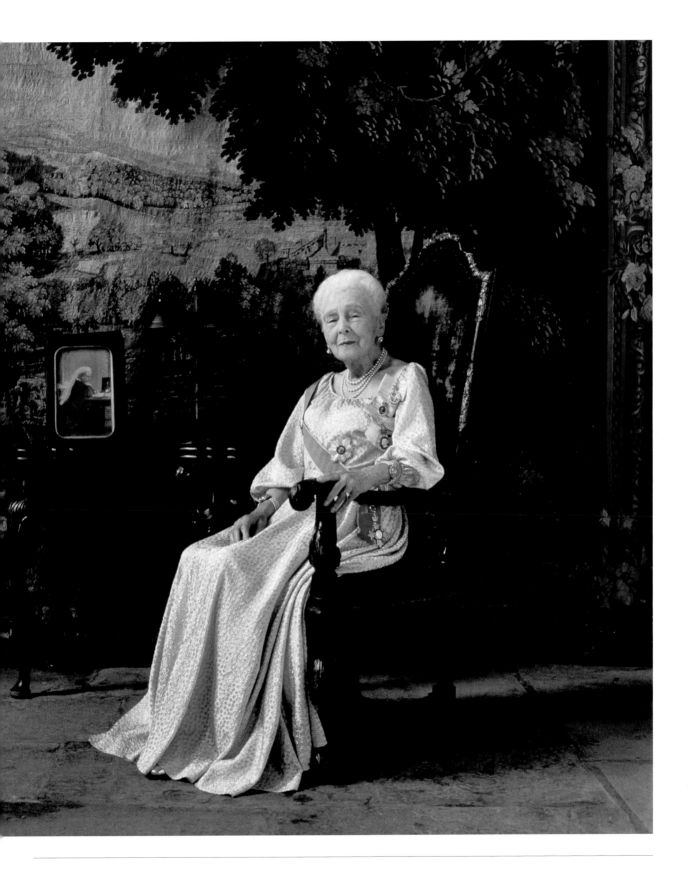

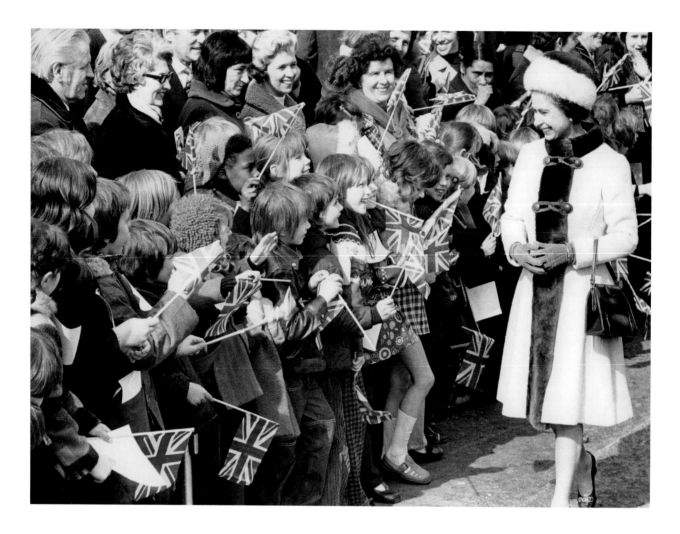

The image makers of today are no longer portrait painters, they are photographers and film and television directors backed by an entourage of technicians from make-up to lighting experts. They are the new magicians in whose power is the ability to make or destroy.

Will we remember the Queen by Gunn, Kelly, Cuneo or Greenham? Apart from a nostalgia for the painted canvas, the answer is, no. Of course, the Palace realizes that it is the photographers who matter. Until five years ago, Beaton was the presiding genius. Always brilliantly attuned to the mood of every epoch, he could "up" the image to recall a Van Dyck, or Gainsborough, all glittering tiaras, crinoline, chandeliers, and white and gold, or "down" it to the outdoor image with all the appurtenances of country life to hand. Since then one has sensed a period of experimentation... until the palace image-makers homed in on Snowdon and Parkinson. Who, after all, could beat Snowdon's enchanting romp of Princess Anne tossing her first born in the air, or Parkinson's delightful, hydra-headed group of Princess Alexandra and her family? It is the photographers who matter and no longer the painters.' *April 1979*

**← Queen Elizabeth II on the new London Bridge, 1973.** Royal 'walkabouts' were instituted in the early 1970s so that the Queen could meet her loyal subjects and not just visiting heads of state and other dignitaries. She had just opened a new bridge over the River Thames and was received with jubilation by schoolchildren waving union flags, increasingly a feature of such occasions.

**↓ Queen Elizabeth meets President Ceausescu, 1978.** At the enthusiastic invitation of then Prime Minister Harold Wilson, the brutal Romanian despot was welcomed by the Queen in 1978. (By then the PM was James Callaghan). No one was under any illusions as to Ceausescu and his wife's sheer offensiveness. President Giscard d'Estaing of France warned the Queen to remove any valuables from their guests' quarters or they would be looted. A day into the visit, in the grounds of Buckingham Palace, it was said the Queen hid behind a bush to avoid meeting the couple.

**↘ Princess Margaret and Lady Sarah Armstrong Jones, September 1972.** Princess Margaret and her daughter attend the wedding of Lady Elizabeth Anson to Sir Geoffrey Shakerley. Lady Elizabeth was a cousin of the Princess through the Bowes-Lyon family. Her brother Lord Lichfield was a well-known society photographer. He took the wedding photographs of the Prince of Wales and Lady Diana Spencer. Sir Geoffrey Shakerley was also a royal photographer. He received much media attention for his wedding pictures of Prince Edward and Sophie Rhys-Jones, after admitting that Prince William's face had been digitally enhanced to present a more delighted countenance.

# A Certain Style

*From* **The Queen Mother: Always in** *Vogue*
*by Hardy Amies*

'The Queen Mother has star quality and Norman Hartnell had a sense of theatre. In my opinion, he was a theatrical designer *manqué* – he admired Erté, and he loved working for Gertrude Lawrence.

Norman was clever enough to cotton on to Winterhalter, the Romantic portrait painter. He recreated Winterhalter necklines, colour, line – the idea was a tremendous success and was an inspired transference of style. There is one painting of Queen Victoria, *The Royal Family in 1840,* in which she is wearing a pale, frilled, off-the-shoulder dress with a *fichu,* which says it all.

The bare necklines worked well because the Queen Mother had magnificent shoulders and carriage. One of the blessings is that her head is put on her shoulders in a very good way; she has a splendid neckline. The royal greeting was invented by her and our present Queen has taken it up. The royal greeting requires the right arm to be fully extended, softly, not violently, and the right hand sweeps across you and out and you bow at the same time with it. It is essentially a generous, big gesture – Queen Mary used the royal wave, but it was rather staccato in its movement. However, when the Queen Mother

↑→ **Queen Elizabeth The Queen Mother, 1975 and 1980, by Norman Parkinson.**
As the Royal Family's photographer of choice, Norman Parkinson succeeded Cecil Beaton, who had found it difficult to work again after suffering a stroke in 1974. Parkinson's approach was markedly less formal than his *Vogue* colleague's. He was an inspired choice who invested royal portraiture with a sense of fun and a carefully stage-managed spontaneity, which contrasted with the more familiar and still necessary formal, ceremonial images of the Royal Family. The Queen Mother much appreciated his twinkling-eyed charm and old world courtesies.

greets people from the Royal Box, for example, she turns her head and shoulders in a totally theatrical, ageless way.

One of the major successes was the wardrobe designed by Hartnell for the Royal Visit to Paris in 1938. I was tremendously influenced myself, as a beginner, by the very soft, very appropriate, unmistakably royal clothes. The Queen wore long dresses all day and her entire wardrobe was in white. It was a masterstroke, which even won the approval of the French who were not exactly benign towards the English in the couture world. I would like to put her back in those long skirts for her 80th birthday, for her official appearance during the day.

As a general policy, she has perpetuated the afternoon look from morning till night, which is the best-dressed look of the average established housewife and is never intimidating. Some of her most successful outfits are a dress and a coat of the same material; the uncluttered effect gives her height and is soothing to the eye. Her clothes are natural to her.

Clothes only look odd when they have separate lives of their own and hers don't. They always become part of her. From the very beginning there was no hardness. The softness of the hair fringe in her early years set the note.

It has to be remembered that royalty want to make an impression without being vulgar about it. Our Queen will say to me, "Don't forget that I must have bright colours so that everybody will know who it is the moment I come into a room," which is a lovely modest way of putting it. The Queen Mother probably thinks in the same vein. So beige is out, and black is completely unacceptable because of its association with mourning; white is considered to be extravagant today. Navy blue has no glow. If you were going to make a great entrance on stage, which is what it's all about, you wouldn't put our *prima donna* in dark blue. Gold is marvellous for dressing them up. The best dresses are in white and gold, no question about it.

The Queen Mother looks marvellous in pale blue tulle, and there are many reasons why. Pictures of angels usually have gauzy clouds above them – tulle turns a woman into an angel and so hints at veiled mysteries. She also knows how to wear jewellery superbly. A little bit of plumpness is a positive help – a richer fashion on which to display the regalia. Wonderful necklaces, the pearliness of the skin, the brilliance of the smile, completed with a cosy pat of the hair, which is a very characteristic gesture, presents a wholly beguiling picture.' *June 1980*

# Jubilate!

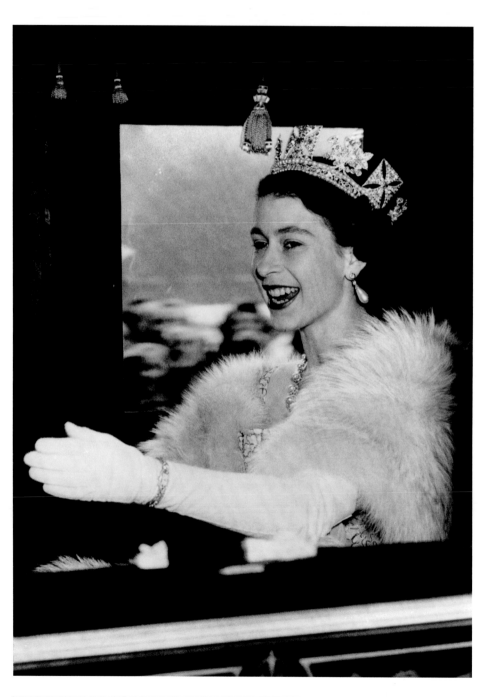

← **Queen Elizabeth II *en route* to the State Opening of Parliament, 1952, by Charles James Dawson.** We are amused. An ineffably joyful image of the Queen in the year of her Accession, wearing the Diamond Diadem, set with over 1000 diamonds. *Vogue* republished this famous image in its Silver Jubilee souvenir special. The accompanying text told us that Winston Churchill, her first of 14 Prime Ministers, considered her a 'pet', but was anxious that 'they may ask her to do too much. She's doing so well…' Meanwhile, Cecil Beaton called her 'the wisest woman that ever was.'

→ **Queen Elizabeth II, 1968, by Cecil Beaton.** To lead its Silver Jubilee celebrations, *Vogue* chose from Beaton's austere 'admiral's cloak' images. He recalled making the set: 'Nothing went right… Each way she turned was worse than the last,' until a *coup de foudre*: 'She turned to the left and the head tilted, and this was the clue to the whole sitting – the tilt…' The sitting would turn out to be the last time Beaton would photograph the Queen.

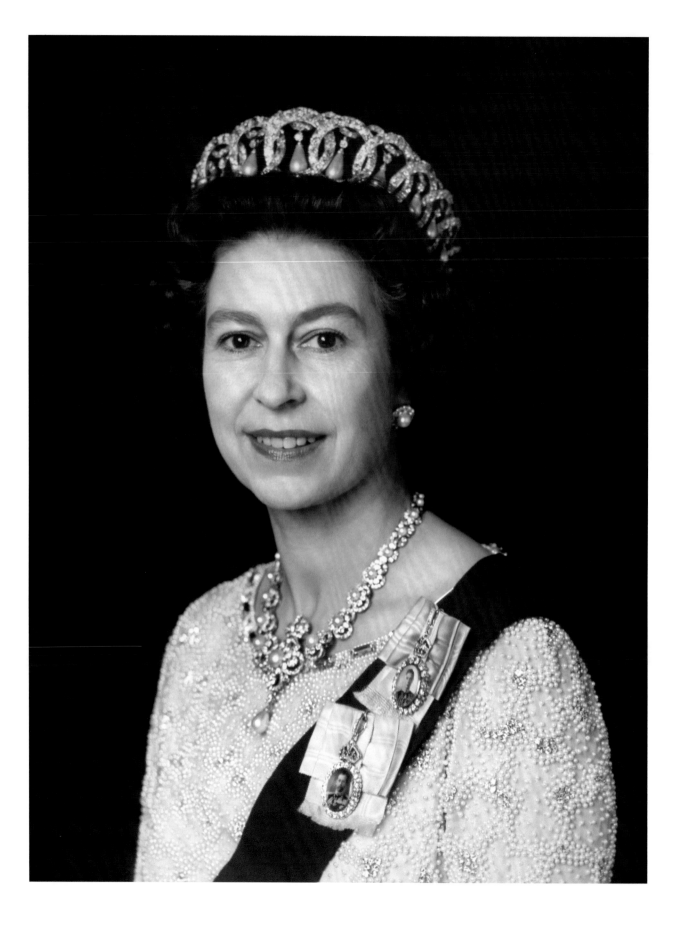

**Queen Elizabeth II, 1977, by Peter Grugeon.** Although this portrait was taken two years earlier, in 1975, it was adopted as the official portrait to mark the Queen's Silver Jubilee.

Grugeon's photograph received further, perhaps unexpected, attention when – reversed, defaced and collaged in a design by Jamie Reid – it was co-opted for the sleeve to the Sex Pistols single 'God Save the Queen'. Released to coincide with the Jubilee, it was strikingly at odds with the prevailing national celebrations: 'There's no future/In England's dreaming.' The BBC banned it and several high street chains, such as WH Smith, refused to stock it.

## Silver Jubilations: *Vogue*'s Observations of Jubilee Year

**'Who Saw the Queen:** In the spring and summer of Jubilee year, 11.5 million tourists arrived in Britain, 1.5 million more than last year. Eighty per cent of them flooded into London. The majority were American, German, French, Belgian, Canadian and Australian, in that order, but most of the people who saw her at close quarters were British – and now that walkabouts have become part of the Queen's routine, more people saw her close up this year than ever before. "Our chief memory of Jubilee Year," says Ronald Allison, Press Secretary, "will be the sheer number of people who waited to see the Queen… particularly the day in Nottingham when she arrived an hour late for the Test Match because the streets had been blocked with people for seven miles."

**Extra Appearances:** The Queen's picture was everywhere in countless guises. Her head appeared on mugs, T-shirts, biscuit tins, tea caddies, trays, book marks, medallions and cameos. The Prince of Wales headed the Design Council's judging panel of souvenirs, which included plastic bags, aprons, sweat-shirts, hologram pendants, tea towels, paperweights ceramic coasters, place mats, badges… .

**Where She Travelled:** Western Samoa, Fiji, Tonga, New Zealand, Australia, Papua New Guinea, Canada, the Bahamas, the Virgin Islands, Antigua, Barbados, and all corners of England, Scotland and Northern Ireland.

**Who Went with Her:** Two Ladies in Waiting and their two maids. A Private Secretary and his assistant. The Commonwealth Director. A Press Secretary. The Master of the Household, his assistant and a Medical Officer. Two Equerries to the Queen and one to the Duke of Edinburgh. Flag Officer, Royal Yachts, Captain of the Queen's Flight. The Queen's Dresser and two assistants. Two Chief Clerks, four Lady Clerks. The Queen's Page and the Page of the Presence. A Travelling Yeoman, Valet to the Duke of Edinburgh. The Royal Chef, the Pastry Sous Chef, two Senior Cooks and a Cook. The Deputy Sergeant Footman, the Queen's Footman and four Footmen. The Dining Room Supervisor and two assistants. A Kitchen Porter. The Queen's Hairdresser. An Orderly.

**What She Did:** Stood, walked, shook hands, made speeches, received presentations, reviewed parades, inspected guards, opened parliaments, unveiled plaques, placed wreaths, attended church services, planted trees, opened buildings,

**Queen Elizabeth II:
A Silver Jubilee
Celebration, 1977.**
*Vogue* made this photographic montage of the Queen's glorious reign from accession to Silver Jubilee – 'Twenty-five Years of Public Appearances' – for a special commemorative edition, the decade's bestselling issue. The accompanying caption read: 'On the occasion of Queen Elizabeth II's Silver Jubilee, *Vogue* sends loyal greetings to Her Majesty.'

inspected racing stables, presented trophies, attended dinners, feasts, banquets, garden parties, visited wineries, museums, hospitals, schools, city centres, art exhibitions. Travelled by boat, train, plane. Drank a secret potion of roots at the Kava ceremonies in Western Samoa.

**What She Was Given:** A Mars Bar, a silver coffee service, boxes of sea shells, pots and pans, a cooked pig, an unborn racehorse, a silver Armenian cross, a box of handkerchiefs, hand-made embroidery, flowers by the thousand – the small presenter of one unofficial bouquet, for whom the Queen stopped her car, got in and settled down with the flowers beside her.

**What She Said:** At the Lord Mayor of London's lunch. "When I was twenty-one, I pledged my life for the service of our people and I asked for God's help to make good that vow. Although that vow was made in my salad days when I was green in judgement, I do not regret nor retract one word of it." *Unsigned, December 1977*

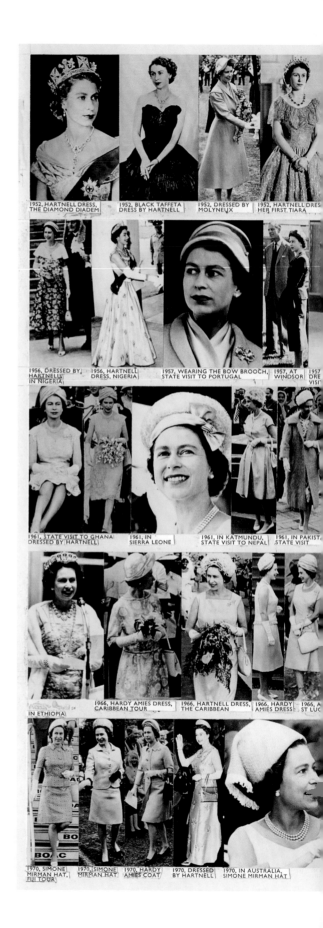

1952, HARTNELL DRESS, THE DIAMOND DIADEM | 1952, BLACK TAFFETA DRESS BY HARTNELL | 1952, DRESSED BY MOLYNEUX | 1952, HARTNELL DRESS, HER FIRST TIARA

1956, DRESSED BY HARTNELL IN NIGERIA | 1956, HARTNELL DRESS, NIGERIA | 1957, WEARING THE BOW BROOCH, STATE VISIT TO PORTUGAL | 1957, AT WINDSOR | 1957 DRE VISI

1961, STATE VISIT TO GHANA DRESSED BY HARTNELL | 1961, IN SIERRA LEONE | 1961, IN KATMUNDU, STATE VISIT TO NEPAL | 1961, IN PAKIST STATE VISIT

IN ETHIOPIA | 1966, HARDY AMIES DRESS, CARIBBEAN TOUR | 1966, HARTNELL DRESS, THE CARIBBEAN | 1966, HARDY AMIES DRESS | 1966, A ST LUC

1970, SIMONE MIRMAN HAT, FIJI TOUR | 1970, SIMONE MIRMAN HAT | 1970, HARDY AMIES COAT | 1970, DRESSED BY HARTNELL | 1970, IN AUSTRALIA, SIMONE MIRMAN HAT

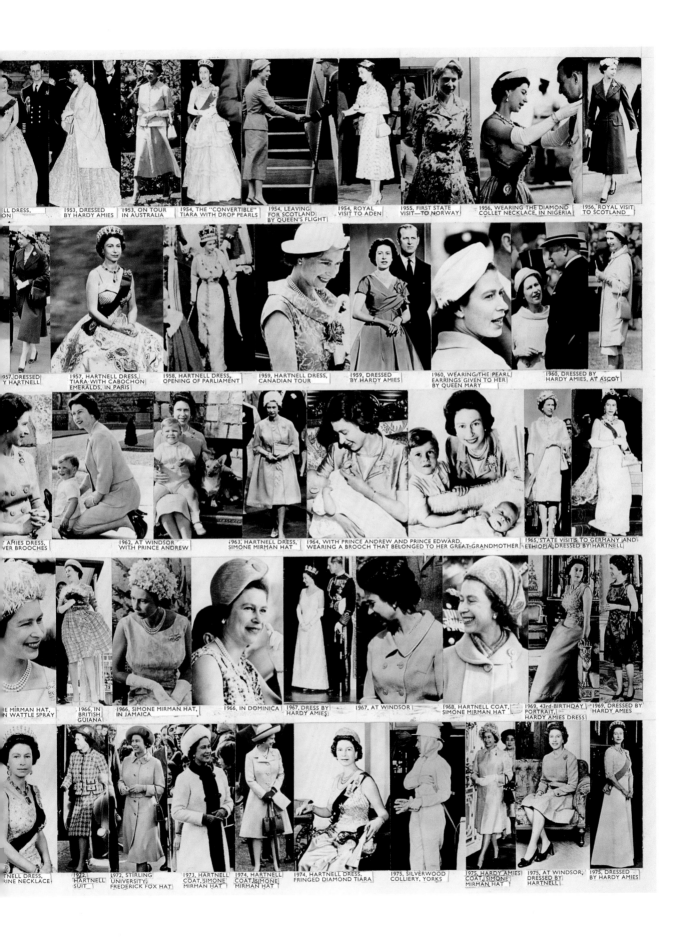

LL DRESS, ON

1953, DRESSED BY HARDY AMIES

1953, ON TOUR IN AUSTRALIA

1954, THE "CONVERTIBLE" TIARA WITH DROP PEARLS

1954, LEAVING FOR SCOTLAND BY QUEEN'S FLIGHT

1954, ROYAL VISIT TO ADEN

1955, FIRST STATE VISIT—TO NORWAY

1956, WEARING THE DIAMOND COLLET NECKLACE, IN NIGERIA

1956, ROYAL VISIT TO SCOTLAND

957, DRESSED Y HARTNELL

1957, HARTNELL DRESS, TIARA WITH CABOCHON EMERALDS, IN PARIS

1958, HARTNELL DRESS, OPENING OF PARLIAMENT

1959, HARTNELL DRESS, CANADIAN TOUR

1959, DRESSED BY HARDY AMIES

1960, WEARING THE PEARL EARRINGS GIVEN TO HER BY QUEEN MARY

1960, DRESSED BY HARDY AMIES, AT ASCOT

AMIES DRESS, VER BROOCHES

1962, AT WINDSOR WITH PRINCE ANDREW

1963, HARTNELL DRESS, SIMONE MIRMAN HAT

1964, WITH PRINCE ANDREW AND PRINCE EDWARD, WEARING A BROOCH THAT BELONGED TO HER GREAT-GRANDMOTHER

1965, STATE VISITS TO GERMANY AND ETHIOPIA, DRESSED BY HARTNELL

E MIRMAN HAT, N WATTLE SPRAY

1966, IN BRITISH GUIANA

1966, SIMONE MIRMAN HAT, IN JAMAICA

1966, IN DOMINICA

1967, DRESS BY HARDY AMIES

1967, AT WINDSOR

1968, HARTNELL COAT, SIMONE MIRMAN HAT

1969, 43rd-BIRTHDAY PORTRAIT, HARDY AMIES DRESS

1969, DRESSED BY HARDY AMIES

TNELL DRESS, RINE NECKLACE

1972, HARTNELL SUIT

1972, STIRLING UNIVERSITY, FREDERICK FOX HAT

1973, HARTNELL COAT, SIMONE MIRMAN HAT

1974, HARTNELL COAT, SIMONE MIRMAN HAT

1974, HARTNELL DRESS, FRINGED DIAMOND TIARA

1975, SILVERWOOD COLLIERY, YORKS

1975, HARDY AMIES COAT, SIMONE MIRMAN HAT

1975, AT WINDSOR, DRESSED BY HARTNELL

1975, DRESSED BY HARDY AMIES

# Silver Service

← **Design for a Silver Jubilee Mug, 1977, by Snowdon.**
A portrait of the Queen engraved from a photograph by Lord Snowdon taken in 1957. Details were bleached out to leave a pure black and white image, the basis of the design for Wedgwood's souvenir Jubilee mug. The Queen wears the Diamond Diadem, perhaps the most recognisable of crowns, worn by every British monarch since 1820 and familiar from British postage stamps and coins.

→ **Queen Elizabeth II on Jubilee Day, 1977.**
The Queen and Prince Philip on the steps of St Paul's Cathedral where on Jubilee Day, 6 February, they attended a Service of Thanksgiving. National celebrations focused on 7 June, when bunting-strewn 'street parties' were held across the country – four thousand, it was reckoned, in London alone. The Queen's most recognizable fashion statement was this silk crêpe dress, coat and stole by Hardy Amies with a Frederick Fox 'bell' hat.

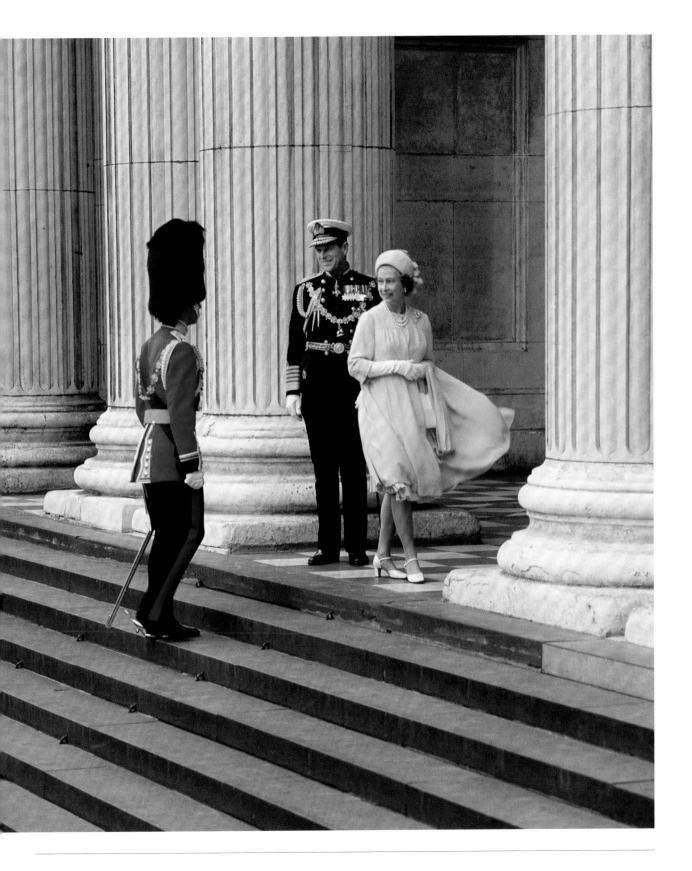

# Senior Service

### ← Earl Mountbatten of Burma, 1979.

In one of his last public appearances, Earl Mountbatten attends the Berkeley Square Ball. This picture was a poignant reminder towards the end of his life that he had had a distinguished career in the Royal Navy.

He had joined the navy as a teenager during the Great War and saw active service, and he ended his time as high as any sailor could get: Admiral of the Fleet, having been First Sea Lord. As captain of HMS *Kelly*, his exploits were recounted in the film *In Which We Serve* (1942), co-directed by David Lean and Noël Coward. In time, but after the war, he became Commander-in-Chief of the Mediterranean Fleet. In the end he died on water too, his life cut short by IRA terrorism aboard his boat in County Sligo, mere weeks after this photograph was taken.

### ↑ Lord Mountbatten's Funeral, 1979.

Lord Mountbatten was accorded a ceremonial funeral at Westminster Abbey. He had planned it meticulously beforehand. 'It is suggested there be no address,' he wrote, 'unless the Prime Minister felt he would like to say a word…' His elderly favourite charger Dolly accompanied the gun carriage carrying his coffin with, as tradition dictated, his riding boots reversed in their stirrups.

# VOGUE

**THE DAY OF THE WEDDING**
Since Charles and Lady Diana Spencer
the Snowdon portraits

**FASHION
AND
BEAUTY
NOW**

what to wear with what
the new nature colours
best of the best buys

# 6.

# *Rock & Royalty*

**'The Day of the Wedding'
August 1981, by Snowdon.**
For Snowdon's cover portrait,
the future Princess of Wales
wears a diamond suite
by Collingwood from the
Spencer family collection.

Two women from markedly different backgrounds and with little in common framed the 1980s. Both enjoyed international celebrity. Margaret Thatcher, who served three terms as Prime Minister, was first marked out for her intellect and oratorical skills. If she was then caricatured for her stridency, the other figure who dominated the decade and whose unique glamour radiated into the next, was by her own assessment, 'thick as two short planks'. Further, by virtue of her marriage, all but voiceless. At least to begin with. Instead, her life was played out in pictures. In time, she would become a global fashion icon and member of an international jet set whose notions of style and behaviour removed her from her aristocratic roots. As *Vogue* observed in its obituary of Diana, Princess of Wales: 'Millions rarely heard her speak. Clothes were her vocabulary.'

Barely five years after her marriage, *Vogue* noted hers was the most intoxicating media image of the decade, the most photographed woman on the planet. In a life cut short at 36, she was to become one of the most photographed women of the 20th century.

When Diana left the stage, she also she left a vacuum that *Vogue* found difficult to fill, even as the nation's long-serving monarch celebrated her milestone anniversaries. Not perhaps until the arrival of Catherine, Duchess of Cambridge, the daughter-in-law Diana never met but who will one day be accorded her title, the Princess of Wales.

# The Dawn of Diana

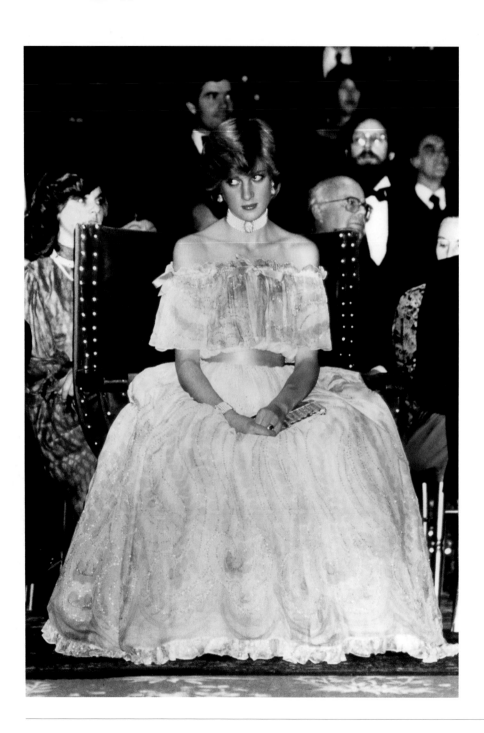

← **Shy Di: The Princess of Wales, 1981.**
*Vogue* had uttered a note of caution early on: 'To be royal in the 1980s is to accept increasing pressure and diminishing privacy… Earlier royal weddings happened in more innocent times when media and public kept their distance.'

→ **Lady Diana Spencer, 1981, by Snowdon.**
Her first appearance in *Vogue* pre-dated the announcement of her engagement. There was some inside knowledge. Fashion editor Anna Harvey had first met Lady Diana in 1980, after her two older sisters who had worked for *Vogue* asked for help. A fashion *faux pas* had recently occurred (to the delight of the press pack, a diaphanous skirt had turned see-through in the afternoon sun). Harvey was despatched to give advice and, being discreet and with immaculate taste, her firm hand ensured no such inelegancies were repeated. A sitting was arranged with Snowdon, sure in the knowledge that an announcement would soon be made. *Vogue*'s timing was impeccable.

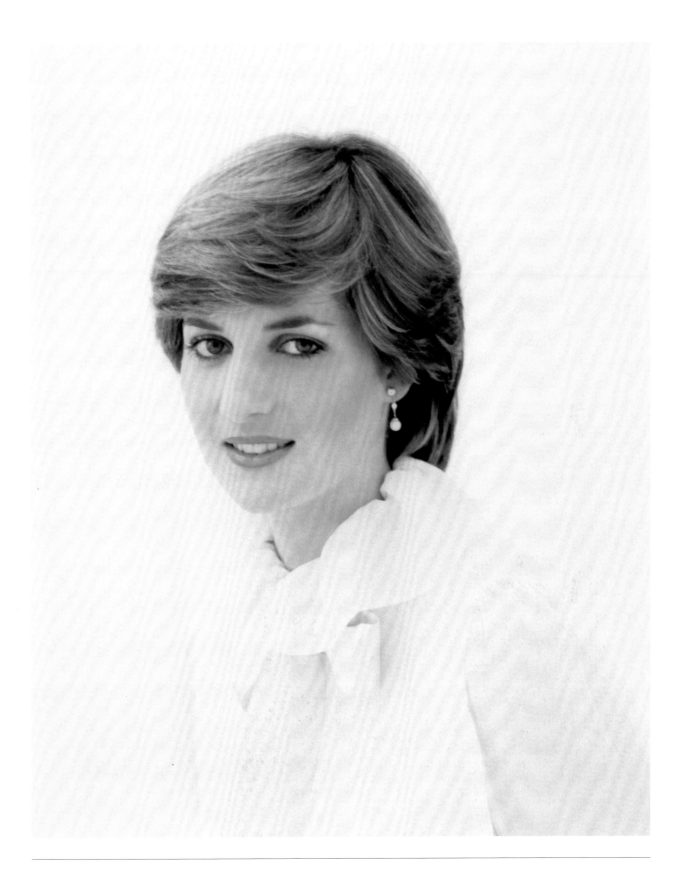

**↓↘ Lady Diana Spencer and Prince Charles, 1981, by Snowdon.**
A joint sitting, though here in separate portraits, of Prince Charles and the future Princess of Wales. Snowdon's formal *mise-en-scène* owed a little to Cecil Beaton's painted backdrops, Winterhalter-inspired fantasies of swags, branches and vistas, far and near. Beaton had died the previous year, his long reign as royal photographer over before then. *Vogue* concurred after the event that 'Of all Diana's early looks, the most successful were the shimmery, fairy tale dresses designed by the Emanuels that she wore during her engagement.' To Barbara Daly, who did her make-up for the wedding, she confided: 'It's a lot of fuss for one girl, isn't it?'

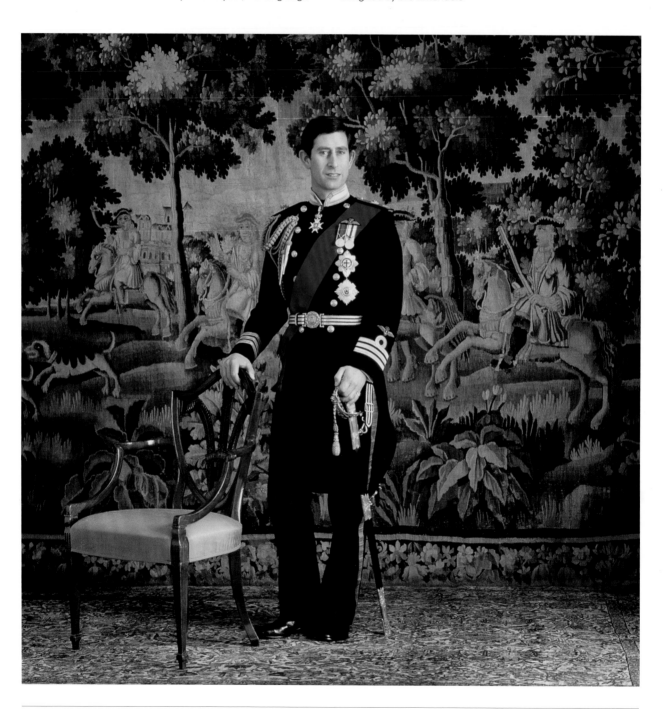

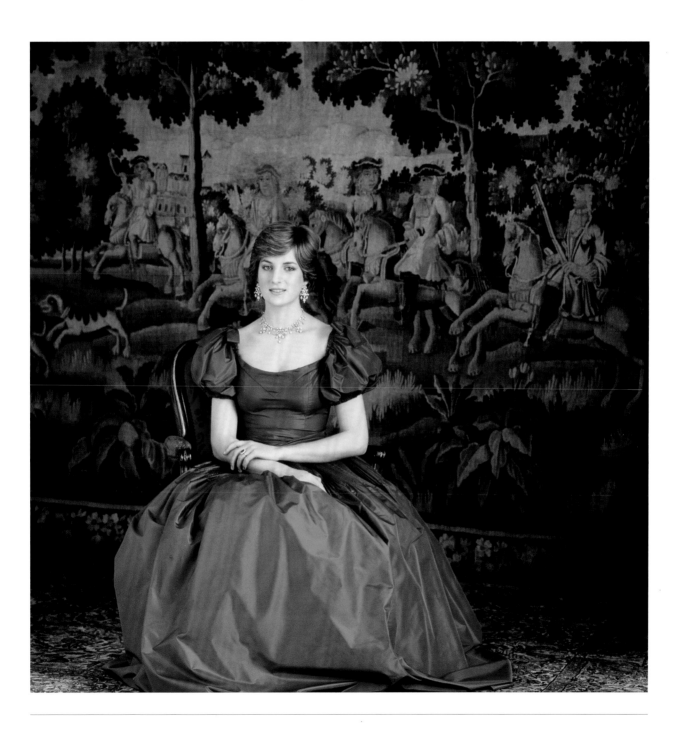

### From **Vogue's Eye View: Lady Diana Spencer**
*by Antonia Williams*

'With a life that has been more private than public, the fact that she adamantly does not smoke and prefers soft drinks to alcohol, she is the antithesis of a go-go bright young debutante. She would seem a most amiable mixture of the qualities the Royal Family needs – with charming natural good manners and an instinctive good-humoured response to the importunate: when shown her photograph in that now famous see-through skirt her instant comment was that her legs looked like those of a grand piano.

She has enormous consideration for other people. Both Prince Charles and her father have called her splendid, others sweet. This is not a word she likes, but it does not mean soft. With her discretion and humour there is a certain toughness and determination.

She is naturally pretty, tall but inclined to round shoulders and flat shoes – as if anxious not to dwarf Prince Charles who is barely an inch taller. She has a fair complexion, and an engaging giggle. Her humour, vitality and youth could go a long way to counteract Prince Charles's extreme sense of responsibility.

Her voice is gentle, not the upper-class bray that can carry across three counties, her nails are short, her nose reasonably strong, her eyes large and blue-grey with good lashes, her hair, blonde-streaked brown, is thick and well club-cut – difficult perhaps for tiaras and crowns but perfect for her preferred easy style.

Her tastes are for country pursuits – walking for miles on end on those good long legs. She will be a decorative and sympathetic spectator, patient in the butts, on the river bank, breathless at the finishing post. She bicycles and she skis. she loves music, playing the piano and dancing.

Very much of her generation, her fashion sense is far removed from the royal tradition. Before she was swept into the purdah of Buckingham Palace, she shopped at the most straightforward and bright young places. Now Emanuel for evening and wedding dress, Harrods for the Cojana sapphire silk suit, scalloped and belted, that she wore with an Italian swallow-print silk shirt for Engagement Announcement Day. Her jewellery has been discreet, as in fine gold chain and initial pendant, small gold hoop earrings. Now, apart from that giant sapphire surrounded by diamonds, she will have troves of jewels to rifle.'
*May 1981*

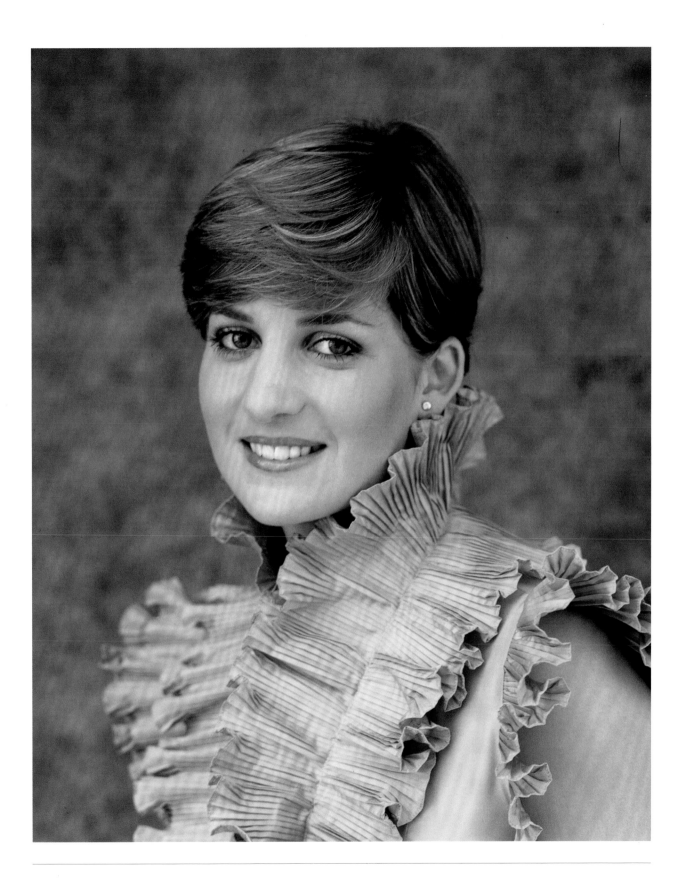

# Crossing the Line

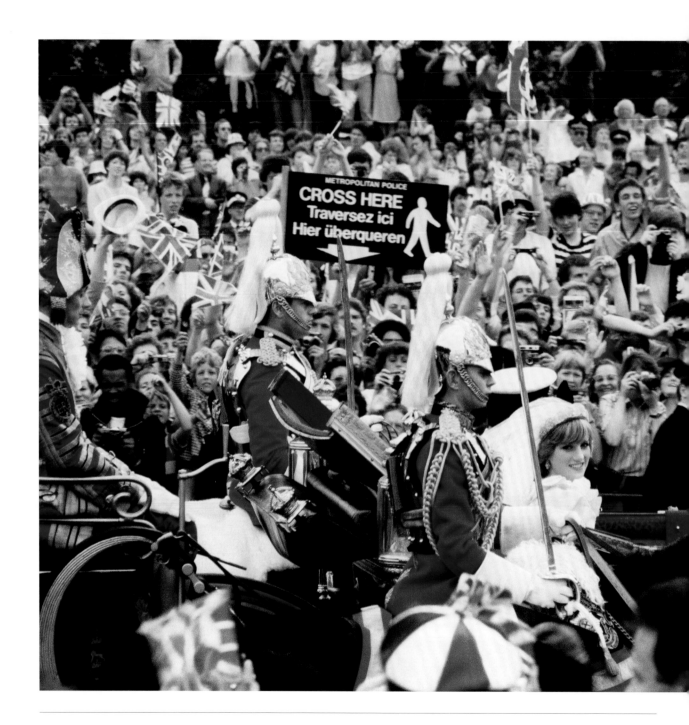

**The Prince and Princess of Wales return to Buckingham Palace, 1981, by David Bailey.**
In May 1981, *Vogue* noted that the reaction to the engagement of Lady Diana Spencer and the heir to the throne revealed vast numbers of hitherto unsuspected royalists, declaring 'Romance is in the air, the obvious delight is catching'.

When the magazine had intuited early on that the engagement was on the cards and had organized a sitting for Lady Diana with Lord Snowdon, the countdown had begun: May saw more pre-engagement Snowdon pictures and an article asking, pertinently, how Lady Diana might take on such a responsibility at not yet twenty. A historical supplement was produced: 'Royal Weddings in *Vogue*.'

But it was this wedding on 29 July that would dominate two issues of the magazine. The bride started her journey as Lady Diana Spencer, sitting with her father in the Glass Coach *en route* to St Paul's Cathedral. She ended it at Buckingham Palace as the Princess of Wales in the open-topped 1902 State Landau, accompanied by her new husband. 'Theirs is a triumphant journey,' wrote *Vogue*.

A hundred beacons were lit across the land in celebration and there were reportedly 27 wedding cakes at the reception (although only one was the official cake). It was a phenomenon, a watershed moment. A new era beckoned. The bride and groom's appearance on the balcony at Buckingham Palace was seen, they reckoned, by over 750 million people worldwide (did the radio audience really push it to a billion?). As one wedding guest told *Vogue* years later, 'We planned our future lives in the slipstream of what promised to be the most romantic wedding of them all.'

# Wedding of The Prince & Princess of Wales

**From The Wedding of Prince Charles and Lady Diana** *by Emma Soames*

'The week of the royal wedding was a social marathon: there were parties to watch the fireworks, picnics and pool parties, parties where girls dressed up in Lady Di wigs, and a party for people called Charles and Diana at the Embassy club. San Lorenzo, Tramp and Annabel's were packed every night and there were thrilling sightings of Prince Charles and Lady Diana dining at discreet tables in local restaurants.

It would be hard to concoct a more royal wedding than the one that brought the country to a standstill: 3,500 guests, four choirs, six officiating clergy, a world-class soprano and a huge orchestra made up from the three of which the Prince of Wales was patron. In truth, the anticipation was more tantalising than the reality.

After the brilliance of the sunshine and the noisy crowds outside, the cathedral was dark, muted and echoing to the click of a thousand stiletto heels on stone as waves of guests swept in. There followed a long wait on hard pews before the bride arrived. The most exciting moment came when the 3,500 people in the cathedral held their breath as the couple exchanged their vows – followed by cheers and roars of approval from the crowds outside.' *May 2011*

**The Princess of Wales on her Wedding Day, 1981, by Lichfield.** After the wedding, the new Princess of Wales, in a typically empathetic moment, comforts her youngest bridesmaid, five-year-old Clementine Hambro. This probably remains the defining image of a magical summer's day.

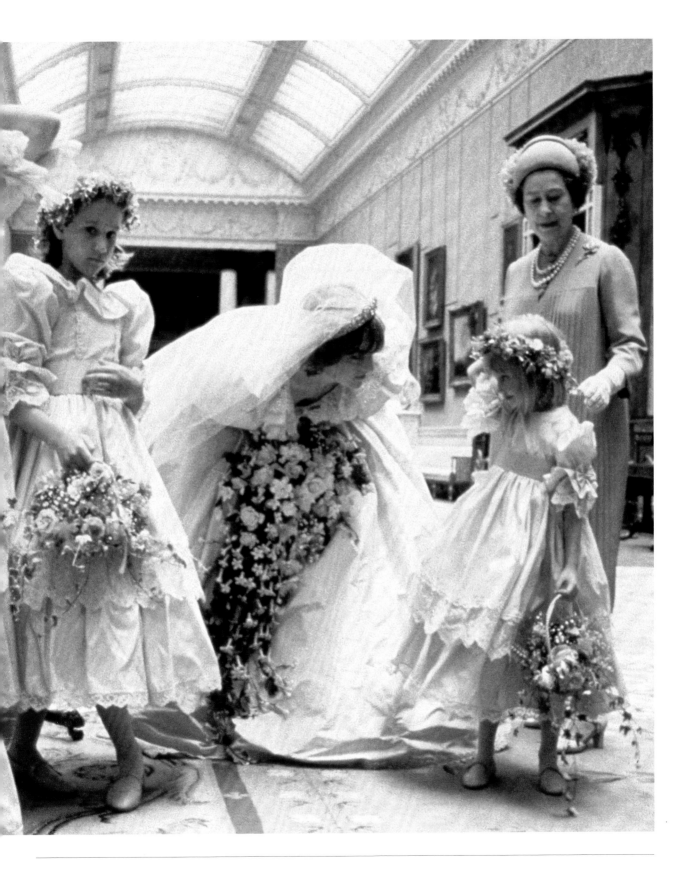

# Up & Under:
# In Australia & New Zealand

'I do not regard welcoming them as the first important thing I'm going to have to do in my first nine months,' Australia's new Prime Minister, Robert 'Bob' Hawke remarked of the imminent visit of the Prince and Princess of Wales to his country, before adding ominously, 'I don't think we'll be talking about kings of Australia forever more.'

Australia and New Zealand had been chosen some time earlier for the royal couple's first official overseas tour. Now the backdrop was one of increasing republican sentiment, which made the mission sensitive. But it presented a golden opportunity for the couple, who had also brought with them their infant son, to change the perception of the monarchy in a nation gradually loosening its ties to the mother country. Nothing could afford to go wrong. For the 21-year-old princess, inexperienced on the international stage, it was thought that the tour, 6 weeks long, covering 30,000 miles, with 40 internal flights and multiple appearances a day, might prove too punishing. In the run-up there had also been rumours of a personal battle with eating disorders and with post-natal depression. 'Would she snap, would she cry, would she collapse from the heat?' asked the *Sydney Morning Herald*, expectantly.

The visit was an astonishing success, confirming to the world that the Princess was

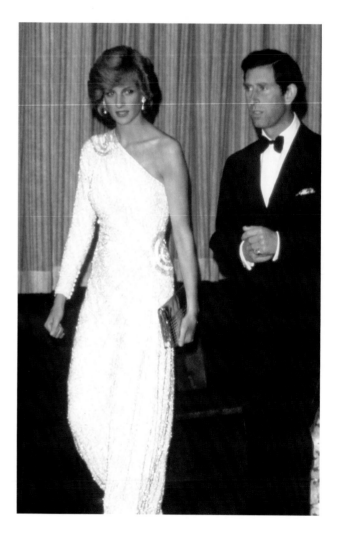

↑ **The Prince and Princess of Wales in Melbourne, 1983, by Lionel Cherruault.** The royal couple attended a gala ball at Melbourne's Hilton Hotel. It was the last official function of their Australian tour. The Princess's draped, off-the-shoulder columnar dress was made by the Japanese designer Hachi and became the hallmark of a freer sense of style.

**→ The Princess of Wales in Sydney, 1983.** Lost in a throng of admirers outside the Opera House, the Princess is a singular figure in a pink dress by Bellville Sassoon and hat by John Boyd. As one photographer, a veteran of the royal press pack, observed: 'When we got there it was like the whole of Sydney had come out. It was just a sea of people as far as you could see, not just on the land, the harbour was full of boats and people.' It was noted later that the Princess's staff had packed more than 200 changes of clothes for her.

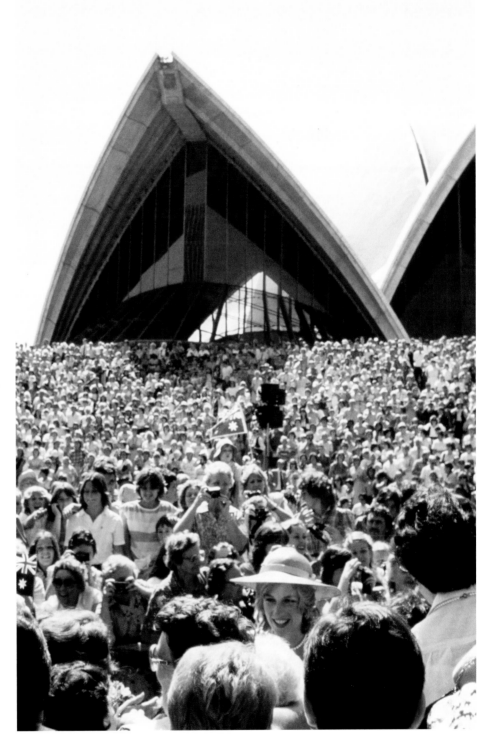

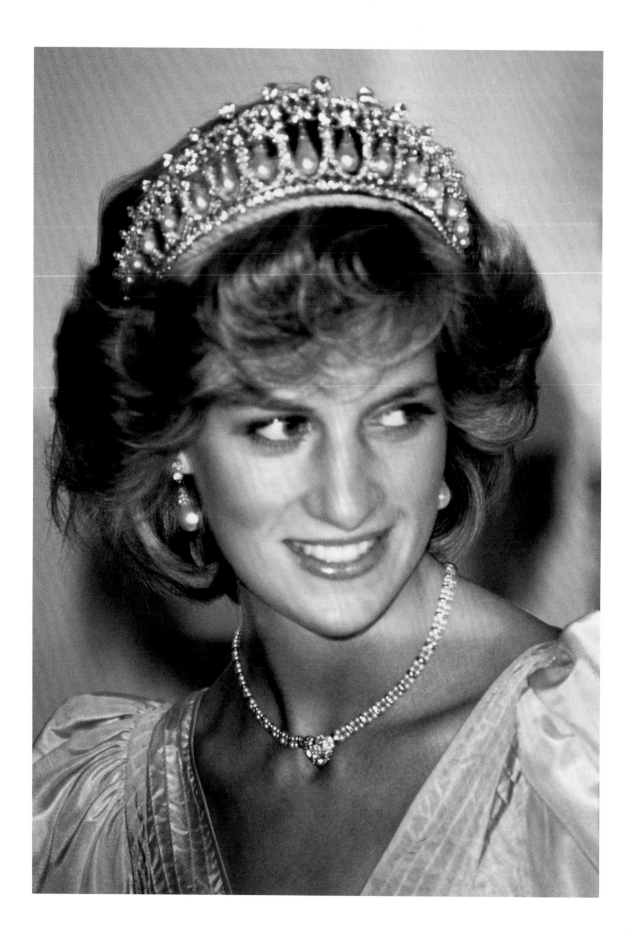

a superstar of global significance. In Brisbane, a crowd of 400,000 turned out to catch a glimpse of her. At state receptions, walkabouts, primary schools, Maori ceremonies, she charmed with the aplomb of a seasoned pro. Her shyness became an asset, as she gravitated towards those in the room who might feel as overwhelmed as she. She eclipsed her husband, whose lifelong sense of propriety did not allow him to chat quite as amiably about Prince William's cuddly koala toy or the vagaries of the Australian climate. At Government House, she had charmed Bob Hawke, who admitted a republican Australia was never a priority. As he wrote later to the Prince of Wales, 'Your visit to Australia in company with the Princess of Wales and Prince William has delighted the people of Australia,' he said. 'I hope you and your wife have felt this yourselves from the enthusiasm of the people who have greeted you as you travelled through the country.'

At home, the *Evening Standard* believed that the Princess had set back the cause of republicanism by a decade. She had dazzled beyond imagining; a secret weapon that might defend the reputation of the Crown for years to come. If things were to run true to form.

# New Arrivals

**The Prince and Princess of Wales and Family in Italy, 1985, by Tim Graham.**
The royal couple flew to Sardinia and from there boarded HMY *Britannia* for the start of a 17-day tour of Italy. It was billed by certain sections of the press as a 'second honeymoon' – the first had also been spent on board the royal yacht, as it toured the Mediterranean. And not entirely happily, as the Princess would later reveal.

Their visit to the Vatican naturally included an audience with Pope John Paul II, during which gifts were exchanged (Bede's *Ecclesiastical History of the English People* for the Pontiff and a copy of an original mosaic from the Basilica of Santa Maria Maggiore, Rome, in return). On the last day of the tour, they were joined on *Britannia* by three-year-old Prince William and eight-month-old Prince Harry.

**'For the Miss
Ferguson Wedding':
The Bride's Shoe, 1986,
by Manolo Blahnik.**

1986 saw another royal
wedding, that of Sarah
Ferguson to Prince Andrew,
the Duke of York. Since the
1920s, *Vogue* had published
(often exclusive) drawings
of successive royal wedding
dresses and trousseaux.
In 1947, the magazine had
commissioned a sketch of
Princess Elizabeth's strappy
satin wedding shoe, by Rayne,
from the artist John Ward.
In 1986, the consummate
designer Manolo Blahnik, a
favourite of the Princess of
Wales, provided this painterly
image of the shoe he created
for the new Duchess of York.
The caption, in his distinctive
flowing hand, reads 'For the
Miss Ferguson Wedding. Silk,
satin and pearls.'

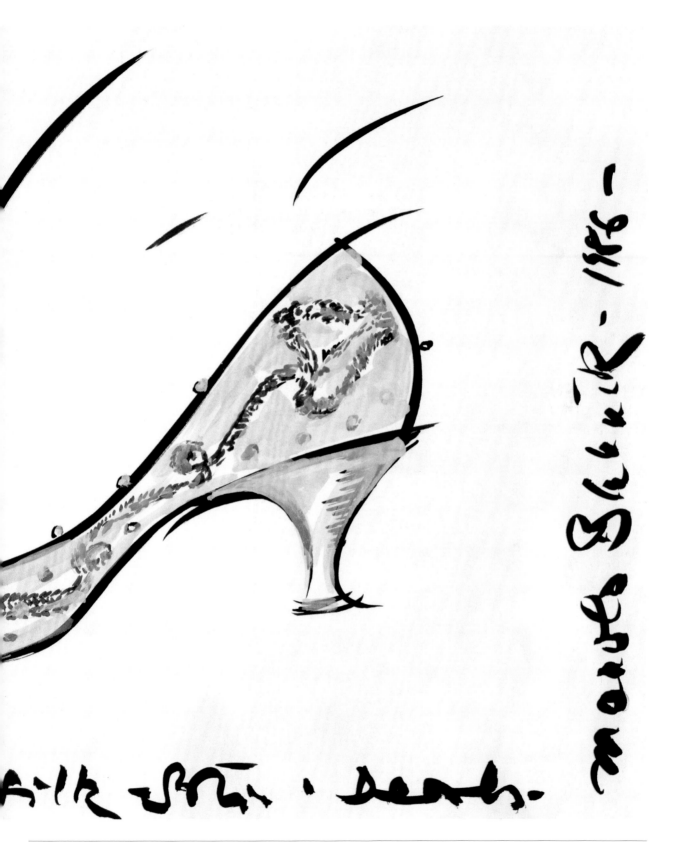

# Style & Substance

*From* **Rock & Royalty** *by Sarah Mower*

'In the 1980s, there have been no livelier indicators, no more vigorous influences on British fashion than the young royals and our multifarious pop groups. At first sight, it's a distinctly odd coupling, but viewed from an objective foreign standpoint, it becomes quite clear. For the New York teenager, the European or Japanese housewife, British fashion means pop videos on MTV and splashy Di and Fergie stories in weekly magazines. To the world at large, our style is that which is worn by youth at its class extremes: British fashion in international markets *is* Rock 'n' Royalty.

Royals must dress by the rule of the Establishment, properly and appropriately, according to the occasion and their own standing as figureheads. Pop stars dress to be different, often to shock and outrage, sometimes in a manner that is blatantly anti-establishment and anti-fashion. Yet in many ways pop star and princess are up to the same thing: they dress to be noticed. When you examine how they do it, that peculiar, sometimes inspired, sometimes eccentric strain of individualism is evident in all of them. It's that element we love, and the world admires as essentially British.

**The Princess of Wales, 1985, by Snowdon.**
A formal portrait for *Vogue* to mark the Prince and Princess of Wales's official trip to Italy. The backdrop was painted by Carl Toms, who had worked with Cecil Beaton and had been Snowdon's much-valued collaborator on 1969's Investiture ceremony. The Princess wears a black velvet dress by Bruce Oldfield, one of her favourite designers. She wore it to a gala première of the musical *Les Misérables* later that year.

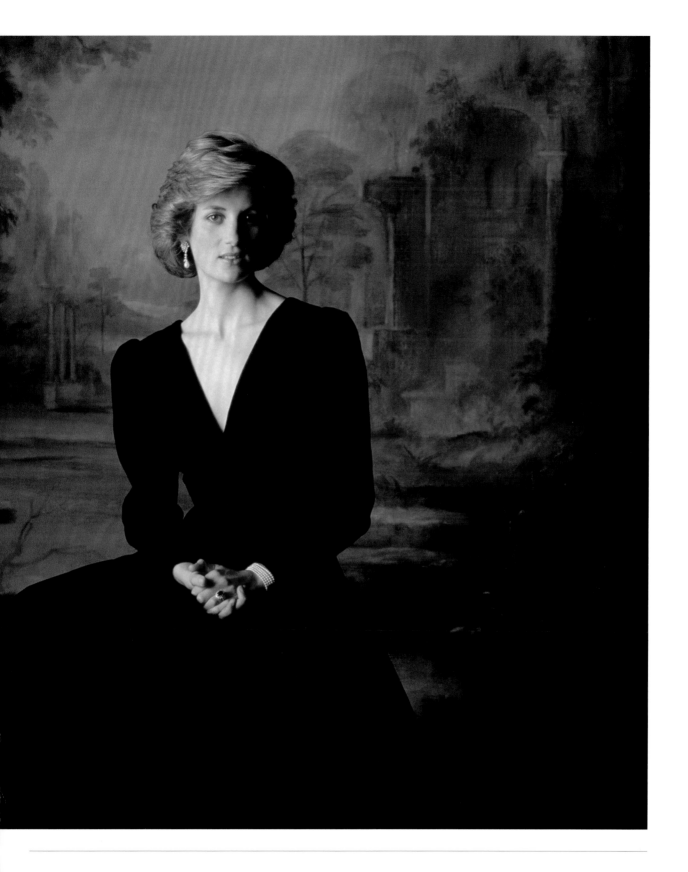

'She wanted to wear British because she felt it was something positive she could do for the fashion industry,' *Vogue*'s Anna Harvey revealed. 'She was a very English girl and the romantic style suited her. Everyone was thrilled to do things for her; there was such a feeling of euphoria that here was this young, glamorous girl who loved clothes.'

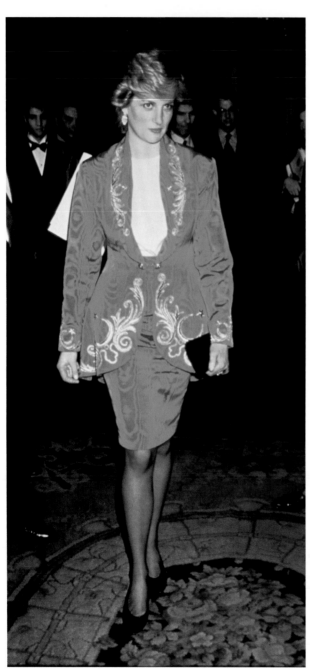

The Princess of Wales has dared to buck the old-established royal rule that fashion is mildly suspect and should be avoided wherever possible. Queen Victoria's remark, "Fashionable dressing – anything but that" has echoed sternly down the generations and until very recently it has been family policy always to appear suitable, but never glamorous. The Queen, distancing herself from an unseemly concern for clothes, calls her wardrobe "my props", implying that it is the substance of her "act", rather than her costume, that she considers to be the point.

The moment Diana stepped out of that limousine at the Goldsmiths' Hall for her first public engagement in 1981, it was obvious the focus was to shift. The *Sunday Mirror* breathlessly announced that her off-the-shoulder, plunging, black taffeta ballgown by the Emanuels "would go down in history"; looking back, so it has. It was the future Princess's announcement to the world that she *did* care about glamour and how she looked, that she was determined to cut a figure nobody could ignore...

As the Princess hits her stride, dressing ever more sensationally, even her once resolutely uninterested in-laws have been noted taking small cues from her...' *August 1987*

# Mother & Sons

**←→ The Princess of Wales and her sons, 1989, by Patrick Demarchelier.**
As a new decade dawned, interest began to drift towards younger members of the Royal Family. *Vogue* sought a new dynamic and drew chiefly, but not exclusively, from a string of reliable fashion photographers, such as Mario Testino and Patrick Demarchelier. Rails of clothes were called in, stylists and hair and make-up artists attended. The results, as polished as any fashion shoot, radiated glamour.

*Vogue*'s gaze began to focus primarily upon the Princess of Wales and her two young sons, Princes William and Harry. When news of the royal couple's separation became public knowledge, the Princess made use of *Vogue* to reflect a carefully crafted image of a hard-working, high-profile woman of the world, engaged in urgent humanitarian causes.

Ushering in this new era was a portfolio by Patrick Demarchelier for the last issue of the decade: the Princess and her sons in and around the family home, Highgrove.

Patrick Demarchelier's pictures taken for the last issue of the 1980s marked the first time the two princes, seven-year-old William and Harry, his younger brother by two years, had appeared in *Vogue*, at least in a commissioned set. There had been glimpses before but their parents were mindful of how quickly well-meaning interest might turn to alarming intrusion, and the young boys were habitually kept off-stage.

For *Vogue* at Christmas 1989, the two brothers and their mother posed in and around the stables at Highgrove, the message as contrived as the informality. By now the hairline cracks in the royal marriage had widened into deeper fissures – 1989 was the year, according to several biographers, that the Princess of Wales confronted her husband's mistress, Camilla Parker Bowles, about their extramarital affair – so it was advantageous, if not in her eyes imperative, for the unhappy Princess to develop a new narrative, one that showed her as a woman of independent ideas and spirit with a fresh and bold approach to the job. Contrived certainly, but there was an openness and a genuine sense of warmth in Demarchelier's pictures. Eighteen months later, Snowdon's witty *fête-champêtre* of a picture, with its emphasis on familial harmony also set at Highgrove, was seen as something of a corrective to the Princess's solo turns.

The Waleses, despite their increasingly separate lives, tried hard to give their two sons a freer, more buoyant childhood than perhaps either parent had enjoyed. Both brothers were distinguished from a young age by their immaculate manners but also by a streak of mischief – both endearing and exasperating. Observers noted that, although encouraged to express themselves as individuals and to mix with children from different backgrounds, the boys would move as a close-knit unit of two. Many years later, in 2007, they would tell a television audience that while wanting to appear as normal as possible, 'it's hard because to a certain respect we never will be normal'. In the meantime they would continue, to quote an idiom familiar to their generation, to have each other's backs. And never was this more vital than in the tumultuous decade that lay ahead.

# The Public Face

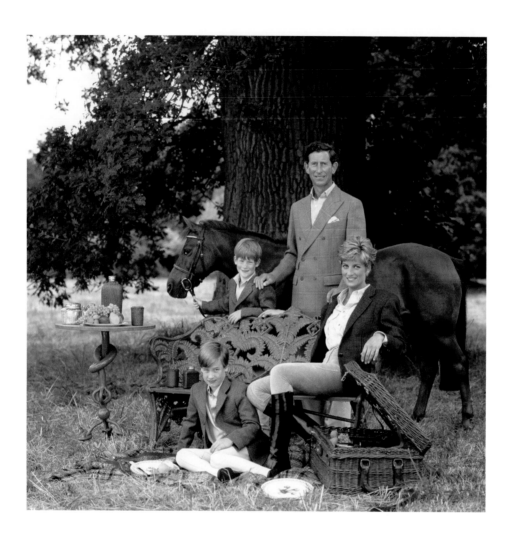

**↑ The Princess and Princess of Wales and Family, 1991, by Snowdon.**
One newspaper attached price tags to the props on show in Snowdon's conversation piece, offering advice on where to acquire them. But as Snowdon revealed, 'I had brought everything down in the car from London.' Despite underlying anxieties in their marriage, the couple appeared composed, managing to present to the world an image of family unity.

**→ The Princess of Wales, 1990, by Patrick Demarchelier.**
Of her new appearance, hair stylist Sam McKnight recalled that he had 'faked a short style for the shoot, using hair grips to tuck her shoulder-length hair under the tiara', which the Princess came to like so much that she asked him to cut her hair short, and a sensation was born. 'She said, "Shall we do it now?" So I did. It was as simple as that,' continued McKnight. 'The '80s were gone, and she was – bang! – in the '90s.'

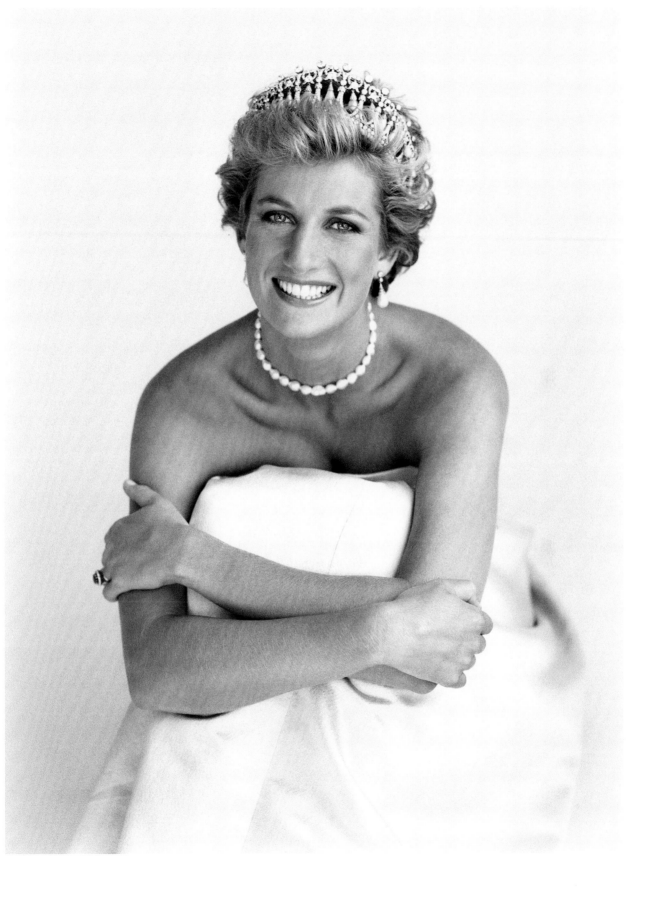

# In Royal Fashion

**'*Vogue*'s Spy: A Right Royal Affair', 1989.**

Two centuries after the French Revolution terminated the *Ancien Régime* and led, in time, to the abolition of France's hereditary kings and queens, Paris was seen once again, in *Vogue*'s words, to 'lose its head over the Monarchy'. The British monarchy this time, and Paris of course meant Paris couture. The House of Lacroix set the tone, sending its models out in A-line suits and 'Queen Mother' hats against the kind of Fragonard backdrop favoured by Cecil Beaton. Meanwhile, with a nod to Norman Hartnell, Scherrer and Ungaro confected generously beaded tulle and chiffon creations in primrose and wisteria, laburnum, rose pink, blushing apricot and forget-me-not blue, 'a glorious garden party of Beatonesque colours'. Paris had come full circle, catching 'a wave of monarchist sentiment'. 'The London old guard,' opined *Vogue*, 'suddenly began to look so right.'

A RIGHT ROYAL AFF

SARAJANE HOARE sees Paris couture lose its head over the Monarchy

A wave of monarchist sentiment set the Paris couture awash as the designers sent out a procession of creations fit for British royalty. Against a Fragonard backdrop reminiscent of Cecil Beaton's romantic royal portraits, models stepped out at Lacroix in ER II A-line suits, foaming tulle Queen Mother hats and "royal" diamond brooches.

YSL, Chanel, Dior, Scherrer and Givenchy followed suit, sprinkling emblems on their A-line skirts and producing >

The inspiration of a Beaton photograph of Princess Margaret, 1, and Hartnell drawing, 4, of The Queen (1958): 2 and 3, evening dresses, both by Lacroix. 5, Chanel's shocking pink pleated dress and 9, "Queen" coat

Huge brims at Scherrer: 6, 7; 8, with Lady Diana Cooper blouse; 10, with pastel pleating

LAWRENCE MYNOTT
MICHEL ARNAUD

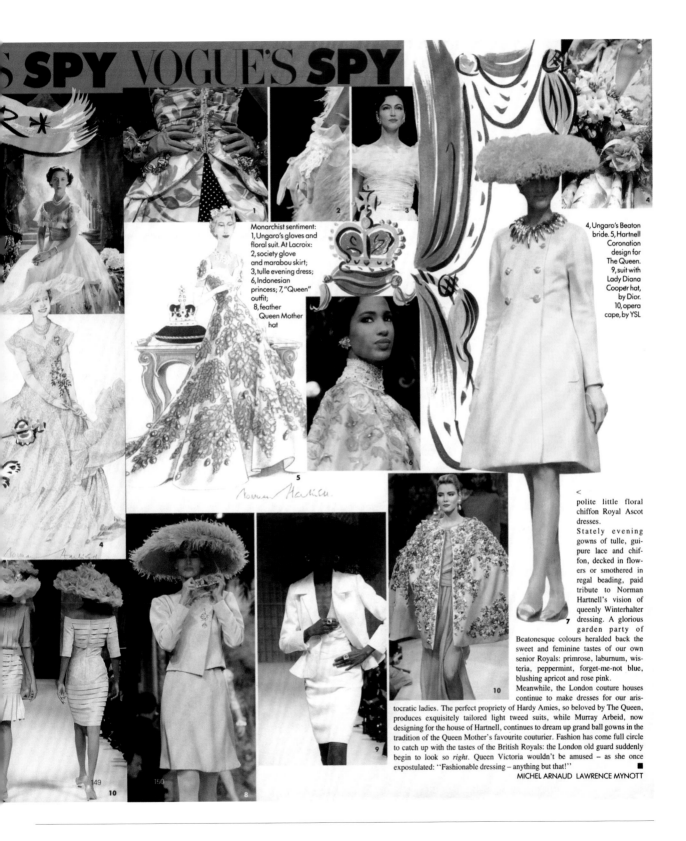

Monarchist sentiment:
1, Ungaro's gloves and floral suit. At Lacroix:
2, society glove and marabou skirt;
3, tulle evening dress;
6, Indonesian princess; 7, "Queen" outfit;
8, feather Queen Mother hat

4, Ungaro's Beaton bride. 5, Hartnell Coronation design for The Queen. 9, suit with Lady Diana Cooper hat, by Dior. 10, opera cape, by YSL

polite little floral chiffon Royal Ascot dresses.

Stately evening gowns of tulle, guipure lace and chiffon, decked in flowers or smothered in regal beading, paid tribute to Norman Hartnell's vision of queenly Winterhalter dressing. A glorious garden party of Beatonesque colours heralded back the sweet and feminine tastes of our own senior Royals: primrose, laburnum, wisteria, peppermint, forget-me-not blue, blushing apricot and rose pink.

Meanwhile, the London couture houses continue to make dresses for our aristocratic ladies. The perfect propriety of Hardy Amies, so beloved by The Queen, produces exquisitely tailored light tweed suits, while Murray Arbeid, now designing for the house of Hartnell, continues to dream up grand ball gowns in the tradition of the Queen Mother's favourite couturier. Fashion has come full circle to catch up with the tastes of the British Royals: the London old guard suddenly begin to look so *right*. Queen Victoria wouldn't be amused – as she once expostulated: "Fashionable dressing – anything but that!" ∎

MICHEL ARNAUD  LAWRENCE MYNOTT

# New Age Royalty

← **Lady Helen Windsor, 1990, by Patrick Demarchelier.**

An emerging generation of royals would make for more intriguing features. No longer purely public servants, they held down jobs and positions in the 'real' world; had made marriages outside a traditional social milieu. There would always be room for displays of pomp and ceremony, but by making themselves more available, accessible and behaving more open-mindedly, these younger figures appeared more in tune with the *fin-de-siècle*. At 26, Lady Helen Windsor, daughter of the Duke and Duchess of Kent, was then working with the German-born, London-based cutting-edge art dealer, Karsten Schubert.

→ **Lady Sarah Armstrong Jones, 1990, by Patrick Demarchelier.**

Lady Sarah Armstrong Jones, daughter of Princess Margaret and Lord Snowdon, was also involved in the arts, having enrolled as a student of painting firstly at Camberwell School of Art and latterly at the Royal Academy schools.

# Flying Solo

*From* **Diana: Leading Royalty into Reality**
*by Georgina Howell*

'Wreathed in marigolds and cornflowers, she moves on to be greeted by Crown Prince Dipendra and the prime minister. Head and shoulders above the crowd, she swims briefly into focus, the most famous woman in the world, the honey-coloured hair and skin, the demure sweep of eyelashes, the swoony, brilliant gaze familiar from a billion photographs. Chief among her companions is a more earthly being, the redoubtable Baroness Chalker, the United Kingdom's Minister for Overseas Development, signalling the purpose of this, the Princess of Wales's first official foreign trip since her separation from her husband in December. The throng on the wrong side of the rope, some 55 of the royal hack pack, led by the high priests James Whitaker of the *Daily Mirror* and Paul Callan of the *Daily Express*, surge forward as she passes, ramming their cameras into the ranks of five-year-olds, muttering ritual incantations.

"She didn't look in this direction once."

"I got bugger all."

Of all the transformations Diana has undergone, from kindergarten teacher to princess to single parent, this may be her toughest challenge yet, as she moves from a backup royal role to being a solo performer. With the Queen's blessing, she has come to Nepal to highlight the work of the British aid program and support the Red Cross and the Leprosy Mission.

Over the last few years, Diana has become the consummate professional in the traditional royal role of charity worker, effortlessly surpassing Princess Margaret, who always treated the work as a chore and once silenced a roomful of aides by telling the head of a children's organization, "I don't want to meet any daft children." Princess Anne broke the mould when she threw herself into organizational and field work for the Save the Children Fund as if her life depended on it. But there has never been a member of the Royal Family

**The Princess of Wales, 1994, by Patrick Demarchelier.**
*Vogue* celebrated the Princess's 23rd birthday with two portraits and a cover. By this time, the Prince and Princess of Wales had separated, 'amicably' according to Prime Minister John Major, although their marriage had fractured several years previously. This set of pictures coincided with the airing of *Charles: The Private Man, The Public Role*, a televized documentary on the Prince of Wales. It featured several interviews with the Prince, in one of which he admitted adultery after it was clear his marriage had irretrievably broken down.

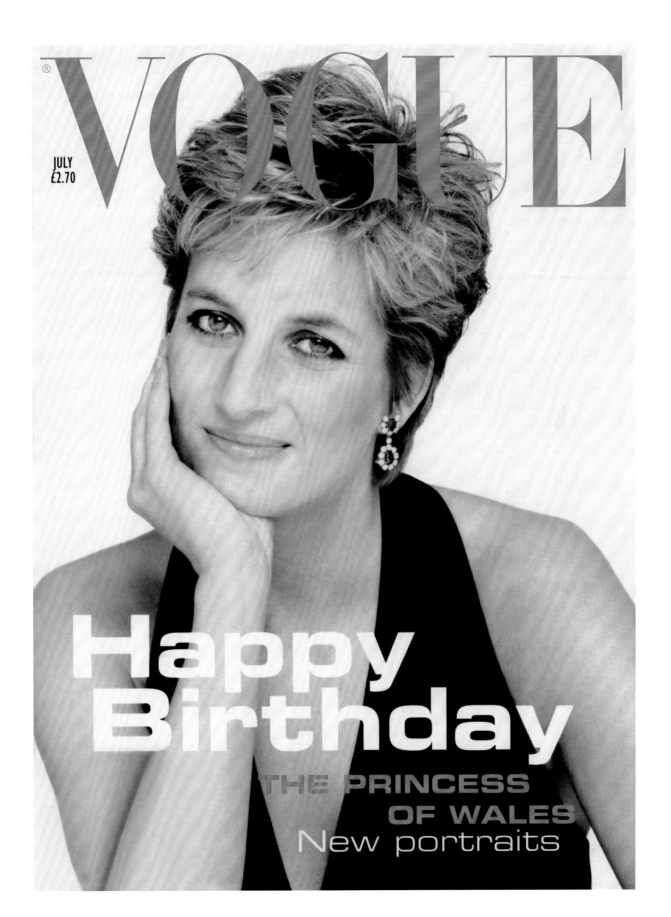

# VOGUE

JULY
£2.70

# Happy Birthday

### THE PRINCESS OF WALES
New portraits

**The Princess of Wales
in Nepal, 1993, by
Anwar Hussein.**
On the third day of her visit
to Nepal, the Princess visited
the Leprosy Mission at
Anandaban. In Nepal, there
were then more than 100,000
leprosy sufferers. 'The way
she touches the sick and
dying', *Vogue* observed, 'is
almost like an act of healing
in itself, a laying on of hands.'

so supremely well suited to the human interface
of what Diana calls the Work. "Have you seen
everything you wanted to see in Nepal?" "I came
to see the Work."

Ted Unsworth, chairman of Turning Point,
a British national organization that deals with
mental-health problems including alcohol and
drug abuse, was struck by a quick retort by the
princess in a recent conversation. "She made a
remark about drug addiction that impressed me
as being particularly well informed. I said so, and
she told me very firmly, 'This is my job. I take it
very seriously.'"

Walking along a line of children she will
pat heads, brush a cheek and, seeing a boy in a
baseball cap, reach out teasingly to pat the peak
right down over his eyes. The ability to empathize
and communicate, to hug and show affection, is
not a natural impulse with other British royals.
The personal value of what Diana does was
expressed by the mother of a severely brain-
damaged young man with whom she spent time
recently at a Barnardo's centre, one of several run
by a society dedicated to helping disadvantaged
and handicapped children. She knelt on the floor
beside the sofa where he was propped up between
his parents, put her face close to his, and spoke
to him for several minutes so quietly that only he
could hear. His mother told reporters, "I feel if my

**The Princess of Wales in Nepal, 1993, by Tim Graham.** Garlanded with flowers, the Princess visited the Red Cross project school in Panauti. At the Red Cross office, she sat beneath a hand-painted sign reading: 'Dignity for All! Respect for Women,' while signing the visitor's book in a distinctive hand.

kid is acceptable to the Princess of Wales, then he is acceptable to everybody."

"That warmth is not something you learn," I was told by a colleague of Diana's, Baroness Jay, daughter of ex-prime minister Lord Callaghan, who invited the princess to be patron of the National AIDS Trust. "From the time in spring 1987 when she opened the first ward for AIDS patients at the Middlesex Hospital and made the breakthrough gesture — courageous at that time — of shaking hands with them, we realized what a powerful communicator she could be. She has a genuine concern and sees any kind of social stigma as a serious issue." Photographed and reported all around the world, that symbolic gesture did much to change the public perception of AIDS, acquiring almost the significance of a papal blessing.

To be the Princess of Wales is, in the words of a U2 song, to cry without weeping, talk without speaking, scream without raising your voice. She communicates her own struggles through the medium of the speeches she writes herself, in the same breath identifying aspects of her own predicament with the victims throughout the world that she works so hard to help. Listen, and you frequently hear the personal note.

Diana's future is uncertain, but it is, says a friend, her mission in life to protect William and Harry from the pressures that have broken up four royal marriages in two generations. She has this, and the Work, to live for. She struck the personal note once more in a remote village in Nepal as she emerged from the smoky interior of a family's one-room hut. She took a deep breath and told Lady Chalker, "I shall never complain again." This remark, the most revealing of the entire tour, was relayed by the rota journalist to the other hacks that same evening in the bar. Paul Callan of the *Daily Express* leaned forward eagerly. "When she said that," he asked, "did she cry?" "No, Paul!" "Oh, shit!" Callan later licked his pencil and wrote about the Leprosy Mission. "This is a place where it is difficult not to cry. Where the patient acceptance of a terrible, wasting disease is so obviously visible...as Diana tours this tiny ward she cannot fail to be moved." Few tabloids even mentioned the visit to the mission, preferring to dwell on the decorous but transparent skirt Diana wore to visit the Gurkha regiment and the pigs that evaded the traffic police to run onto the helicopter pitch at the Red Cross project in Panauti. "The see-through skirt is all over the place," reported Judy Wade of *Hello!* magazine, emerging from the fax room. "The lepers didn't get a look-in.'" *American* Vogue *May 1993*

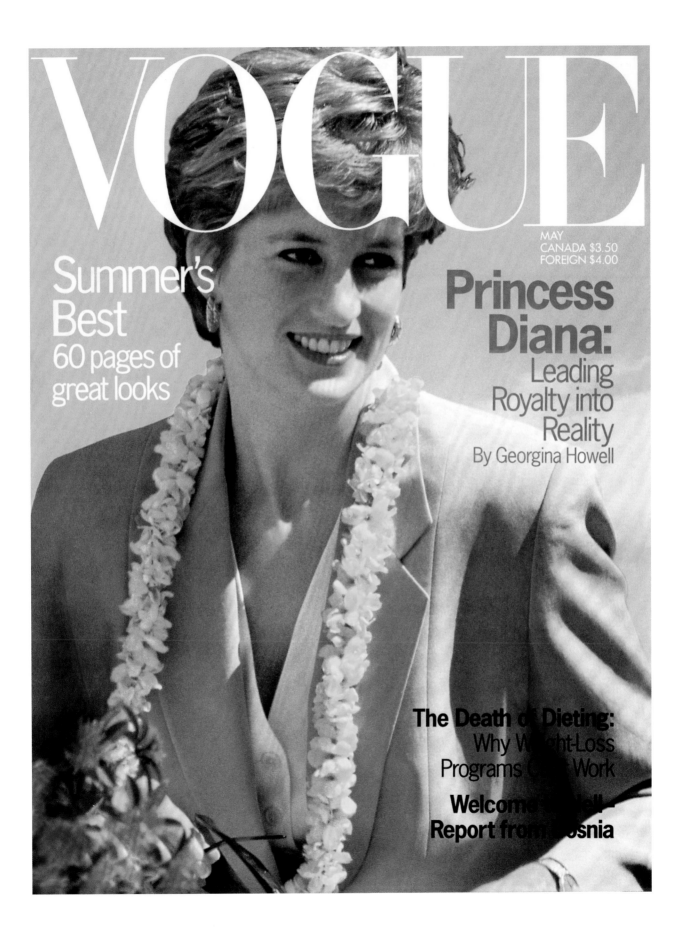

# VOGUE

MAY
CANADA $3.50
FOREIGN $4.00

## Summer's Best
60 pages of great looks

## Princess Diana:
### Leading Royalty into Reality
By Georgina Howell

**The Death of Dieting:**
Why Weight-Loss
Programs Can't Work

**Welcome to Hell:
Report from Bosnia**

# A Modern Duchess

**Sarah, Duchess of York, 1996, by Brigitte Lacombe.** *Vogue* found that the Duchess was fully aware of her shortcomings and the foibles that created and kept the tabloid fodder churning.

'I was just doing things spontaneously, impulsively. OK I was a breath of fresh air, but at the time I didn't like myself, I can tell you that. I had no confidence, no self-esteem. I couldn't walk into a room…'

*From* **Face to Face** *by Alexandra Shulman*

'The big question is whether her actions are the work of somebody foolish, headstrong and with astoundingly poor judgement or whether they are part of a more cynical and manipulative scheme. Somewhere along the line, Sarah Ferguson, a girl who, right from the start, one suspected would be the noisiest shrieker at the noisiest table in the Italian restaurant, became the target for the nation's collective lampooning and more recently dislike. In the absence of any appearance at all by the Duke of York, she has had to face on her own the media attention paid to this royal divorce. With every silly picture of her, and every new criticism of her behaviour, an opportunity has been found to get back at *all* those had-it-too-easy, good-time Sloaney girls.

So meeting this pariah, it came as a surprise to find an extremely attractive woman, who, although she had a tired face, was finer featured than expected, had sparkling eyes and a deep, confiding voice. Unlike her sister-in-law the Princess of Wales, Fergie does not have a good relationship with the paparazzo camera. Where the PoW has a blond, honey-coloured shimmer to her skin that appears radiant in daylight or flashbulb (Marilyn Monroe shared this quality), the DoY has the matt skin of a redhead that soaks up the light like vellum.

Dressed in a country-mum's uniform of long blue skirt and crew-neck sweater finished off with trainers, ankle socks and not a scrap of make-up, she looked younger than 36, winningly unselfconscious, and certainly not the *femme fatale* of the front pages.

We met just before the decree absolute in her divorce from the Duke came through. She talked of her search for "inner peace" and the "mammoth journey" she had embarked upon, a journey she started with a book called *Absolute Happiness* by her Australian guru Michael Rowland. In predictable Fergie style, she's already been photographed on a garden bench somewhere earnestly discussing the book with its author, a generous gesture made to help publicise his work, but one which once more made her look ridiculous, a new-age groupie.

The Duchess works out three days a week with Josh Salzmann (as is stressed in his press release) at the Wentworth golf club, doing "cardiovascular stuff, circuit training, press-ups. Fit mind, fit body. Fit body, fit mind. Free your mind and your bottom will follow, we say," she chants.' *August 1996*

**↙↓ Sarah, Duchess of York, 1996, by Brigitte Lacombe.** After a series of unfortunate incidents and tabloid furores, the Duchess did not enjoy a good relationship with the British press. To the red tops, she would endure as gaffe-prone 'Fergie', unrepentant Sloane Ranger now counting the cost of hubris. The Duchess's divorce settlement from the Duke of York, with whom she maintained a cordial relationship, netted her £600,000 but her debts were colossal. Her *Vogue* interview coincided with the divorce becoming absolute, and she was keen to re-engage with her many foundations and charities and to forge ahead with a writing career.

# In Memoriam

*From* **Diana 1961–1997** *by Anna Harvey*

'The first time I met Lady Diana Spencer was in 1980, in the editor's office. Then the engagement was announced and she couldn't go anywhere without being mobbed. Her sisters had worked at *Vogue* and we thought we might be able to help with her image. I'd called in far too many clothes because I had absolutely no idea of the kind of thing she liked. By the time she arrived, I was shaking like a leaf, but I took one look at her and thought, this isn't going to be too difficult after all.

She was about 5ft 10 and completely in proportion. Her eyes lit up when she saw all the racks – I don't think she had any idea how many lovely things there were out there – and her enthusiasm was contagious. After that, I'd trundle over to Kensington Palace with a rail full of clothes for her to go through and we'd sit on the floor in her drawing room, looking at sketches and swatches of fabric, while the butler brought endless coffee.

Diana had been called a fashion icon, but at the start she was incredibly unsophisticated about it all. Her taste was typical of her background; upper-class English girls weren't as knowing about clothes as they are now. But she was very open to ideas. The fashion press would have liked her to be more fashionable, but it would have been inappropriate.

She rapidly learned how to make an impact. She knew that the midnight-blue velvet dress by Victor Edelstein, which she wore when she danced with John Travolta at the White House, was one heck of a number. Once she asked me whether I minded if she called her husband into the drawing room to ask him what he thought of a black Murray Arbeid, with a huge oyster-grey waterfall skirt, and he just stared at her in it and said, "You look absolutely wonderful."

She enjoyed sitting for portraits (not just for the press; the members of the Royal Family traditionally give their charities and visiting dignitaries signed photographs of themselves).

**The Princess of Wales, 1994, by Patrick Demarchelier.** Although newly independent and keen to pursue her various causes, the Princess was criticised by an Establishment that considered she had jarred the system that supported them all. The book *Diana: Her True Story* by Andrew Morton, published in 1992 and sensationally laying bare the state of her marriage, had caused a media storm.

She especially loved Terence Donovan, who made her laugh, and Patrick Demarchelier, who was incredibly flirtatious and not remotely deferential. Snowdon, perhaps, understood better than anyone what was required.

In the early days, we didn't know what was expected. There always had to be something black in case she was suddenly called to a state funeral. And soon after the wedding she was – to Princess Grace's. It's hard to imagine now, but she really had nothing in her own wardrobe – a few Laura Ashley blouses and skirts and some bobbly jumpers. That was it. My first thought was tea at Balmoral, because she told me that the Royal Family changed for afternoon tea.

Once you had her trust, it was implicit, which made the responsibility even greater. I'd pore over the newspaper photographs – and she did – to see which outfits worked. I remember looking at those pictures of her sitting next to Prince Charles by a stream at Balmoral and thinking that she'd transformed completely from the girl I'd met eight months earlier. She was wearing a tweed suit, with those bare brown legs, and she looked great. It wasn't just the weight loss, which was dramatic, and the blonde hair – she was, I think, very happy at that time.

From the start she used clothes to make gestures; on her first visit to Wales she wore the Welsh colours – a green and red silk suit; for her arrival in Japan she wore Yuki and for a trip to Paris, Chanel. But the turning point style-wise in her marriage came on the second tour to Australia when she began playing with glamour and becoming much more daring. She'd ask advice but not necessarily take it. Once she asked me what I thought of the kohl she wore and I told her it was a little heavy, perhaps. Obviously I was completely ignored. I discovered that it was pointless to be didactic. As she became more independent, the heels got higher, the skirts shorter – it was almost a semaphore of clothes to signal her state of mind (as she well knew).

It is said she was more beautiful in the flesh. Once, on a visit to *Vogue*, the art department, who'd been quite cynical about her, were agog. She had sparkle. It was simply magnetic and, in the end, it transcended her clothes.' *October 1997*

*Diana had been called a fashion icon, but at the start she was incredibly unsophisticated about it all. Her taste was typical of her background.*

VOGUE

OCT
£2.90

1961-1997

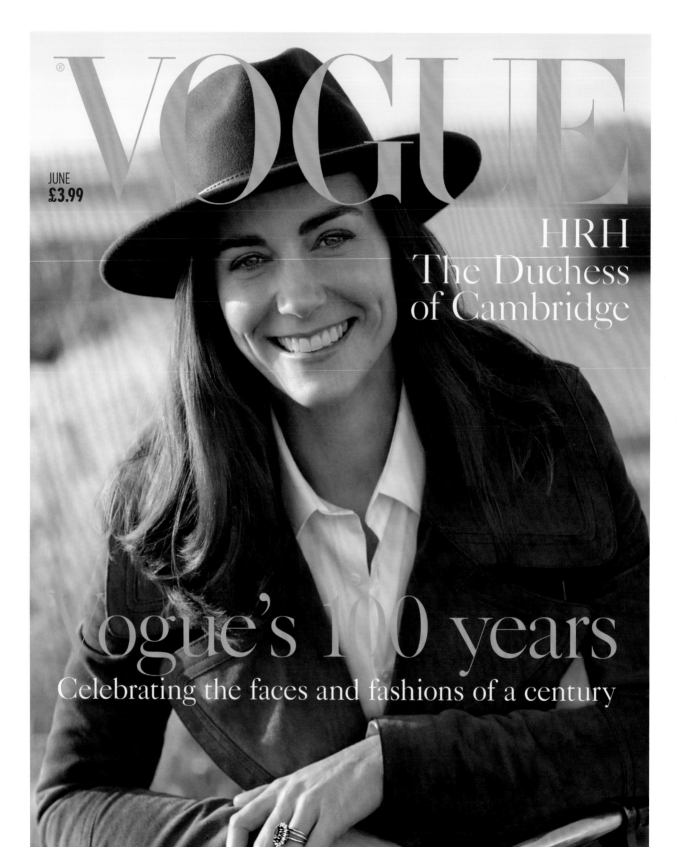

# VOGUE

JUNE
£3.99

## HRH
## The Duchess
## of Cambridge

# Vogue's 100 years
### Celebrating the faces and fashions of a century

# 7.

# *The Way Ahead*

December 1999. As we entered the Age of Aquarius, were we not also witnessing the twilight of the Second Elizabethan Age? It has not, of course, quite worked out that way, these twilit years stretching out to two further decades and counting. In June 2012, during the Diamond Jubilee year, *Vogue* reminded readers that Queen Elizabeth's first picture in *Vogue* was at her mother's knee in 1927, and that in the succeeding years her landmark moments have had much to do with our own history.

A Royal Wedding has always excited *Vogue* as much as it has the whole nation. When in 2011 Catherine Middleton married the heir to the heir to the throne, the magazine approved of the new Duchess of Cambridge's pragmatism, applauding the rise of 'the postmodern princess', and coining a neologism, 'Katepedia', by which to scrutinize her every fashion moment as a botanist might the petals of an exotic orchid.

The wedding of Prince Harry to the American Meghan Markle, identifying as mixed race, saw the nation rejoice again, a more modern image of monarchy for modern times. In 2020, they stepped back from royal duties and made California their home.

Meanwhile, Queen Elizabeth II strides into the 70th-year of her reign, more than ever, as *Vogue* put it ten years earlier, 'a constant. She has been around for as long as most of us can remember: a quiet safe-feeling presence, endlessly "turning up", perfectly punctual, impeccably turned out.'

# Heir of Conviction

*Vogue*'s first photograph of Prince Charles Philip Arthur George Mountbatten-Windsor, taken just before Christmas 1948 when he was a month old, was taken by Cecil Beaton. It was also the first royal photograph to be reproduced in full colour.

In 1950, Beaton photographed him again in the grounds of Clarence House, near beds, he observed, of 'salmon-pink geraniums and other vividly coloured flowers'. There, against a sizeable classical pillar, the young prince beamed broadly, proffering a leaf, which, if one were to be poetic (and prophetic) might point towards those passions to come, for horticulture and environmentalism and for architecture, too, principally his enthusiasm for the harmonies of the past. In fact, as he told *Vogue* almost exactly 60 years later, he was opening up those very gardens at Clarence House for another cause close to his heart, 'a twelve-day sustainability festival'.

When he became heir apparent aged three, few would have guessed that 74-year-old Prince Charles would be the longest-waiting heir in history. There will be no second abdication crisis, for, as historian Hugo Vickers has pointed out, 'we live in a golden age created by the Queen,' an anointed sovereign, who for the seventy years of her reign has been mindful of the very political controversies that *Vogue* hinted at in 1948.

**The Prince of Wales, 2002, by Mario Testino.** This photograph (and the one overleaf) were intended for a special 'Royal Issue' of *Vogue*, published for Christmas the previous year. After several months of planning, the sitting was scheduled for 11 September 2001, but was overtaken by world events. It took place instead in November at Highgrove. Here, the Prince of Wales feeds his Maran chickens outside their beautifully constructed hen house. The Prince wears a woollen coat from Pakistan, part of a collection of similar coats that, he told *Vogue*, he often wears in the garden.

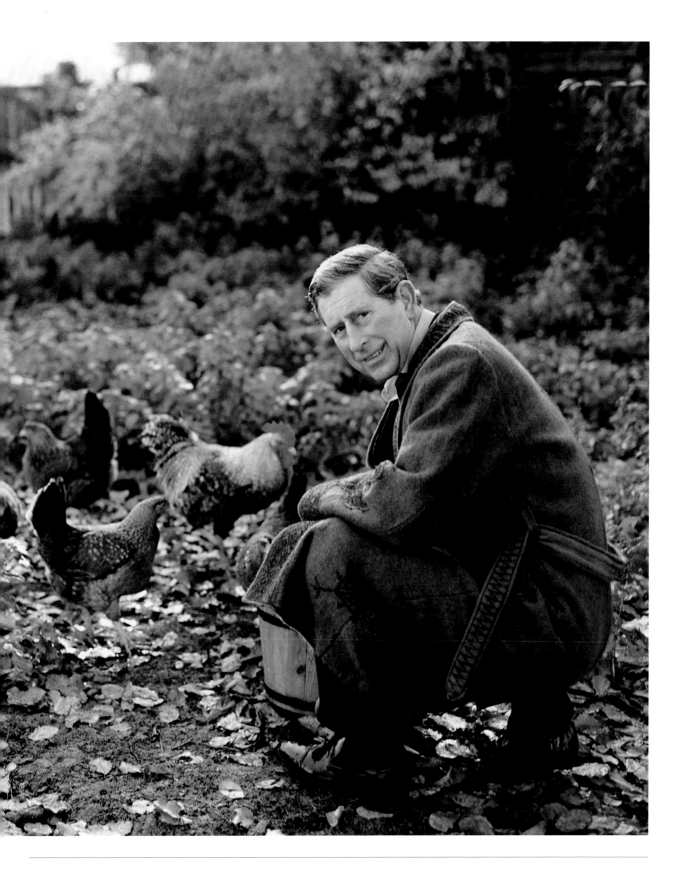

**The Prince of Wales, 2002, by Mario Testino.** The Prince of Wales acquired Highgrove in 1980, making improvements to its neo-Georgian architecture throughout the decade. He also landscaped its extensive gardens and is justifiably proud of his designs. *Vogue* noted of this early morning portrait that it 'shows a man who is comfortable in his formal, royal persona and relaxed in his own world at Highgrove'.

Similarly, despite a succession of polls suggesting that only a quarter of those asked think him suitable to be King, there is no likelihood of the Prince of Wales stepping aside for his elder son. Would there be much point to the Crown in the modern age if it was subject to the will of public opinion?

The Prince's controversies have been many, not least the fall-out from his first marriage, his declamations on cutting-edge architecture, his often 'circular thinking'. His genuine interest in statecraft and the exercise of power is often misconstrued as meddling interference, but few can doubt his drive and his ability to cut through to the very essence of public duty. The Prince's Trust, founded in 1976, is perhaps his most conspicuous, significant and proudest achievement. His Prince of Wales motto is '*Ich Dien*' – I serve – and it will continue irrefutably to be so once the nation has a new Prince of Wales. And a new King and, who knows, a new Carolean age.

# In Farewell

← **Princess Margaret, 1954, by Cecil Beaton.**
The Queen Mother and her younger daughter died only weeks apart. This portrait of Princess Margaret was taken in 1954 at Clarence House, where she lived with her mother and her Sealyham puppy, Pippin. Beaton admired Princess Margaret's independence of spirit and her inclination towards an unconventional life. *Vogue* considered the Princess as 'probably the first member of the House of Windsor to understand how positive an injection of glamour and style can be to those who look on...'

→ **Queen Elizabeth, 1948, by Cecil Beaton.**
Beaton's grander portrait of Queen Elizabeth, later Queen Mother, was taken in 1948, at the end of the year of her and the King's Silver Wedding anniversary. Beaton dispensed with the lightness of touch that had marked out his white tulle and satin 'Faerie Queen' portraits, preferring instead a more stately *mise-en-scène*. Norman Hartnell created the black velvet crinoline dress and long gloves especially for the sitting.

# The Jewels of a Princess

**↑ Princess Margaret at the Schleißheim Palace, 1981.** At a showcase of British fashion abroad, which culminated in a grand operatic finale with Montserrat Caballé and José Carreras, Princess Margaret wore a favourite item. This diamond *rivière* necklace was inherited from Queen Mary and she wore it to her wedding.

**→ Princess Margaret at London Zoo, 1972.** At a party given by Mrs Drue Heinz, in keeping with the surroundings, guests were asked to attend masked as either beasts or saints. *Vogue* reported that most elected for the former.

In 2006, four years after her death, Christie's held a sale of nearly 200 pieces from Princess Margaret's remarkable collection of jewellery. Unthinkable as it was for the Queen to sell her jewels publicly, this was as close as anyone might get to items of the highest royal provenance.

The Princess was known for radiating a natural glamour. For her 21st-birthday portraits she wore a creation by Christian Dior. 'She was a real fairy tale princess,' the couturier wrote in his memoirs, 'delicate, graceful and exquisite.'

If she was restrained in her fashion choices, she was at the cutting edge of style when it came to jewellery. She commissioned items from Andrew Grima and John Donald, then at the forefront of avant-garde British jewellery design. She had a piece of lichen picked up on a country walk fashioned into a diamond brooch and earrings by Grima, 'wearable sculpture,' as he recalled. Her lady-in-waiting Davina, Countess Alexander, remembered, 'I never saw her without jewellery... Even on holiday she always wore earrings, although she never had her ears pierced because she thought it rather barbaric.'

The Christie's sale did not disappoint. The fabled Poltimore Tiara worn at her wedding quadrupled expectations to sell for £926,400. The entire sale fetched almost £10 million.

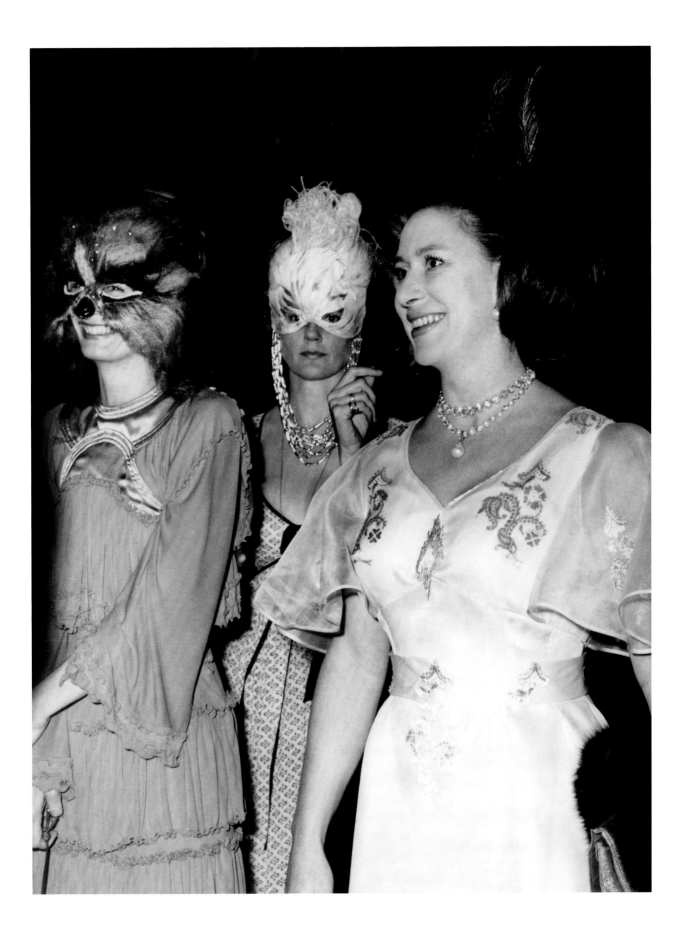

# Royal Variety

*From **Royal Variety** by Drusilla Beyfus*

'HM the Queen and I are close contemporaries. Memories in her name reach back to babyhood. My nannie related with the greatest possible pride that one day, when pushing our Silver Cross pram in the park, I was mistaken for the young Princess Elizabeth. It must have been my bonnet – an early intimation that clothes were to become the very mark and signature of the Queen's public image. That episode ended my heads-up in sartorial royal history, as our tidy day wardrobes parted company – hers towards Norman Hartnell and Hardy Amies, mine towards Jean Muir and Jil Sander

HM is now the longest-serving monarch in the nation's chronicles. One can speculate whether she will be our last female sovereign. Males are in line for the throne for the next three generations, and we don't know what or who comes after that.

I metaphorically raise my hat to her – no matter that our generation is the first in modern times in which a woman could be considered well-dressed without one.

Much of the Queen's public life has been bound up in sartorial considerations. Decisions over the decades range from satisfying her often-aired belief that people who come to see the Queen ought to be able to do so easily, without being frustrated by her chosen form of outfit, to the more complex question of selecting forms of dress that communicate with the audience. Diplomatically, culturally and socially, the royal wardrobe has an obligation to be booboo-proof, well able to function in the light of a sartorial hotchpotch of tricky sensitivities and trip-up issues. Few would question that the clothing of the Queen has constituted a big help in enabling her to play the part of Her Royal Nimbleness.'
*March 2016*

**Princess Elizabeth on HMS *Vanguard*, 1947.** A photograph, unexpectedly informal, of Princess Elizabeth playing 'tag' with the midshipmen of HMS *Vanguard*. The previous year she had become secretly engaged to Lt Philip Mountbatten. It was hoped that joining the King and Queen's tour to South Africa, would give the Princess time to reflect upon her decision. It did. Shortly after her 21st birthday, while on board, the King gave his daughter his blessing to marry. This trip marked the first time the Princess had left British shores.

# A Love Fulfilled

These portraits of the Prince of Wales and the Duchess of Cornwall, opposite and on the following pages, were taken in and around Clarence House to mark their first wedding anniversary. Mario Testino's portfolio is typically relaxed and for the most part informal, but the journey to Clarence House over the past several decades had not been an easy one. It took in a public admission of infidelity on the part of the Prince, their respective high-profile divorces (she from Andrew Parker Bowles, a brigadier in the Blues and Royals; he from the Princess of Wales) and, of course, the tragedy of the Princess's death in Paris.

How Camilla Shand met the heir to the throne, 16 months her junior, is open to conjecture. Popular imagination, supported by the BBC, assumes that love blossomed on the polo field around 1970. Other theories have it that the pair were introduced by Charles's sister Princess Anne, who was then herself romantically involved with Parker Bowles. Most likely they were introduced by a mutual friend, Lucia Santa Cruz, the daughter of a Chilean diplomat who is often referred to as the Prince's 'first girlfriend'. However and whenever they met, it was ill-timed. The writer and royal observer Sally Bedell-Smith told *Vogue* that the Prince 'had sort of parachuted into the middle' of the already complex relationship of Camilla with long-term boyfriend Parker Bowles. 'For Charles,' she continued, 'it was a *coup de foudre.*' Their affair drifted on and the Prince, a serving member of the Royal Navy, left it too long for her to commit to a royal marriage. In the summer of 1973, she married Parker Bowles, but her friendship with Charles remained strong and they resumed their affair.

The Princess of Wales's remark in a candid television interview that 'there were three of us in this marriage, so it was a bit crowded' cast Camilla in a devastatingly unfavourable light. She bore it and the shockwaves of the Princess's death with discretion and dignity, never considering setting any records straight. On 10 February 2005, Clarence House announced that the Prince of Wales would marry Camilla Parker Bowles.

On the 70th anniversary of her accession, as her Platinum Jubilee year unfolded, the Queen released a letter to the country and the Commonwealth in which she stated her 'sincere wish' that the Duchess of Cornwall, her daughter-in-law, should be Queen Consort. If acceded to, when the time comes, she will be crowned side-by-side with her husband, the royal couple known as 'King and Queen'. A deeply personal gesture by the monarch, it recognises The Duchess of Cornwall's loyalty, discretion and hard work.

**The Prince of Wales and the Duchess of Cornwall, 2006, by Mario Testino.** The royal couple's official wedding anniversary photograph taken in the grounds of Clarence House, their official London residence. The Duchess's blue silk outfit is by Robinson Valentine, who had created her wedding dress a year earlier. The Prince wears a cornflower buttonhole from the garden of his country home, Highgrove.

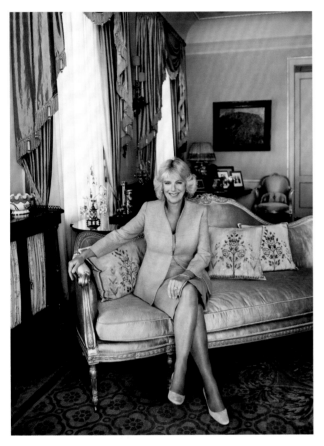

**← The Prince of Wales and the Duchess of Cornwall, 2006, by Mario Testino.**
The Prince and the Duchess in the doorway between the Morning Room and the Library at Clarence House. The Duchess wears a favourite cream evening dress by Robinson Valentine. Both rooms were backdrops to Cecil Beaton's first pictures of the infant Prince Charles, taken in 1948, Clarence House being Princess Elizabeth's home before her accession and after her marriage in 1947. Princess Anne was born there in 1950 and from 1953 it was home to Queen Elizabeth The Queen Mother and her younger daughter Princess Margaret.

**↖↑ The Duchess of Cornwall, 2006, by Mario Testino.**
The Duchess sits (*above left*) in the morning room in a blue ensemble by Robinson Valentine and (*above right*) in a turquoise chiffon dress by Roy Allen, who trained with royal dressmaker Hardy Amies. The diamond necklace, fashioned from a tiara once belonging to her great-grandmother, was a gift from her husband.

# The Cambridge Comets

Just after lunchtime on their wedding day in spring 2011, the newly created Duke and Duchess of Cambridge (Prince William was the first Duke of Cambridge since Prince George of Hanover in 1850) stood on the balcony at Buckingham Palace and waved to the crowds below. He wore the uniform of an officer of the Irish Guards; she an exquisite wedding dress by Sarah Burton for Alexander McQueen, the pleats of the skirt, fashion observers noted, echoing the petals of a budding flower.

The same balcony, the same spot, in which thirty years previously the Duke's parents had made the same appearance, delighting the crowd by kissing in public and in so doing establishing a new tradition. In 1981, the crowd held up flags and banners; in 2011 the crowd held up their mobile phones. But still there were elements of ages old British eccentricity: a man in a suit had climbed a lamppost to blast out *Rule Britannia* on a trumpet, while Union Jacks waved approvingly below.

The Duchess's luminosity has only intensified in the years since. 'Kate is that rare commodity,' observed *Vogue*, 'a royal exhibiting a delighted-to-meet-you-and-thrilled-to-be-here enthusiasm that isn't lost on those who've waited hours in the sleeting rain to catch a glimpse of her.' So too her husband's. Most accounts had the student prince marked down for almost terminal reticence, the mirror of his mother's when she first stepped into the light. The weight of responsibility and his sense of duty – and purpose – have changed everything, and in the decade since his wedding he and Kate have emerged as the most appealing figures in a family that has often side-stepped charisma. Together, the Cambridges possess, as Cecil Beaton once wrote of the Queen, 'the radiance of people who are much praised and much loved.'

William will implicitly understand that the Crown is not motivated by personal hopes and ambitions, dislikes and prejudices, but is of a higher calling, an office defined solely by duty. By virtue of the stratagems of his father it is slimline for the modern age, a 'value for money' monarchy, but William will in time make the same promise as Queen Elizabeth II made 70 years ago: to serve her nation and its peoples for as long as she should live.

Not that any of it has come as a surprise. When seven-year-old William intimated what he might like to be when he grew up, his five-year-old brother declared quick as a flash: 'You can't. You've got to be King!'

**The Wedding of the Duke and Duchess of Cambridge, 2011, by Clara Molden.**

The wedding of Prince William to Catherine Middleton was announced for 29 April 2011. *Vogue*'s Editor-in-Chief Alexandra Shulman was there.

'We all watched Prince Harry's glance back as the bride approached, his obvious grinning approval conveyed to the groom. As the bride and her entourage passed down the aisle, you could see the broad smiles on the faces opposite close enough to the bride to see, even if you couldn't make out any more of the bride herself than a sparkling tiara. When she reached her prince, we could see the whole picture: Pippa Middleton's sensational figure in that dress, the adorable pages and bridesmaids, and the almost regal silhouette of the wedding gown. All through the rows, people were mouthing, "Who did the dress?"'

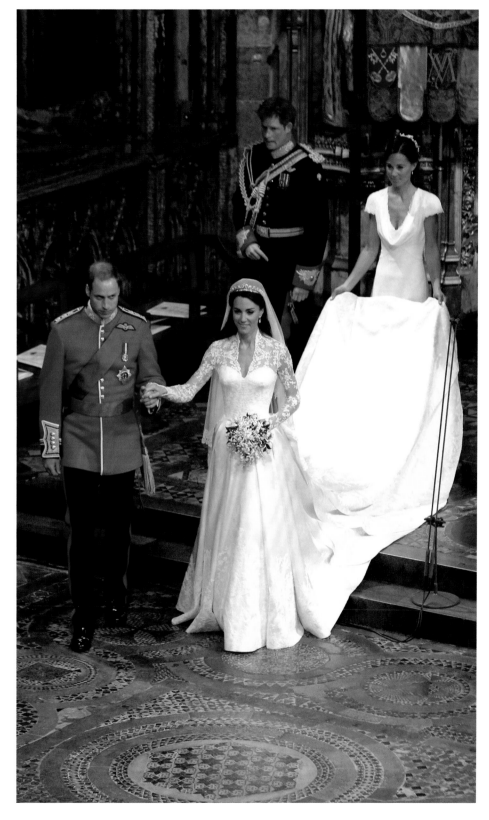

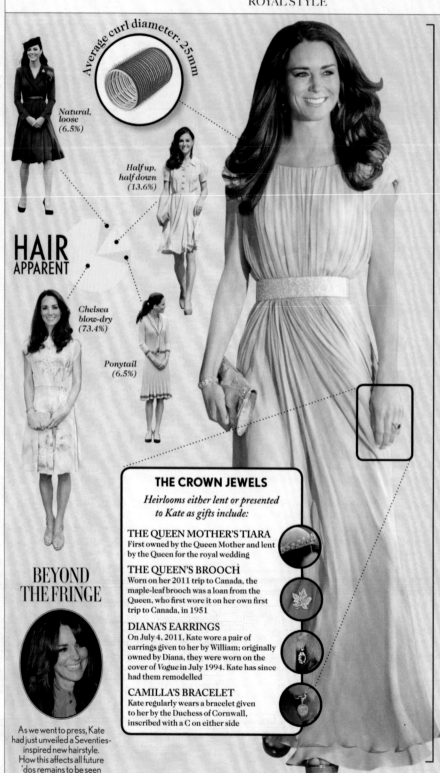

*Average curl diameter: 25mm*

*Natural, loose (6.5%)*

*Half up, half down (13.6%)*

# HAIR
## APPARENT

*Chelsea blow-dry (73.4%)*

*Ponytail (6.5%)*

## BEYOND THE FRINGE

As we went to press, Kate had just unveiled a Seventies-inspired new hairstyle. How this affects all future 'dos remains to be seen

### THE CROWN JEWELS

*Heirlooms either lent or presented to Kate as gifts include:*

**THE QUEEN MOTHER'S TIARA**
First owned by the Queen Mother and lent by the Queen for the royal wedding

**THE QUEEN'S BROOCH**
Worn on her 2011 trip to Canada, the maple-leaf brooch was a loan from the Queen, who first wore it on her own first trip to Canada, in 1951

**DIANA'S EARRINGS**
On July 4, 2011, Kate wore a pair of earrings given to her by William; originally owned by Diana, they were worn on the cover of *Vogue* in July 1994. Kate has since had them remodelled

**CAMILLA'S BRACELET**
Kate regularly wears a bracelet given to her by the Duchess of Cornwall, inscribed with a C on either side

## VITAL *statistics*

### 178
Kate's height in cm, without heels

### 888
Diamonds in the Cartier tiara she wore at her wedding

### 6:1
Most commonly seen arm-to-sleeve-length ratio

### 23
Estimated (pre-pregnancy) waist measurement in inches

### 8.6
Average number of teeth exposed when smiling

### 42
Percentage of engagements on which she has worn a boat neck

# Future Perfect

*From* **Katepedia** *by Lisa Armstrong*

'It's possible to detect that Kate is partial to a three-quarter-length sleeve – all the better to display the royal wrist-bling and fend off speculation about whether the royal arms have become too skinny – and that, pre-pregnancy, she was fond of fitted dresses with fluid and, increasingly, pleated skirts. Just like the three-quarter sleeve, pleats are a demure but youthful solution for a 30-year-old woman having to walk a tightrope between frumpy and the cover of French *Closer*. Personally, I loved the slim navy Erdem dress she wore in Canada and the taupe Alexander McQueen dress with its Sophie Hallette French lace, that she wore to a jubilee luncheon in June. But ooh, she looked thin in a pencil skirt and every minuscule crease sparked another is-she-or-isn't-she furore.

Furores? According to Roland Mouret, Kate doesn't even want to provoke a frisson if she can help it. "She's highly attuned to those details that will provoke a tabloid frenzy and above all she *does not* want a tabloid frenzy." The long white Roland Mouret showstopper she wore to the Thirty Club annual dinner at Claridge's in May with some sexy Jimmy Choos (finally, cheered the front row) was, by royal request, cut slightly looser than the sample. "That split was interesting," he says, "She hadn't worn one before. She doesn't seem to feel the need to dress sexily to woo the world. She's dressing for William and for herself." So the split? Harmless according to Mouret. And with its high neckline and long sleeves, entirely appropriate. "She doesn't want a bottom situation like Pippa had."

Increasingly, her skirts are waftier and skimmier; she's all but jettisoned that odd mid-thigh length she and Pippa unwisely loved and which used to make her outfits look as if something had accidentally been missed off. The necklines are simpler, too, usually curved boat necks – much better with all that hair than those dowager shawl and rolled necklines. She has a weakness for shimmery pastels, particularly pale pink (because what Home Counties girl doesn't?), and how lovely did she look in that blush Jenny Packham flowy sequinned dress, which she wore to wow Hollywood in 2011?

**The Duchess of Cambridge, 2013.**
Fashion for fashion's sake? As one friend remarked: 'She wants to continue dressing herself; she likes her style, and she doesn't want someone changing it.' Adding, 'She's also wary of being cited as a style icon.' Despite her best efforts, she just can't help it. Britain's most powerful royal influencer *non pareil*.

**The Duchess of Cambridge, 2013.**
**The Duchess of Cambridge, 2013.** When did 'The Kate Effect' first take hold? Possibly when that Issa engagement dress and its myriad copies flew off the shelves. But true aficionados point to 2002 and that undergraduate charity catwalk moment, with the sheer-to-actually-see-through strapless dress by fashion grad Charlotte Todd. It was an unusual item. It was meant only to be a skirt, but the future Duchess stretched its possibilities and it became, in effect, a mini dress. 'Wow, Kate's hot!' audience member Prince William reputedly exclaimed. Many years down the line, the Duchess of Cambridge has become the contemporary standard by which a more understated elegance is measured.

I used to marvel at the hats before she got engaged – no one had worn a hat like that since the late Princess of Wales dispensed with them 20 years ago. She's brilliant in millinery – good Marlborough College training – especially the tilty kind that perches to the right of the royal "do" at a 50-degree angle, thus emphasizing her cheekbones.

Pre-pregnancy, she never failed to accentuate her tiny waist. Although as one (anonymous) designer points out, she favours a slightly raised waist because – they claim – she has a long body and relatively short legs. What? Short legs? Kate Middleton? I looked and looked again. And blow me down, the designer's absolutely right – her dresses all sit a centimetre or two above her natural waist. I can't vouch for the long body. That's how successful the raised-waist tactic is. Memo to self. And isn't a raised waist useful in throwing the press off the scent in the early stages of pregnancy? If it hadn't been for the nausea and the alcohol abstinence, she could have spun it out for weeks more.

Our future queen seems to have an eye for what really works with her body shape as well as a handy practicality gene. (On an official engagement with her father-in-law last spring she looked on in amusement while he gazed quizzically at an iron, until she eventually showed him how this mysterious implement worked. "Don't laugh at me," he was overheard affectionately reproving her.) Both skills will probably hold her in better stead than *bona fide* fashionista status...

Why do you like her, I asked a group of teenagers gathered round my kitchen table in various states of Rihanna dress. Simple question. Not so simple answers. "Because she's not trying to be cool." "Because she always looks nice." "Because she's not flashing her crotch." "She looks demure. That's quite exotic." "Nice hair."

They're probably never going to dress like the Duchess of Cambridge, these cool London girls. They don't need to trouble their tousled heads about whether their skirt will fly up when they curtsey or what an asymmetric shoulder means in Tonga. But should they ever find themselves going to a Van Cutsem-type society wedding, they'll know just what to crib. I can't see them wearing flesh-coloured tights. Mind you, in Kate's position they're probably a godsend on knife-slicingly cold days when what an outfit really needs is bare legs. But lots of teens seem to find this sweetly modest alternative to the hyper-sexualised images that surround them reassuring...

Perhaps with her traditional way of dressing and her beautiful posture, the Duchess of Cambridge has hit on something peculiarly modern.' *February 2013*

## ANATOMY OF A DRESS

DESIGNER: ISSA

NAME: DJ57

COLOUR: KNIGHT

PURCHASED: FENWICK
between August and November
2010, by Kate Middleton herself

### AVAILABILITY
The dress has since become
a collection staple. It was
recut in 2011, and sold
out nationwide on its first
day on sale

PRICE TODAY:

# £415

## ROYAL SUITCASE

### 103 ITEMS  VS  61 ITEMS

For her 17-day tour of Australia
and America in 1985, Diana's
suitcase included…

For her eight-day Far East tour,
Kate's 18 looks for her royal
engagements included…

| Diana | Kate |
|---|---|
| **20** DAYTIME OUTFITS | **16** DRESSES |
| **19** PAIRS OF EARRINGS | **13** PIECES OF JEWELLERY |
| **15** PAIRS OF SHOES | **9** PAIRS OF NUDE TIGHTS |
| **15** BAGS | **5** PAIRS OF SHOES |
| **12** EVENING DRESSES | **6** CLUTCHES |
| **12** HATS | **4** BELTS |
| **8** NECKLACES | **3** TOPS |
| **2** TIARAS | **2** SCARVES |
| | **2** PAIRS OF TROUSERS |
| | **1** SKIRT |

**AVERAGE OUTFIT COST ON TOUR** (IN TODAY'S PRICES)
**£4,270**

**AVERAGE OUTFIT COST ON TOUR**
**£1,427**

### FASCINATOR ANGLE-O-METER

50°

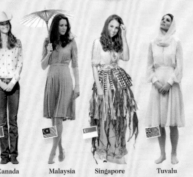

Canada    Malaysia    Singapore    Tuvalu

## KATE ON TOUR

# The Debonair Duchess

*From* **HRH** *by Alexandra Shulman*

'That morning, as we all gathered in a bare house, which would once have been two farm cottages, with 10 suitcases of clothes, a van-load of props including furniture (in the end mainly not used), and several wood-burning stoves on the go, there was a mixture of silently contained excitement and a certain amount of tension. This was not just another *Vogue* cover shoot

We drank coffee and everyone prepped until the Duchess arrived, in jeans and a parka, her hair in big rollers, with a bright, inclusive smile. She walked through the small door with her hairdresser Amanda Tucker, who was dragging a wheelie case of products. The Duchess joked about how she must appear to anyone who saw her driving her car in her rollers, before introducing herself.

Although the Duchess of Cambridge is one of the most photographed women in the world, she is not entirely comfortable at the end of the lens, nor as the centre of attention, and throughout the whole mood was very low-maintenance. Make-up artist Sally Branka's work was slightly different to what the Duchess usually does for herself and it was a measure of how easy-going she is that she trusted Sally – scarcely even checking herself in the mirror afterwards. Most of us would fuss about our skin or our lines or whether we looked thin or fat or in some way wrong and would need constant reassurance, whereas she had none of these neuroses, which showed an admirable lack of vanity.

The Duchess sifted through the clothes on the rails, laughing at some of the options, overlooking the three evening gowns we had brought just in case.

Miraculously, the early fog had completely burnt off by the time we took the first picture and a brilliant winter sun stayed with us all day.'
*June 2016*

**The Duchess of Cambridge, 2016, by Josh Olins.**
'The Duchess of Cambridge was the perfect cover star for our 100th-birthday issue for a number of reasons,' recalled Creative Director Jamie Perlman. 'She had never been photographed for a magazine before, so this was a very special coup for us. She is not only universally loved, but is also symbolic of the future of England. Putting her on the cover for our anniversary issue felt like a nod to *Vogue*'s bright future, not just looking back at its rich history.'

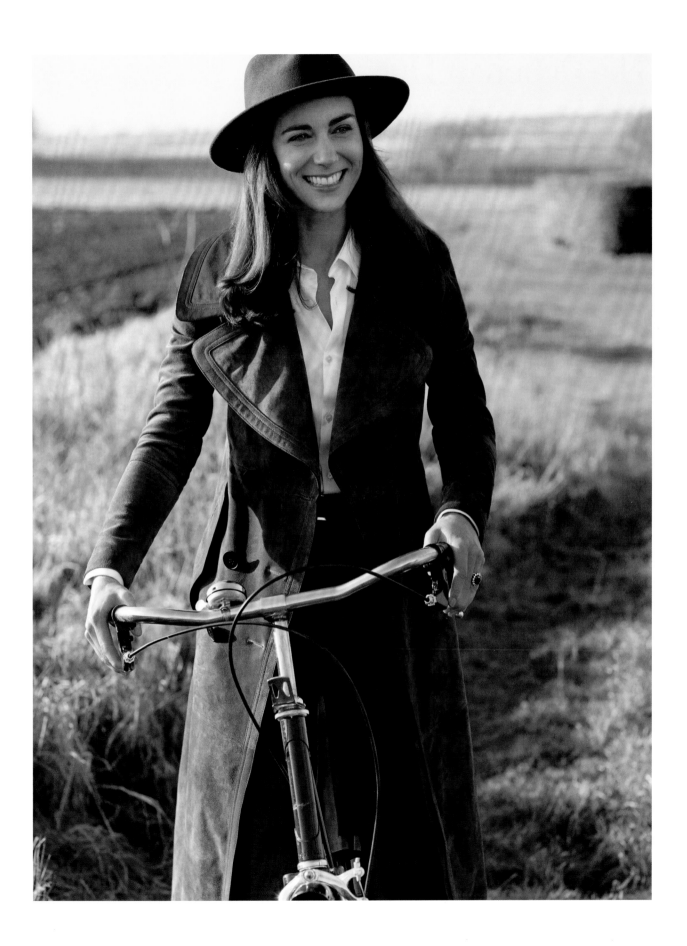

**The Duchess of Cambridge, 2016, by Josh Olins.** The shoot took place on a misty January morning, which cleared into bright blue skies. (*Right*) With the family's cocker spaniel Lupo as co-star, the Duchess wears dungarees by AG Jeans and sweater by Claudia Schiffer for TSE; (*below*) Her shirt is by Cabbages and Roses and (*below right*) by Burberry with jeans by 7 For All Mankind. The clothes gathered for the day were based upon what the Duchess would choose to wear off-duty: jeans, shirts, T-shirts. 'The same as the rest of us,' said *Vogue*.

**The Duchess of Cambridge, 2016, by Josh Olins.** The Duchess, herself accomplished with a camera, was keen to give the commission to a British photographer for whom this would be a new opportunity. 'We're all about the same age; it was all very comfortable,' said Olins. 'It was a fun day for everyone.' (*Left*) The Duchess's top by Petit Bateau and trousers by Burberry. (*Above*) Her vintage hat is from Beyond Retro. From the outset, it was clear that the pictures were to be of the woman rather than a figurehead and they would be as easy-going as possible. The day became one of unexpected informality.

# Photographer Royal

Snowdon's first royal photographs were taken in 1956 when he was plain Tony Armstrong Jones. His last photograph of the Queen, by then his former sister-in-law, was taken in 2010. But it was another Photographer Royal who lit a fire under him. 'He'll never succeed,' said Cecil Beaton. He had called upon Beaton, a friend of his uncle, for a step up the ladder. Instead, Beaton sought to demolish it rung by rung.

Of course, Armstrong Jones did succeed. In his spare time he was out on the streets of London, making pictures of shopkeepers and passers-by. He moved among them with ease. And then *Vogue* came calling. By 1956, he was the magazine's new star, while Beaton's had waned. When he married Princess Margaret, becoming the first Earl of Snowdon, Beaton seethed. 'Thank you, ma'am,' he said to Princess Margaret, 'for ridding me of my most *admired* rival.' Her reply confirmed his worst fears: 'What on earth makes you think Tony's going to give up?'

Snowdon's earliest royal coup for *Vogue* was his first sitting with Lady Diana Spencer, taken at the end of 1980: pre-engagement portraits when few knew an engagement was imminent. But by then all Beaton's fears were as naught. He had died several months earlier.

**Lord Snowdon, 2007, by Julian Broad.**
In his studio, holding a camera fashioned from old Schweppes tonic water cans and acquired in India. (*Below*) Snowdon's loupe for looking at photographic transparencies.

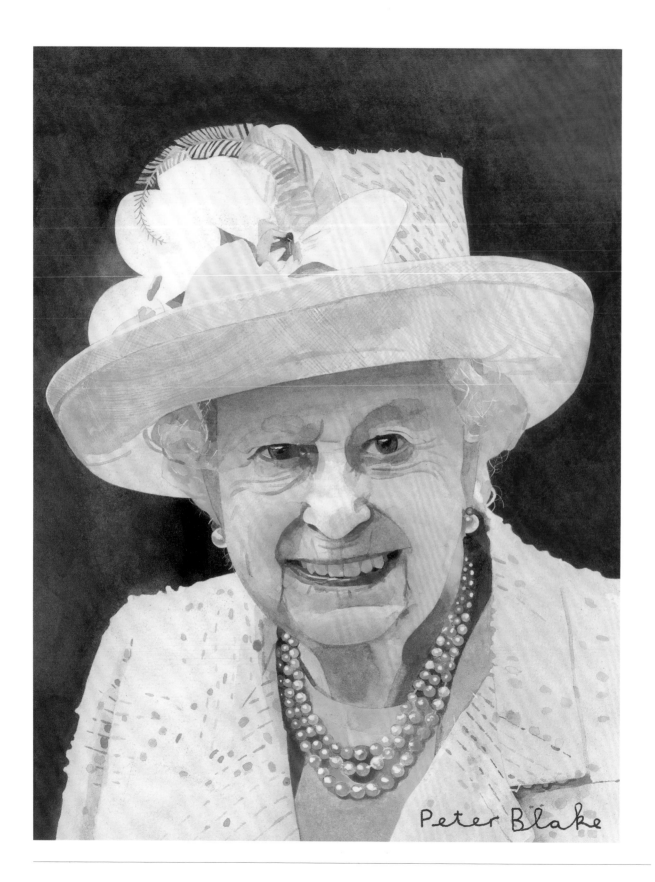

Peter Blake

# The Image of a Queen

*From* **Mrs Windsor** *by Zadie Smith*

'When writing about the Queen, I don't think there's much point in pretending you are discussing a real person. I can't claim to be speaking for a particular British woman, aged 91, mother of four, bearing the last name Windsor and so on. That person is a stranger to all but her family and friends – and perhaps even to them. We can only speak of the Queen as she appears in the minds of the people. And the thing that has always struck me as deeply odd about the idea of Elizabeth II is the fact that she appears, in our mental picture of her, to be distinctly lower middle-class. It's strange: all her children are recognisable aristocratic types; her grandchildren aw'fly posh. Yet around the Queen there hangs this persistent aura of Mrs Windsor. Consider it: did ever a monarch seem more likely to prefer a nice flowery pelmet curtain to a white wooden shutter? Or a staycation (in front of the telly) to a glamorous Tuscan retreat or Caribbean break? Did any resident of Buckingham Palace – replete as it surely is with bone china and silver serving dishes – ever before have breakfast delivered to them in airtight plastic Tupperware alongside a copy of the *Racing Post*? There is no precedent for such a monarch in either our history books or our fairy tales. The reign of Elizabeth II has been marked not by grandeur and imperiousness – as it was with the first Elizabeth – but by a quality of intense familiarity, the by-product of the unprecedented replication of her image, for she is of course the most photographed Queen in history.

Since childhood, I have watched news footage of her sitting down to tea in the houses, flats and bungalows of her "subjects", or by their hospital beds, or suddenly appearing in the middle of their local tragedies or sporting events, and I have yet to see any citizen of the kingdom remotely surprised to find their Queen amongst them.

**Queen Elizabeth II, 2017, by Peter Blake.**
'I was determined,' said *Vogue*'s new editor Edward Enninful, 'that my first issue would be a true celebration of Britain. But what should such a celebration look like in 2017? This is a country built on tradition...' He commissioned Sir Peter Blake, one of Britain's greatest living painters, to make this buoyant portrait of the world's longest-serving monarch and the world's oldest-living monarch. Blake's fascination with Hollywood films and the ephemera of American popular culture has always been balanced by an equal enthusiasm for British tradition and motifs drawn from the nation's heritage. He made several studies of the Queen, including a portrait to celebrate her 90th birthday, and was knighted in 2002.

'On public duty,' observed *Vogue* in the Queen's Diamond Jubilee year, 'her guard is up, her clothes formal, her jewels dazzling. In private she becomes the ordinary countrywoman she is. She wears a tweed skirt and cashmere twinset like any other Fifties woman of her milieu – and she likes to be out of doors as much as possible.' It is her very ordinariness – in the sense of normality – that is perhaps her greatest strength. She is unchangeable, immutable, present and, as it would seem, permanent.

Not that she can't be queenly, in her own way. But her imperiousness – such as it is – takes the lower middle-class form of "taking a dim view", which is also, I think, the root of her (inadvertent?) comedy, for the dryness with which she tends to take her dim views is often funny. She took a dim view of Silvio Berlusconi bellowing at a G20 summit ("What is it? Why does he have to shout?"), as well as to being asked, that very same day, to smile for a photograph ("is this supposed to be a happy event?"). She takes a dim view of the TV show *Bargain Hunt* – finding it "slightly vulgar", preferring *Antiques Roadshow* – and a dim view of her own fondness for *The Bill* ("I don't like it but I just can't help watching it"). Her history of tacit disapproval goes back a long way, including such varied items as her sister's celebrity friends, several humourless prime ministers, people who don't like dogs or horses, crowds of folk weeping outside her house, overly complicated meals, and, of course, overwrought daughters-in-law.

*There is no precedent for such a monarch in either our history books or our fairy tales.*

Thus, things upon which we are informed she looks kindlily are equally telling: *EastEnders*, cornflakes, most cakes, gin, Dubonnet (but no fancy wines and nothing gourmet), TV quiz shows and *Question Time* (but only if there's a good bust-up), *Benny Hill* re-runs and Royal Variety shows (as long as she doesn't have to leave the comfort of her sofa to watch one). For this Queen the category of literature is described – and fulfilled – by the collected works of PG Wodehouse. She likes to name a dog "Susan" and a horse "Peggy". But at this point you will protest. Dogs! And horses! But instead of the Queen of the hunt flushing a fox out of the covert, majestic cape flying behind her, I'm pretty sure the Queen you have in your mind is the one who puts a fiver on the 3.15 at Goodwood, just like your own grandmother.

And instead of greyhounds and borzois or even a pretty King Charles spaniel, of all the dogs available in the empire, Elizabeth II opted for the squat little corgis with their stubby legs, bush tails and uninspired faces, who are the very doggy definition of "nothing to see here". Put it all together and you can see why, where poets of the first Elizabethan age immortalized the majesty of their monarch, the writers of this one have intuited the suburban spirit of the Queen and made much lightness from it.'
*December 2017*

# Making a Mark

*From* **The Meaning of Meghan** *by Afua Hirsch*

'In 1862, the British newspapers were buzzing with news of a royal wedding – of sorts – that was unlike any other that people could remember. The bride was the goddaughter and ward of Queen Victoria – newsworthy in itself. But the fact that Sarah Forbes Bonetta was a black woman elevated the event to something sensational.

It seemed the chattering classes were fascinated not just by the bride herself, but by the presence of so many black guests at the church in Brighton where they wed. There were, one newspaper exclaimed, "white ladies with African gentlemen, until all the space was filled".

Even today, people remain fascinated. "Will Meghan Markle's mother be displaying her dreadlocks in Windsor?" one commentator asked. What else would she do, I thought? It's hard to forget about Meghan's mother's hair, because when news of the royal engagement was first broadcast, the newspapers kept discussing it. There were also questions about whether Harry would be popping in for tea in "gang-scarred" Compton – the LA neighbourhood where Meghan grew up – and the description of Markle's blood as "exotic".

Sometimes, it almost feels as if it could still be the 1860s, when the British press pulled off a similarly ironic feat of congratulating itself for being so tolerant as to allow "natives of a distant continent" at an English wedding, all the while banging on about "Negroes" this and "civilization" that – fairly good evidence that the couple's race was, most definitely, an issue.

When Meghan and Harry's wedding was announced, I was surprised by the need to explain that she will not be the world's first black or brown princess. Apart from England's own potential precedents, it had not occurred to me that anyone

**Meghan Markle, 2018, by Peter Blake.**
The future Duchess of Sussex in the month of her wedding to Prince Harry. Long before the couple decided to step away from royal duties, *Vogue* was entranced with what was, while anticipating what might be: 'The Meghan Markle fairy tale involves a humble background, a handsome prince and a wardrobe so relatable it could add £1 billion to the British fashion economy…'

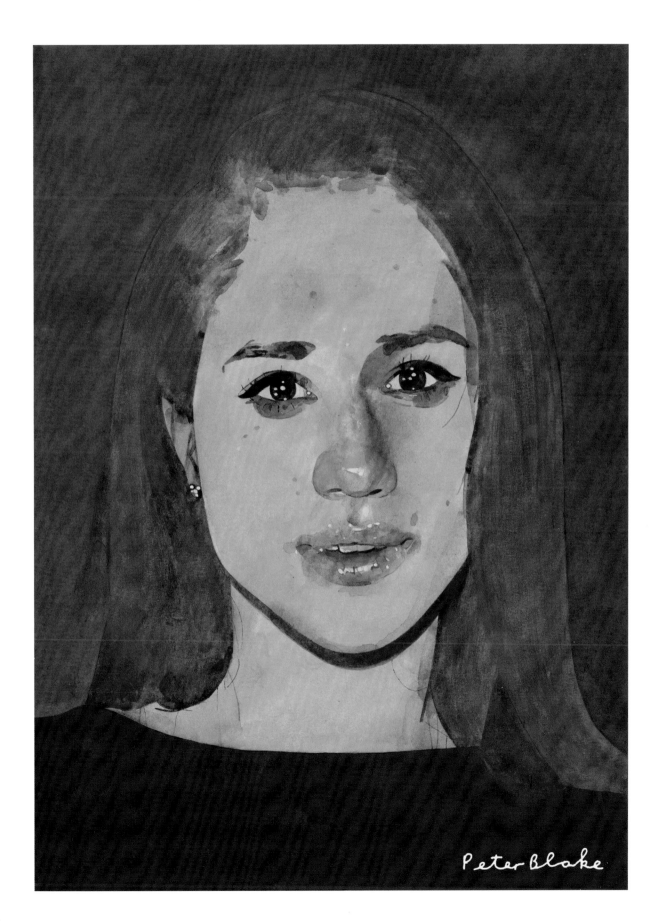

Peter Blake

needed reminding of the countless kingdoms, empires and royal families that have existed and survive across the world in palaces where people are not white. But in Britain, it seems, a princess – or a duchess, as Meghan Markle will be – is still regarded as something intrinsically to do with whiteness.

I have no idea whether she – or anyone – can truly be prepared for the realities of the institution she is entering. But Meghan has already done so much for us. She has served as a key to unlocking things in our own society that have remained hidden in plain sight. The long history of blackness in Europe that is now finally becoming mainstream. The personal experiences of race and identity that other high-profile people in this country so often shy away from discussing, but which she has so openly addressed.

"While my mixed heritage may have created a grey area surrounding my self-identification, keeping me with a foot on both sides of the fence, I have come to embrace that," she has explained. For myself, growing up as a mixed-race woman in a part of Britain where that placed me firmly in the minority, Meghan's tales of the awkwardness of growing up the mixed girl in a white neighbourhood were powerfully resonant with my own.

I am not alone in relating. Britain has the greatest number of interracial relationships of any country in western Europe, and a rapidly growing mixed-race population. As the face of Britain changes, would it have been sustainable for the Royal Family to remain, as they largely have in recent years, an entirely white institution?

We all project ourselves on to the Royal Family. In one sense, that is their role. They are symbols of who we are as a nation, arbiters of belonging and, for some people, love for them is a test of patriotism and commitment. At the same time they are a blank canvas on to which we, as British people, paint our feelings, fantasies, fears and identities.

There is no escaping the significance of this royal wedding, whether as historic journey into the ritual of British pageant and tradition, joyous statement against British isolationism, declaration of the irrelevance of a divorce – the legacy of Wallis Simpson redeemed – a radical step toward diversity and a true reflection of modern romance, or even a simple party to warm the heart of troubled Brexit Britain. This royal wedding is whatever you want it to be, but the one thing it is is unparalleled.' *June 2018*

**Meghan Markle and Prince Harry, 2018, by Samir Hussein.**
In March 2018, Prince Harry and Meghan Markle made a visit to Northern Ireland, where among other engagements they visited a youth-led peace-building initiative at Lisburn, which the Prince had launched the previous year. Markle wore a cream sweater by Victoria Beckham and a pale pink coat from Mackage.

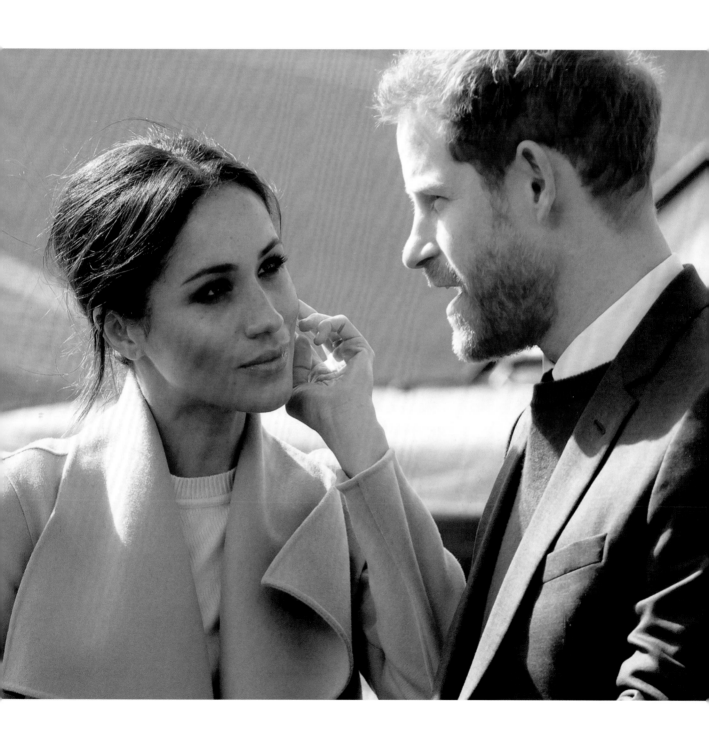

# All Change

*From* **Guest Editor's Letter**
*by HRH The Duchess of Sussex*

'It was in early January, on a cold and blustery London day, that I sat down for a cup of tea with British *Vogue*'s editor-in-chief, Edward Enninful. Though we have several mutual friends, our first encounter had been years in the making, the impetus for which was my asking him to support an organisation I strongly believe in called Smart Works.

What evolved over the next hour was a promising pow wow of two like-minded thinkers, who have much in common, including our love of writing. Over a steaming cup of mint tea, we teased through how one can shine light in a world filled with seemingly daily darkness. Lofty? Of course. Worth it? Without question.

Within hours of our meeting's end, we were already texting one another – philosophising about how to communicate this shared understanding and the lens through which we see the world, how to pivot from a perspective of frustration to one of optimism.

So I asked the question. Actually, I typed and deleted the question several times until I built up the courage to ask the question in question.

"Edward... instead of doing the cover, would you be open to me guest editing your September issue?"

(Mind you, I know how important the September issue is for the fashion industry. I realise the reach, and I see the opportunity to be a part of fashion's push for something greater, kinder, more impactful. But I am also a little nervous to be boldly asking the editor-in-chief, whom I'd only just met, to take a chance on me.)

I sent the text.

...

The ellipsis... the "dot dot dot" that inspires the greatest practice of patience in this digital era.

And then it appeared, EE's reply: "Yes! I would love for you to be my guest editor."

**'Forces for Change' September 2019, by Peter Lindbergh.** Guest edited by the Duchess of Sussex, this was the fastest-selling issue in *Vogue*'s history. The cover and inside pages featured 15 game-changers, activists, artists, politicians, campaigners set to re-shape society in positive ways, from Jane Fonda to Greta Thunberg, Jacinda Ardern to Adwoa Aboah. With meticulous planning, the shoot by Peter Lindbergh took place over three continents that summer: 'All the women were different, but they each had something special,' he said. 'It's a monumental moment and a real coup,' said editor Edward Enninful, 'I am so thrilled and honoured Peter could capture the true personalities of our 15 forces for change.'

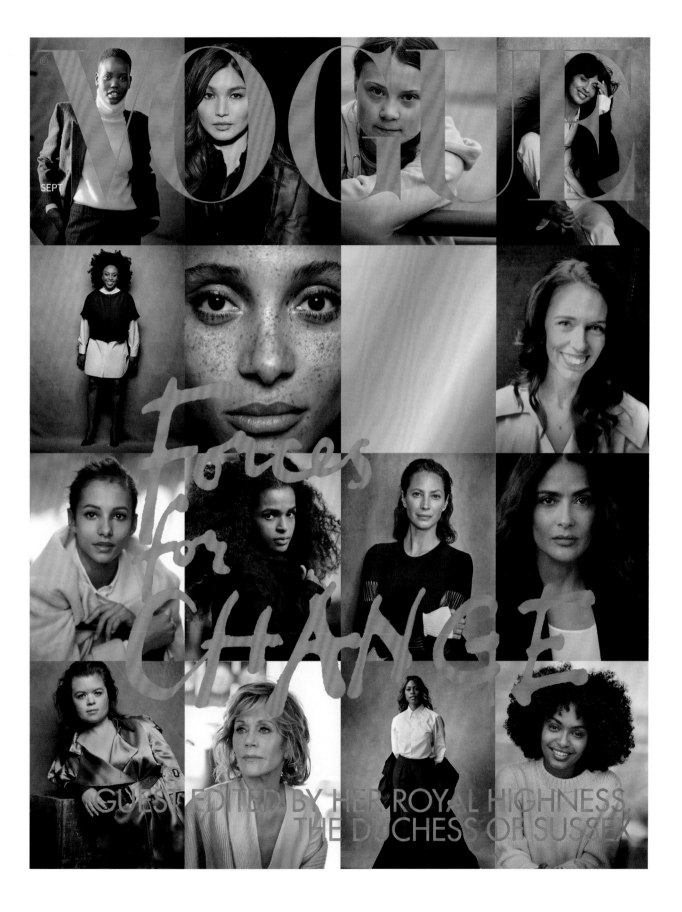

VOGUE

SEPT

Forces for CHANGE

GUEST EDITED BY HER ROYAL HIGHNESS
THE DUCHESS OF SUSSEX

Sitting on my sofa at home, two dogs nestled across me, I quietly celebrated when the words appeared on my screen.

Within a week, Edward and I were having our regular meetings – discussing goals, ideas, who would feature on the cover, all while I was undergoing a crash course in editorial lingo ("the well", meaning the inner crux of the book) and acronyms aplenty ("FOB", which I took a stab at being "front of book"). I was trying to blend in, to keep up with the pace of these seasoned professionals, and to learn as much as I could as quickly as possible.

There were facets I felt were of prime importance to include within this issue – elements that would hopefully set the tone, knowing this issue hits stands in August, just as readers gear up for the September fashion shows, where judgement can become clouded and focus skewed toward the superficial. I had read a book many moons ago called *The Four-Chambered Heart*, by Anaïs Nin, which had a quote that has always resonated with me: "I must be a mermaid, Rango. I have no fear of depths and a great fear of shallow living." For this issue, I imagined, why would we swim in the shallow end of the pool when we could go to the deep end? A metaphor for life, as well as for this issue. Let's be braver. Let's go a bit deeper.

That's what Edward and I have aimed to achieve. An issue of both substance and levity. It is, after all, the September issue of British *Vogue*, and an opportunity to further diversify what that typically represents. Throughout these pages you'll find Commonwealth designers, ethical and sustainable brands, as well as features with designers not about clothes but about heritage, history and heirloom. You'll also find a beauty section that puts its energy towards internal beauty, celebrating the power of breathing and meditation, and a favourite workout that urges you to use your heart as much as your core.

As you flip the pages, you'll find familiar faces and names that I hope you get to know a bit better, a bit more deeply, even. And there are less familiar names that you may want to know, such as the women of Luminary Bakery and Tessa Clarke, co-founder of food-sharing app Olio, whom I met with discreetly last year.

There are inspiring reads from Brené Brown and Jameela Jamil. You'll also find a very special piece with Dr Jane Goodall, interviewed by my husband, and a candid and heartfelt conversation between myself and the extraordinary Michelle Obama.

More than anything, this issue is about the power of the collective. In identifying our personal strengths, it is anchored in the

knowledge that we are even stronger together. You will find that spirit of inclusivity on the cover: diverse portraiture of women of varying age, colour, creed, nationality and life experience, and of unquestionable inspiration. Some, I've had the pleasure of meeting and enlisted personally for this issue, others I've admired from afar for their commitment to a cause, their fearlessness in breaking barriers, or what they represent simply by being. These are our forces for change. And among all of these strong women on the cover, a mirror – a space for you, the reader, to see yourself. Because you, too, are part of this collective.

There is one caveat for you to remember: this is a magazine. It's still a business, after all. I share that to manage expectations for you: there will be advertising sections that are requisite for every issue, so while I feel confident that you'll feel my thumbprint on most pages, please know that there are elements that just come with the territory. The overall sentiment I hope you'll find, however, will be one of positivity, kindness, humour and inclusivity.

I was about five months pregnant when this process began, and by the time you hold this issue in your hands, my husband and I will be holding our three-month-old baby boy in ours. It's a very special time for me personally, on so many levels; working with Edward and his team, both during

my pregnancy and my maternity leave, has played no small part in that joy – it has been a privilege to be welcomed and supported by this amazing team. To Edward, thank you for entrusting me with this. I am deeply honoured. To the women who have taken my aspirations for this issue and brought them to life by being a part of this time capsule, both on the cover and in-book, I am so grateful; you are inspirations to me and I'm humbled by your support.

And to you, the reader, thank you – and I hope you enjoy…'
*September 2019*

**Prince Harry and Meghan Markle at Kensington Palace, 2017, by Steve Back.** Prince Harry announced his engagement to Meghan Markle on 27 November 2017, at the Sunken Garden, Kensington Palace, where nearly four years later, he would unveil with his brother a statue of their mother, Diana, Princess of Wales. Although the couple's first official public appearance was at the Invictus Games in Toronto in September 2017, news had begun to leak out earlier. When in October 2016 Markle posted on Instagram an image of two bananas cosily clinging together and annotated in felt-tip pen, it was assumed to be a coded acknowledgement. Both parties were unprepared for the degree of scrutiny now visited upon Markle on a near daily basis.

As a television actress of prominence in the United States, she was perhaps expected to treat the onslaught with a polished nonchalance. This was not the case; she admitted to previously leading a quiet life away from 'tabloid culture'. 'I think we were just hit so hard at the beginning with a lot of mistruths,' she told the BBC, 'that I made the choice to not read anything, positive or negative. It just didn't make sense and instead we focused all of our energies just on nurturing our relationship.'

They married in May 2018. In the spring of 2020, now the Duke and Duchess of Sussex, they decided to settle in California and step away from royal duties.

# Sisterhood

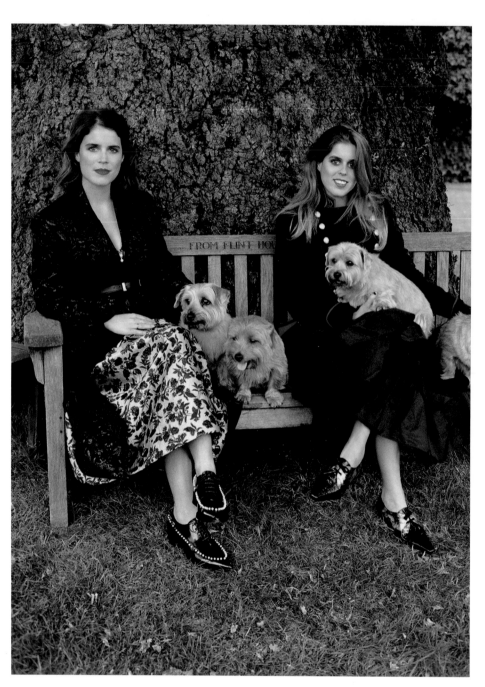

**←→ Princesses Beatrice and Eugenie, 2018, by Sean Thomas.**
Growing up in the glare of the media spotlight, the daughters of Prince Andrew and Sarah, Duchess of York, know much about press scrutiny. They profess a desire only 'to shine light and love in the world.' And of course they have each other: 'We're the only other person in each other's lives who can know exactly what the other one is going through.'

Shining light and love has taken the form of multiple charitable roles and patronages, many with snappy names and direct messages. Big Change encourages young people to develop skills beyond the traditional academic structure; Be Cool, Be Nice campaigns against bullying; Project Zero aims to banish single-use plastics. The pair also have 'day jobs' (receiving nothing from the Sovereign Grant). Eugenie is a director of the Hauser & Wirth group of art galleries and Beatrice is a vice president at Afiniti, a technology company developing the scope of artificial intelligence.

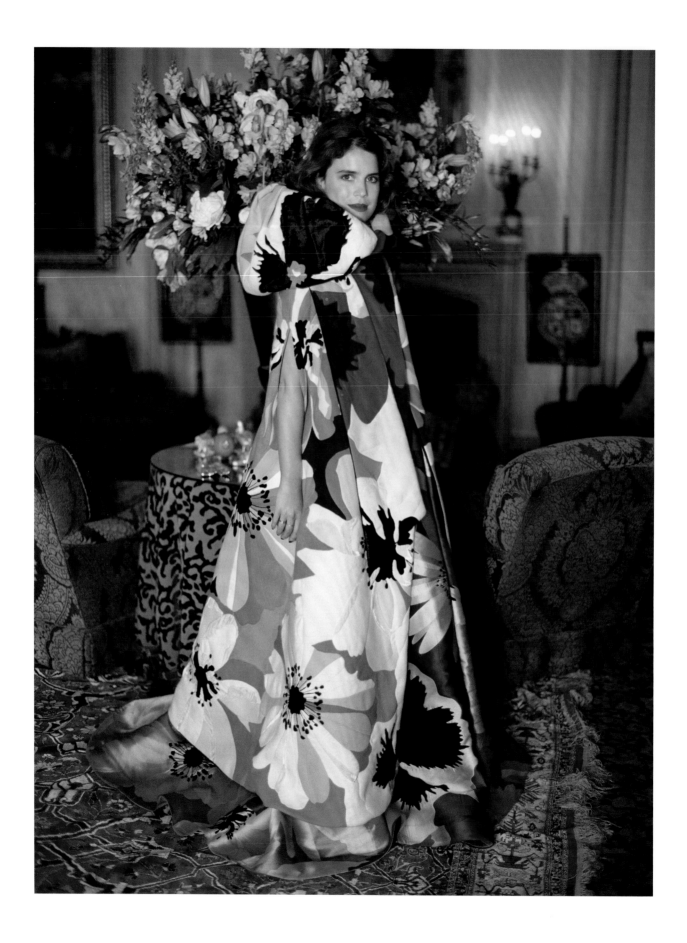

**Princess Eugenie,
2018, by Sean Thomas.**
The Princess wears a hooded
wool cape and silk dress
from Valentino. Both sisters
are interested in fashion but
inevitably their (rare) missteps
have garnered the most
attention. Commendably,
Beatrice turned 'Pretzel Hat
Gate' – the comparison of a
Philip Treacy creation worn to
Prince William's wedding
to a knotted baked pastry –
into a positive by auctioning
it for charity and raising
£81,000. On their shoot, the
sisters were understandably
hesitant about the more
exuberant confections,
but unreservedly
applauded them.

*From* **Between Sisters** *by Ellie Pithers*

'In a year of milestones (Beatrice turned 30 in August), the sisters felt it was the right time to "share our world", as the younger York puts it, with its mix of unique demands as well as the common-or-garden concerns that come with being a twenty-something woman in 2018: navigating a work-life balance, falling in love (and out of it), trying to be a good daughter, a good sister, a good friend. "We want to show people who we are as working, young, royal women, but also not to be afraid of putting ourselves out there."

"Out there", in its most literal sense, is a good way to describe the York sisters. They are unusual in that they have bona fide careers in addition to their royal obligations and philanthropic ventures to keep them frantic-levels of busy. Beatrice, who is vice-president of partnerships and strategy at Afiniti, a US-based technology company that uses AI to improve call-centre service, has just arrived from New York, where she lives half of the time. In the past fortnight she has chaired a Women in Leadership round table in Sydney and spoken about AI on a panel in Canada. Eugenie, who is an associate director at contemporary art gallery Hauser & Wirth, has been at Art Basel all week.

Then there is the gang of friends to keep up with: Friday night saw Beatrice at Annabel's and Eugenie attempting to go incognito at a Beyoncé and Jay-Z concert. Both activities made the papers. How intrusive do they find the press? "It was quite funny because the headline was totally contradictory, something like: 'Eugenie gets spotted and is unrecognizable at Beyoncé'," says Eugenie, wryly. "Growing up in the media, it's... interesting." She chooses her words carefully. "We've had some serious grounding from our parents. They've had their fair share of terrible media interest and it makes us stronger." She pauses. "We believe very strongly in who we are, and the support system of our friends and our family is pretty incredible. There's no point being angry with anyone for beating us up – we just need to shine light and love in the world."

"It's hard to navigate situations like these because there is no precedent, there is no protocol", Beatrice says. "We are the first: we are young women trying to build careers and have personal lives, and we're also princesses and doing all of this in the public eye."

"We're each other's rocks," says Eugenie. "We're the only other person in each other's lives who can know exactly what the other one is going through."' *September 2018*

# Sense and Sustainability

From **Royal Wisdom** *Edward Enninful interviews the Prince of Wales*

'**Edward Enninful: Your Royal Highness, I am delighted and honoured to be talking to you today. I wanted to begin by asking you about your own commitment to sustainable fashion. Your mantra is, "Buy once, buy well." Have you always taken this approach to your own wardrobe?**
**HRH The Prince of Wales:** Well, I'm one of those people who hate throwing anything away. Hence, I'd rather have them maintained, even patched if necessary, than to abandon them. The difficulty is, as you get older, you tend to change shape, and it's not so easy to fit into the clothes. I can't bear any waste, including food waste; I'd much rather find another use. Which is why I've been going on for so long about the need for a circular economy, rather than a linear one where you just make, take and throw away – which is a tragedy, because inevitably we over-exploit natural resources that are rapidly depleting.

**This pandemic has been a chance for all of us to reflect and find a new normal. What does this new normal look like to you? Is there anything you'd do differently going forward?**
Well, I rather hope it will accelerate awareness of what we need to do in order to rescue our world from disaster. We need to understand that nature and everything on this planet is interconnected; you cannot do one thing without having an impact somewhere else. We don't realise half the time that what we're eating has been produced in a way that is causing mammoth pollution, which ends up in the sea. It's all out of sight and out of mind, but it's creating dead zones in the ocean. Therefore, we have to clean up our act. But it can be done. There are wonderful things going on, but we need to scale up. This is why I've got the Sustainable Markets Initiative going – to try to build a global alliance between business and banking and investment and consumers. Because the consumer has immense power in deciding

**The Prince of Wales at Highgrove, 2020, by Nick Knight.**
Fashion editor Kate Phelan's first-hand account: 'A pocket handkerchief and a cornflower in his button-hole were little details that said a lot about him. They almost told stories. Prince Charles's clothes seem to match the flowers. Sweet peas brought out one colour in his shirt, and hydrangeas another. He has incredible personal style; it's so individual and a little bit eccentric without being stuffy. He knows all the tricks of how to preserve and look after clothes. His jacket, in particular, is a work of art. He has had it repaired, with binding added to the lapels and new cuffs added on, then gently rolled back.'

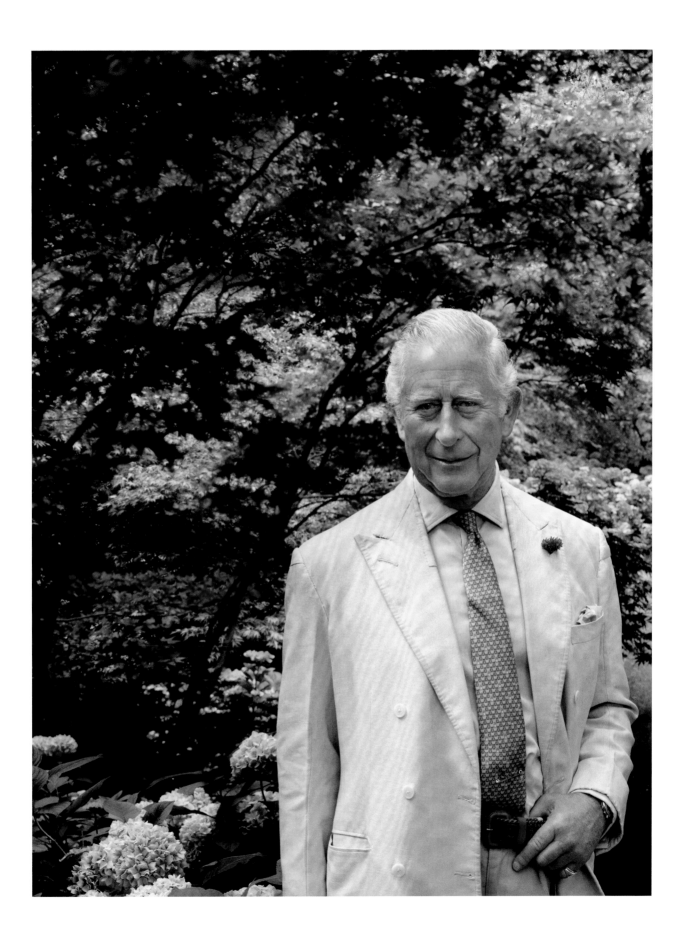

where to buy from, and the best companies will lead the way, we hope, in demonstrating that if you follow the right principles of operation, not only are you moving more and more towards net zero but also you're removing pollution and emissions from supply chains. Thirty years or so ago, I decided to look at those companies that apply for my warrant, where they put "By Appointment To" up outside their shop with a coat of arms. And I said, you're not going to get my warrant anymore unless you conform to the following – in those days, pretty basic – environmental requirements. And there were howls of protest and anguish and gnashing of teeth and they all said, "It'll ruin our businesses." I said, "Sorry, we have to do it." So of course, they went away, looked at their supply chains, looked at the way they did things. Lo and behold, they came back and said, "Well, actually, it's saved us money and made us money – to do it in a better way."

*We have to clean up our act.
But it can be done. There are
wonderful things going on.
But we need to scale up.*

**The pandemic has allowed the natural world to heal a little. As someone who contracted COVID, are you at least grateful for that silver lining?**

Yes, absolutely. But the tragedy, as we've heard recently, is that despite that, and despite lockdown, the rate of global warming is still accelerating. And we still haven't been able to tackle this issue, which is so utterly crucial if we're to avoid total catastrophe. Which is why, it seems to me, that the vital thing now is to buy more time in the battle to make the transition to an infinitely more sustainable, decarbonised economy. Because, again, there are extraordinary new developments in capturing carbon and finding new uses for the carbon you capture. But unless we take more of the emissions out of the atmosphere, particularly through coal-fired power plants and so on, we will never win this battle. We need to put nature back at the centre of everything we do in a circular bio-economy. Species are becoming extinct at a rapid rate. We can't go on like this, but there are solutions, we just need to act – and now.' *December 2020*

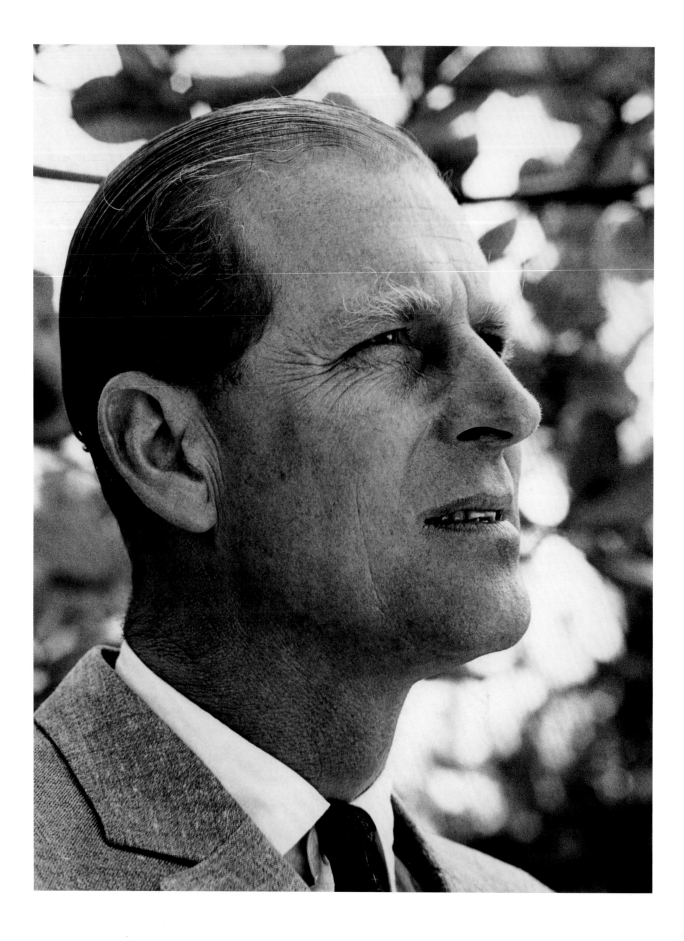

# Edinburgh Rock

← **The Duke of Edinburgh, c.1970.**

→ **The Duke of Edinburgh with his grandchildren Peter and Zara Phillips, 1984, by Tim Graham.**

COVID protocols ensured that, when the Duke of Edinburgh died in spring 2021 in his hundredth year, he had likely spent more time with the Queen than at any time since their honeymoon. They had been married for 73 years. At Christmas 1947, *Vogue* wished the newly-weds good luck in the dual aspect of their lives together, public and private. What *Vogue* and the couple did not realise, of course, was that four-and-a-half years later, Princess Elizabeth would become Queen Elizabeth II and the former Lt Philip Mountbatten RN her consort. Reputedly one of the finest officers in the senior service, his destiny was instead to walk several paces behind his wife, but his singularity of character guaranteed his views would never be ignored. His wife paid tribute to him on their 50th wedding anniversary: 'He has, quite simply, been my strength and stay all these years...'

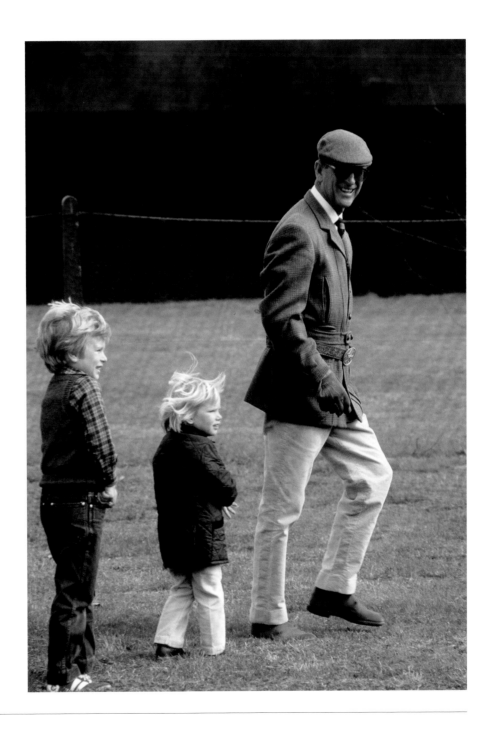

# In Salute

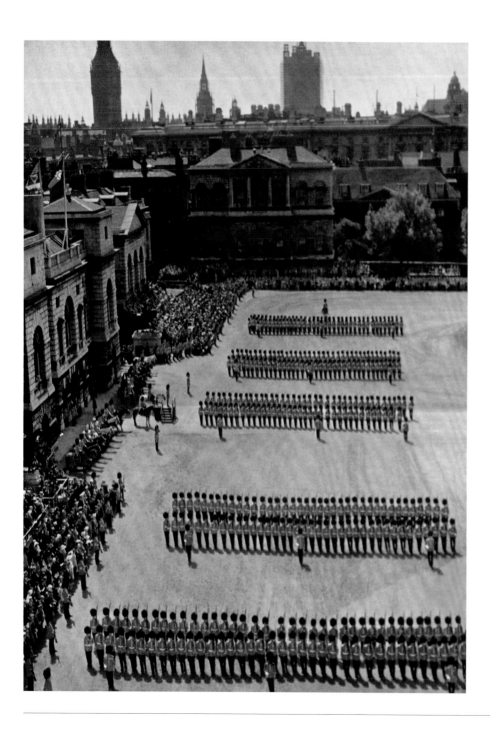

← Trooping the Colour, 1951, by Norman Parkinson.

→ **Queen Elizabeth II at the Trooping the Colour ceremony, 1963.**

The year 2022 was to mark Elizabeth II's Platinum Jubilee, the 70th anniversary of her accession to the throne. The eagerly anticipated celebrations for the longest reign in British history would be spectacular, ranging from a Thanksgiving Service in St Paul's and a greater-than-ever Trooping the Colour ceremony, to a historic pageant of horses, and a 'river' of silken flags in the Mall. How 'long to reign over us' a monarch in her mid-90s might be was unknowable; but beyond all doubt was the depth of pride and gratitude felt for the seven decades of devoted, selfless service from one of the greatest sovereigns ever to wear the Crown.

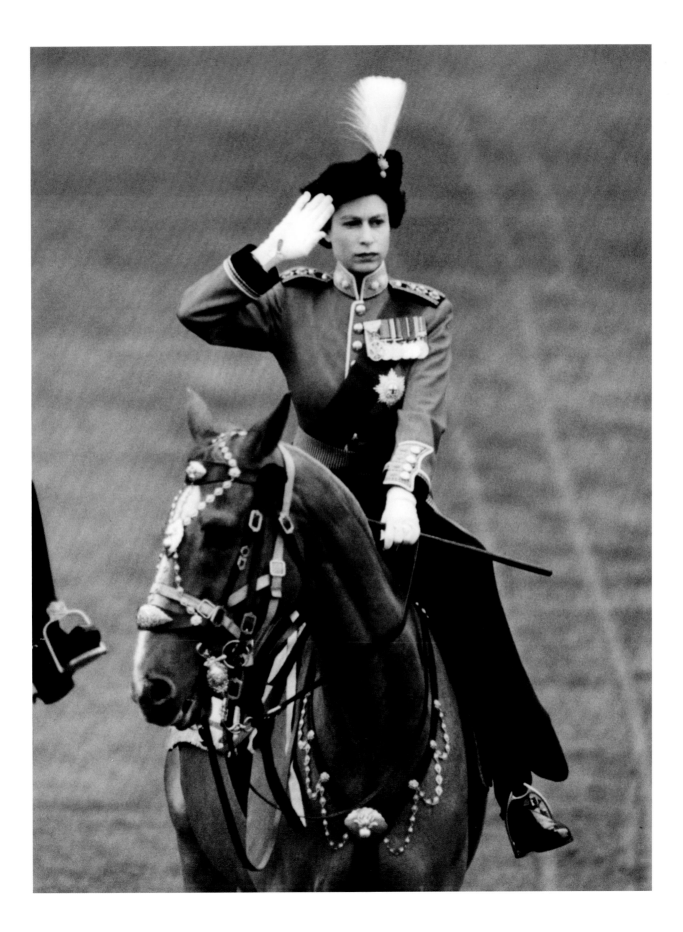

# Who's Who in *The Crown in Vogue*

**Adams, Marcus (1875–1959)**
Long renowned as a leading photographer of children, in 1919 he joined forces with Bertram Park and his wife Yvonne Gregory to establish a formidable photographic studio. His first photographs of Princess Elizabeth were taken in 1926 and he continued up to 1956 with his last royal sitter Princess Anne.

**Aris, Brian (b. 1946)**
Although a well-regarded royal photographer – he photographed the Queen for her 70th birthday and her golden wedding anniversary – for *Vogue* Aris mostly photographed members on tours abroad as one of Britain's leading photojournalists.

**Armstrong, Lisa** One of the outstanding figures in fashion today and currently head of the *Daily Telegraph*'s fashion team, writer and journalist Lisa Armstrong was formerly Fashion Features Editor at *Vogue,* much admired for her witty, highly informed and forthright style. She was recognized for her impact and influence by the award of an OBE in early 2022.

**Back, Steve (b. 1955)** Freelance photographer Steve Back has achieved near mythical status as the 'Downing Street document snatcher', snapping private ministerial papers carried by off-guard politicians. Years earlier, Back photographed Lady Diana Spencer in a diaphanous skirt that turned see-through in the afternoon sun. This unfortunate incident led to Lady Diana seeking *Vogue*'s help with a more appropriate wardrobe.

**Bailey, David (b. 1938)**
One of Britain's best-known photographers and an uninterrupted mainstay of *Vogue* since 1960. His fashion and portrait photographs defined *Vogue*'s 1960s and he is surely its longest-serving photographer. He documented the wedding of the Prince of Wales in 1981 and made a further portrait of him in 1992.

**Beaton, Sir Cecil (1904–1980)**
A towering figure of 20th-century British culture, Beaton's long career with *Vogue* started in earnest in 1927 and lasted until 1979. More than any other photographer he changed the public's perception of the Royal Family and helped it to flourish in the post-war years.

**Beck, Maurice (1880–1960) and Helen Macgregor (1876–*c*.1954)**
Known by the joint by-line 'Beck and Macgregor', the two photographers worked from a studio in Marylebone. In the era before Cecil Beaton, they were *Vogue*'s chief photographers, specializing in portraits of the literary and artistic figures of the Bloomsbury Group.

**Bell, Edward** For *Vogue*, artist and photographer Edward Bell covered only a few reportage assignments before branching out into the more creatively satisfying milieu of music photography. His album and singles covers for musician David Bowie, with encouragement from Brian Duffy (q.v.), are justifiably renowned.

**Beyfus, Drusilla (b. 1927)**
Starting out in 1944 as a junior reporter on a local newspaper, Drusilla Beyfus graduated to the 'Woman's Page' of the *Daily Express* (as well as covering the blockade of Berlin in 1948). She became an editor at *Vogue* under Beatrix Miller, whom she had worked with at *Queen* magazine. A near contemporary, she profiled the Queen on her 90th birthday in 2016. Her latest of many books is *Vogue on Hubert de Givenchy* (2015).

**Blahnik, Manolo (b. 1942)**
Shoe designer Manolo Blahnik, from the Canary Islands, has been a fixture in *Vogue* since the early 1970s. Charming and stylish himself, in 1973 Blahnik was photographed with a young Anjelica Huston for the cover of the magazine – up until then only the third man to appear there.

**Blake, Sir Peter (b. 1932)**
Alongside his friend David Hockney, probably Britain's greatest living painter. He has frequently engaged with popular culture, and elements drawn from, for example, the golden age of Hollywood and the British music hall tradition have found their way into his vivid artworks. For *Vogue* in 2017 he made a portrait of the Queen and another a year later of Meghan Markle, later Duchess of Sussex.

**Blanch, Lesley (1904–2007)**
*The Wilder Shores of Love* (1954) is perhaps Lesley Blanch's best known non-fiction work, but many of her histories and travel books are still in print. The subject of two biographies herself, Blanch was *Vogue*'s Features Editor from 1937 to 1944, her despatches from the London Blitz some of its most powerful wartime writing.

**Bouché, René (1905–1963)**
A leading light of pre- and post-war fashion illustration, Bouché based himself in Paris and the south of France. His despatches on the goings-on of the *beau monde* at play were much appreciated by *Vogue*. Among his sitters were Truman Capote, Somerset Maugham and Jacqueline Kennedy.

**Broad, Julian (b.1964)** Julian Broad spent two eventful years assisting Lord Snowdon on location and at his South Kensington studio. His is one of the most recognizable names in photography today, having worked for most major publications including regularly for *Vogue* and *Vanity Fair*. In 2007, he returned to the South Kensington studio to photograph his former mentor for *Vogue*.

**Bryant, Sir Arthur (1899–1985)**
The popular historian and columnist's many books were distinguished by their scholarship, style and readability. He was a contributor to *Vogue* on a range of subjects, mostly royal. In later life he was an accomplished broadcaster and helped organize many national pageants, often with a royal flavour.

**Cecil, Hugh (1892–1974)** Born Hugh Saunders, he assumed the *nom-de-guerre* 'Cecil' on setting up a photographic business in London's West End. He proved successful and in 1925 the Prince of Wales (later Edward VIII) sat for him, the first of many royal sitters. In 1926, he published a much-imitated volume of pictures, *Book of Beauty*.

**Chapman, Frederick (1887–1983)** Prolific American artist and magazine illustrator. Best known for his contributions to *Woman's Home Companion* and *Collier's* as well as illustrations for popular children's books.

**Cherruault, Lionel (b. 1959)** After several years working for the picture agency Camera Press, Lionel Cherruault became accredited as a freelance royal photographer, an admired member of the press pack. His pictures of royal visits, especially overseas, were often published in *Vogue*.

**Coster, Howard (1885–1959)** The credit line 'Coster, Photographer of Men' singled him out from his contemporaries. By this he meant, of course, the great figures of the day in the arts and politics. His significant 8000-negative archive now rests in the National Portrait Gallery, London.

**Dawson, Charles James (1917–2006)** His portrait of a smiling Queen Elizabeth II returning from the State Opening of Parliament in 1952, published in *Vogue* and around the world, is likely his best known photograph. He had been an accomplished war photographer, covering in 1943 the allied invasion of Sicily, and was mentioned in despatches.

**Demarchelier, Patrick (b. 1943)** The best of Demarchelier's fashion photographs are distinguished by their relaxed and informal style, a 'snapshot aesthetic'. He brought the same sensibility to his *Vogue* portraits of Diana, Princess of Wales. They remain among the best-known images of the princess.

**Donovan, Terence (1936–1996)** One of the towering figures of 20th-century British photography, Terence Donovan's archive spans five decades. His *Vogue* photographs have appeared in many collections, most recently *Terence Donovan 100 Fashion Photographs* (2021). Between 1986 and 1990, Diana, Princess of Wales, sat for Donovan on four occasions.

**Downey, W & D (fl. 1860s to 1920s)** Long-established and dependable Court photographers, patronized by Queen Victoria and her family, especially by the Prince of Wales (later Edward VII) and Princess (later Queen) Alexandra, its first royal subject. The firm received a Royal Warrant in 1879.

**Duffy, Brian (1936–2010)** Associated with his 'Swinging Sixties' colleagues, David Bailey (q.v.) and Terence Donovan (q.v.), all three recognized at *Vogue* solely by their surnames. Duffy's fashion and portrait photography is regarded as among the best of his era. His career as a royal photographer did not last further than snapshots at the wedding of his colleague Tony Armstrong Jones.

**Enninful, Edward (b. 1972)** Editor-in-Chief of British *Vogue* since 2017 and from 2021 European Editorial Director, Edward Enninful's inaugural issue featured an appraisal of the monarchy by Zadie Smith (q.v.) with a portrait by Sir Peter Blake.

**Erickson, Carl ('Eric') (1891–1958)** A prolific fashion illustrator who turned his hand to the drawn portrait. Norman Parkinson (q.v.) recalled his Swedish-born friend as 'a pale and elegant William-pear of a man.. his perhaps the most talented contribution to [*Vogue*'s] formative years.'

**Fraser, Lady Antonia (b. 1932)** The author of many major histories and biographies, some on royal subjects, as well as detective-novelist, Dame Antonia has made regular appearances in *Vogue*, both as a writer and as cultural celebrity. Her most recent article was a personal account of Princess Elizabeth's wedding day.

**Graham, Tim (b. 1948)** An acclaimed royal photographer, one of Tim Graham's earliest assignments was covering the Queen's Silver Jubilee overseas tour. Thereafter, he was an invaluable member of the accredited press pack. A portrait of Diana, Princess of Wales, appeared on the cover of American *Vogue*.

**Grugeon, Peter (1918–1980)** The Silver Jubilee found veteran royal photographer Peter Grugeon at his apogee. His head-and-shoulders shot of the Queen, an official portrait from 1975, gained extra impact as the basis for the design by Jamie Reid of the Sex Pistols' notorious single *God Save the Queen* (1977).

**Harvey, Anna (1944–2018)** The respected fashion editor occupied a unique role in and out of *Vogue*. In 1980, at Vogue House London, she met and forged a lasting friendship with Lady Diana Spencer. Harvey was invaluable in the years to come as a style advisor, helping the new Princess of Wales navigate an occasionally treacherous world. In 1997, she wrote *Vogue*'s obituary of her late friend.

**Hirsch, Afua (b. 1981)** In 2018, the Norwegian-born writer, journalist and broadcaster contributed an essay to *Vogue*: 'The Meaning of Meghan' on the future Duchess of Sussex as a 'game-changing role model for millions'. The same year she published her best-selling part-memoir, part-history *Brit(ish): On Race, Identity and Belonging*.

**Hoppé E(mil) O(tto) (1878–1972)** The most fashionable photographer of his day, who at his height operated from a 33-room Kensington house (formerly Millais' studio). Unlike his contemporaries he did not rely on props and tricks to flatter his sitters, seeking instead 'a truthful likeness'.

**Horst (Horst. P. Bohrmann) (1906–1999)** Horst had a long-lasting career as a *Vogue* photographer. His familiar by-line – 'Horst' – became a byword for the rarefied elegance and consummate style of the 1930s, though he would continue at *Vogue* for a further 60 years.

**Howell, Georgina (1942–2016)** Georgina Howell was a staff member of *Vogue* for several years before becoming Features Editor. Her essays and profiles for *The Sunday Times Magazine* and for American *Vogue* were met with great acclaim. In 1975, she published *In Vogue: Six Decades of Fashion*.

**Hussein, Anwar (b. 1938)** In 2016, with a career lasting over 40 years, Anwar Hussein

became the longest-serving royal photographer, his images marked by a relaxed informality. His son, **Samir Hussein (b. 1979)**, is also an official royal photographer. In 2020, he was awarded the title 'Royal Photographer of the Year'.

**Knight, Nick (b. 1958)** Image maker Nick Knight's more radical ideas find expression on SHOWstudio, established in 2000, promoting a new way of seeing fashion, using film and real-time performance, as well as photography. In 2016, Knight made an official portrait of the Queen with her son and heir Prince Charles to mark the monarch's 90th birthday, and photographed Prince Charles in 2020 for *Vogue*.

**Lacombe, Brigitte (b. 1950)** Best known for her Hollywood portraits and film location work (she started out on Federico Fellini's *Casanova* and Alan J. Pakula's *All The President's Men*, both 1976), Brigitte Lacombe has only rarely shot for British *Vogue* . One of her few shoots was her only royal assignment with the Duchess of York in 1996.

**Lavererie, Raymond de (1901–1956)** De Lavererie was a fixture at French *Vogue*, launched in 1920, mostly for witty, decorative black-and-white flourishes. He also worked in advertising, producing memorable designs for Kayser Stockings.

**Lawford, Valentine (Nicholas) (1911–1991)** The long-term partner of Horst (q.v.), Valentine Lawford, formerly a diplomat, joined him in his later career as an interiors photographer, writing the accompanying texts. These contributions have most recently been collected in *Around that Time: Horst at Home in Vogue* (2016).

**Leslie, Seymour** The novelist Seymour Leslie was a regular contributor to *Vogue* on a variety of subjects from royal affairs ('the dull pain of sadness' of Edward

VIII's abdication) to the vagaries of upper-class visitors to Europe. He formed a friendship with Aldous Huxley, briefly an editor in *Vogue*'s copy department.

**Liberman, Alexander (1912–1999)** Liberman ruled over *Vogue* – for a while all editions – as Art Director and later Editorial Director for some 32 years. He was also a gifted photographer and a sculptor of large-scale conceptual works. His portraits of artists were collected in *The Artist in his Studio* (1960).

**Lichfield, Patrick (The Earl of) (1939–2005)** Lord Lichfield was a kissing cousin to the Queen and enjoyed a privileged position as a royal photographer, having left the Grenadier Guards. He was under contract to American *Vogue* for several years from 1967. Perhaps his best-known royal commission was the wedding of Prince Charles to Lady Diana Spencer.

**Lindbergh, Peter (1944–2019)** The legendary Paris-based German photographer, who started with *Vogue* in the late 1970s, was brought in to make the portraits for 'Forces for Change', the issue of *Vogue* guest-edited by the Duchess of Sussex. It would be his last significant shoot. He died in the month it appeared.

**McMullin, John (Johnnie)** A flamboyant figure of the inter-to-post war years, McMullin was American *Vogue*'s invaluable social editor and man-about-town. He was close to society decorator and inveterate party-goer Elsie de Wolfe, and through her achieved *entrée* to the smartest occasions.

**Man Ray (Emmanuel Rudnitsky) (1890–1976)** Initially a painter, the American Man Ray is better known for his avant-garde photography and creation of Surrealist-inspired objects. Alongside his innovative image making, he made striking

portraits of figures in the arts and society for *Vogue* and other magazines.

**Manton, Denis** The illustrator, who appears briefly to have been attached to *Vogue*'s art department, made few designs and drawings for the magazine. The best known remains 'To Wish Them Well', a celebratory sketch of Princess Margaret and her fiancé Tony Armstrong Jones.

**Marty, A(ndré) E(douard) (1882–1974)** A Paris-based artist, one of the best-known names from the golden age of fashion illustration. A regular contributor to *La Gazette du Bon Ton*, as well as to *Vogue* and *Vanity Fair*, he also designed theatre posters for the Ballets Russes and the Paris Opera.

**Maze, Paul (1887–1979)** Fame came to the now celebrated Anglo-French painter in his 30s. He was Winston Churchill's mentor and a frequent visitor to Chartwell. Among many royal pageants and occasions, he recorded George V's Silver Jubilee, the funeral of George VI and was the Official Artist for Queen Elizabeth II's coronation.

**Millar and Harris (*fl.* 1930s to 1980s)** Historic England now holds the vast archive of this photographic firm, perhaps Britain's most significant firm of architectural photographers. *Vogue* made extensive use of their services for interior shots, especially for its occasional 'House & Garden' supplements.

**Molden, Clara** Barely a year after graduating from the University of Bristol, Clara Molden won *The Times* newspaper's 'Young Photographer of the Year' and hers has been a prominent by-line ever since. In 2011, her photographs from the wedding of Prince William and Catherine Middleton featured prominently in *Vogue*.

**Mower, Sarah** One of the most distinguished fashion writers and

critics of her generation, Sarah Mower won the *Vogue* Talent Contest while a student at Leeds University. A trenchant observer of the fashion industry, she is currently a Contributing Editor to both British and American *Vogue* and a trustee of the British Fashion Council Education Foundation.

**North, Peter (*fl.* 1930s to 1950s)** Peter North, whose contributions to *Vogue* were sparse, was active as a photographer in literature and the arts and forged a friendship with Cecil Beaton, whom he photographed on several occasions. His royal sitters included Princess Marina, Duchess of Kent, and, on his unanticipated accession to the throne, George VI.

**Parkinson, Norman (1913–1990)** Parkinson was apprenticed to royal photographers Speaight & Son before branching out on his own. From 1941 he began a long association with *Vogue*, which ended in the late 1970s. He became an official royal photographer in 1969 with his portraits of Princess Anne. He was a firm favourite of Queen Elizabeth The Queen Mother.

**Olins, Josh (b.1980)** As the son of the occasional *Vogue* photographer David Olins, it was perhaps predestined that Josh Olins would pick up a camera. A frequent contributor to *Vogue*, he is known for the understated, informal elegance of his pictures, and a demonstrable sense of fun. In 2016, the Duchess of Cambridge chose him to take her first *Vogue* cover image, coinciding with the magazine's centenary.

**Pithers, Ellie** An English Literature graduate of the University of Cambridge, Ellie Pithers joined British *Vogue* in 2015 as Fashion Features Editor and is currently a Contributing Editor. She was previously a fashion writer for the *Daily*

*Telegraph*. She masterminded and wrote up *Vogue*'s 2018 shoot with Princesses Beatrice and Eugenie, noting with commendable equanimity that at one stage one of their terriers 'relieved himself on the ruffled hem of Beatrice's cape.'

**Pulbrook, Lady (Susan) (1906–2011)** The co-founder of one of Britain's best-known florists had wide-ranging social contacts. Pulbrook & Gould provided arrangements for the weddings of Katharine Worsley to the Duke of Kent and Princess Alexandra to Angus Ogilvy.

**Rawlings, John (1912 – 1970)** One of the most prolific fashion photographers of the post-war years, credited with over 200 covers for *Vogue* and its sister magazine *Glamour*. Early in his career, Rawlings, born in Ohio, served an apprenticeship at British *Vogue*.

**Rowse, A(lfred) L(eslie) (1903–1997)** The historian, writer and academic was also an unsuccessful parliamentary candidate, his politics veering from left to right. He was also a newspaper columnist and wrote for numerous magazines and journals and was much in demand as a lecturer and television commentator.

**Roy, Pierre (1880–1950)** The French painter showed in the first exhibition of Surrealist artists alongside Ernst and Picasso in 1925. His use of everyday objects, such as ribbons and scissors, made for several eye-catching *trompe-l'oeil Vogue* covers.

**Schall, Roger (1904–1995)** The French photo-journalist-turned-fashion-photographer holds a unique place in *Vogue*'s history for shooting fashion in the street rather than the studio, documenting clothes as they were intended to be worn. He continued his reportage to great effect too.

**Shulman, Alexandra (b. 1957)** A writer, journalist and memoirist, Shulman was Editor-in-Chief of British *Vogue* from 1992 to 2017, the longest serving in *Vogue*'s history. Understanding how closely bound the magazine history has been to that of the nation's heritage, Shulman's *Vogue* regularly featured the Royal Family. In 2001, a special issue was given over to royalty past and present, 'A Royal Salute'.

**Sitwell, Sir Sacheverell (1897–1988)** Younger brother of Edith and Osbert and last surviving member of the celebrated literary triumvirate, Sacheverell Sitwell was best known for his books on art, literature and travel. His poetry in a traditional style was eclipsed by his sister's more baroque approach.

**Smith, Zadie (b. 1975)** The novelist and essayist Zadie Smith won almost instant and near universal acclaim for her debut novel *White Teeth* (2000), which won the James Tait Black Memorial Prize. Four further novels cemented her reputation. For *Vogue* in 2017, the debut issue of editor Edward Enninful, she wrote 'Mrs Windsor', an essay on Queen Elizabeth, 'the most photographed queen in history'.

**Snowdon, The Earl of (Antony Armstrong Jones) (1930–2017)** *See page 264.*

**Soames, Emma (b. 1949)** A granddaughter of Winston Churchill, journalist and writer Emma Soames had a grandstand pew at the Prince of Wales's wedding. She was for a time Features Editor of *Vogue* and later Editor of its sister publication *Tatler*.

**Spencer-Churchill, Lady Norah (1875–1946)** The youngest daughter of the 8th Duke of Marlborough was better known as a pioneering educationalist. Her contributions to *Vogue* were regrettably few.

**Studio Lisa (Lisa Sheridan 1894–1966)** With her husband James, Lisa Sheridan ran a photographic studio off Shaftesbury Avenue. Her first royal commission came in 1936 when she was invited to photograph the Royal Family at Windsor. Her understated style reflected the easy-going nature of the new King and his family.

**Testino, Mario (b. 1954)** Mario Testino, born in Peru, is celebrated for his high-octane fashion photographs and high-sheen portraits. He carried out several royal sittings for *Vogue*, chiefly of the Prince of Wales and his two sons, but it is likely he will be best remembered in this respect for his portraits for *Vanity Fair* of Diana, Princess of Wales, the 'last sitting' published a month before her death.

**Thomas, Sean** Born in Omaha, Nebraska, fashion and portrait photographer Sean Thomas currently divides his time between London and New York. He has been described as 'as much of a storyteller as he is photographer. He is known for his energetic and candid photographs that narrate a constant exploration of the human condition.'

**Topolski, Feliks (1907–1989)** The Polish-born painter and illustrator came to Britain in 1935 after accepting an invitation to record the coronation of George V. He was subsequently an official war artist. For *Vogue*, he attended three royal weddings: Princess Elizabeth's, her sister Margaret's and latterly the Prince of Wales's to Lady Diana Spencer.

**Vandyk Studio (*fl.* 1880s–1940s)** German-born Carl Vandyk founded his Gloucester Road studio in 1882, specializing in royal portraiture, moving to Buckingham Palace Road in 1901. His son Herbert took over in 1913 and garnered 22 Royal Warrants.

**Ward, John (1917–2007)** During his lifetime John Ward was one of Britain's best known illustrators. He had studied at the Royal College of Art under Gilbert Spencer before regularly contributing work to *Vogue*. He was an accomplished royal portraitist, drawing Diana, Princess of Wales, at her wedding and attending the christenings of Princes William and Harry. He also gave drawing lessons to Prince Charles

**Waugh, Evelyn (1903–1966)** The celebrated writer found success with his first published novel, the satirical *Decline and Fall* (1928), but it was *Vile Bodies* (1930), his chilling dissection of the 'Bright Young Things', that made him a literary sensation. A frequent contributor to *Vogue*, mostly as a book reviewer and essayist on newsworthy topics.

**Whistler, Rex (1905–1944)** Primarily a muralist and painter and set and costume designer, Whistler could add a *jeu d'esprit* to almost anything: bookplates and letter headings, textiles and Axminster carpets, as well as magazine covers and decorative flourishes for *Vogue*.

**Williams, Antonia (1940–2020)** A stalwart of the *Vogue* features department for 22 years, New Zealand-born Williams urged *Vogue* to be more racially inclusive and to embrace street fashion and the punk movement. She contributed many articles on the Royal Family, credited and uncredited, and once ghost-wrote a column for Princess Margaret.

# The Royal Family Tree

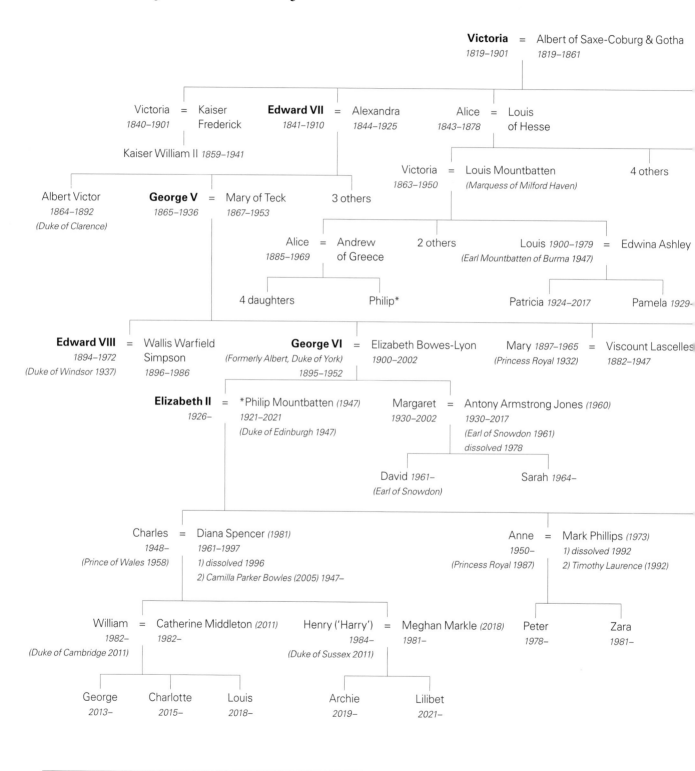

**Victoria** *1819–1901* = Albert of Saxe-Coburg & Gotha *1819–1861*

Victoria *1840–1901* = Kaiser Frederick

Kaiser William II *1859–1941*

**Edward VII** *1841–1910* = Alexandra *1844–1925*

Alice *1843–1878* = Louis of Hesse

Victoria *1863–1950* = Louis Mountbatten *(Marquess of Milford Haven)*

4 others

Albert Victor *1864–1892* *(Duke of Clarence)*

**George V** *1865–1936* = Mary of Teck *1867–1953*

3 others

Alice *1885–1969* = Andrew of Greece

2 others

Louis *1900–1979* = Edwina Ashley *(Earl Mountbatten of Burma 1947)*

4 daughters

Philip*

Patricia *1924–2017*

Pamela *1929–*

**Edward VIII** *1894–1972* *(Duke of Windsor 1937)* = Wallis Warfield Simpson *1896–1986*

**George VI** *(Formerly Albert, Duke of York)* *1895–1952* = Elizabeth Bowes-Lyon *1900–2002*

Mary *1897–1965* *(Princess Royal 1932)* = Viscount Lascelles *1882–1947*

**Elizabeth II** *1926–* = *Philip Mountbatten *(1947)* *1921–2021* *(Duke of Edinburgh 1947)*

Margaret *1930–2002* = Antony Armstrong Jones *(1960)* *1930–2017* *(Earl of Snowdon 1961)* *dissolved 1978*

David *1961–* *(Earl of Snowdon)*

Sarah *1964–*

Charles *1948–* *(Prince of Wales 1958)* = Diana Spencer *(1981)* *1961–1997* *1) dissolved 1996* *2) Camilla Parker Bowles (2005) 1947–*

Anne *1950–* *(Princess Royal 1987)* = Mark Phillips *(1973)* *1) dissolved 1992* *2) Timothy Laurence (1992)*

William *1982–* *(Duke of Cambridge 2011)* = Catherine Middleton *(2011)* *1982–*

Henry ('Harry') *1984–* *(Duke of Sussex 2011)* = Meghan Markle *(2018)* *1981–*

Peter *1978–*

Zara *1981–*

George *2013–*

Charlotte *2015–*

Louis *2018–*

Archie *2019–*

Lilibet *2021–*

| | | | |
|---|---|---|---|
| 4 others | Leopold = Helena of | | 1 other |
| | *1853–1884* Waldeck | | |

Alix = Tsar Nicholas II
*1872–1918*

Alice = Earl of Athlone
*1883–1981*

4 daughters    Alexis
*1904–1918*
*(Tsarevich)*

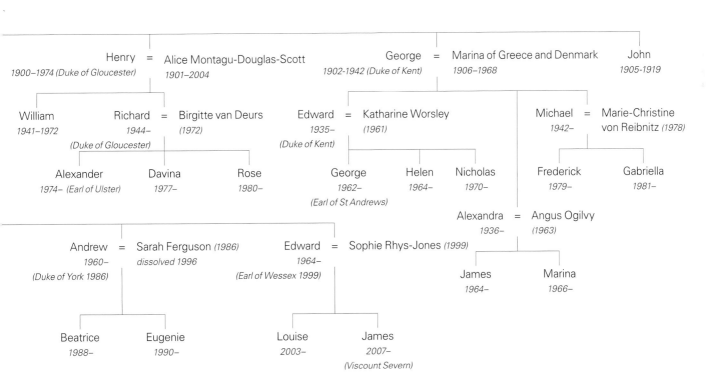

Henry = Alice Montagu-Douglas-Scott
*1900–1974 (Duke of Gloucester)*    *1901–2004*

George = Marina of Greece and Denmark
*1902-1942 (Duke of Kent)*    *1906–1968*

John
*1905-1919*

William
*1941–1972*

Richard = Birgitte van Deurs
*1944–*    *(1972)*
*(Duke of Gloucester)*

Edward = Katharine Worsley
*1935–*    *(1961)*
*(Duke of Kent)*

Michael = Marie-Christine
*1942–*    von Reibnitz *(1978)*

Alexander    Davina    Rose
*1974– (Earl of Ulster)*    *1977–*    *1980–*

George    Helen    Nicholas
*1962–*    *1964–*    *1970–*
*(Earl of St Andrews)*

Frederick    Gabriella
*1979–*    *1981–*

Alexandra = Angus Ogilvy
*1936–*    *(1963)*

Andrew = Sarah Ferguson *(1986)*
*1960–*    dissolved 1996
*(Duke of York 1986)*

Edward = Sophie Rhys-Jones *(1999)*
*1964–*
*(Earl of Wessex 1999)*

James    Marina
*1964–*    *1966–*

Beatrice    Eugenie
*1988–*    *1990–*

Louise    James
*2003–*    *2007–*
*(Viscount Severn)*

Detailed above is the Royal Family, in descent from Queen Victoria, with current first-generation offspring closest to the throne, and such earlier kin as relate to, or feature in, this book.

# Index

# Acknowledgements

The authors would like to acknowledge the prescience of *Vogue*'s editors, who for over a century recognised the significance of the Crown in our national life, as well as the writers they have commissioned, whose words as published here are mostly abridged from longer essays.

They are particularly grateful to *Vogue*'s Editor-in-Chief, Edward Enninful, for his generous and insightful foreword to this book.

At Vogue House, London, they would also like to thank Harriet Wilson (formerly Director of Editorial Administration and Rights) and the current Library staff, Rebecca Lee, Florie Harding and especially Frith Carlisle, who prepared the images for publication. They are grateful also to Jessica Borges (Editorial Business Manager), Mark Russell (Global Print Strategy Lead and European Content Operations Director) and Giles Hattersley (Global Network Lead and European Features Director). They have benefitted greatly from the advice and input of Condé Nast's literary agent, Julian Alexander of The Soho Agency.

At Conran Octopus the authors have been fortunate to work with a superb team: Alison Starling (Publisher), Pollyanna Poulter (Senior Editor) and Katherine Hockley (Senior Production Manager). Jonathan Christie (Creative Director) has art directed and laid out the book with great sensitivity for *Vogue*'s historic archive of pictures.

For their assistance in securing key images, Robin Muir would like to thank Miranda Barbot (Archewell, New York); Ellie Brown and Carrie Kania (Iconic Images); Diana Donovan and Alex Anthony (The Terence Donovan Archive); Elizabeth Kerr (Camera Press); Catherine LaBate (Getty Images); and Isaac Lobel and Ivan Shaw (The Condé Nast Publications Inc, New York).

Josephine Ross would like to express her thanks to Clare Alexander, Fergus Poncia, Timothy Ross and Rollo Webb.

# Picture Credits

**Thunder Bay Press**
An imprint of Printers Row Publishing Group
9717 Pacific Heights Blvd, San Diego, CA 92121
www.thunderbaybooks.com • mail@thunderbaybooks.com

Printers Row Publishing Group is a division of Readerlink Distribution Services, LLC.
Thunder Bay Press is a registered trademark of Readerlink Distribution Services, LLC.

Correspondence regarding the content of this book should be sent to Thunder Bay Press, Editorial Department, at the above address. Author, illustration, or rights inquiries should be addressed to Octopus Publishing Group Ltd, Carmelite House, 50 Victoria Embankment, London, EC4Y 0DZ, UK.

| **Thunder Bay Press** | **Conran Octopus** |
| --- | --- |
| **Publisher:** Peter Norton | **Publisher:** Alison Starling |
| **Associate Publisher:** Ana Parker | **Creative Director:** Jonathan Christie |
| **Editor:** Dan Mansfield | **Senior Editor:** Pollyanna Poulter |
| **Acquisitions Editor:** Kathryn Chipinka Dalby | **Senior Production Manager:** Katherine Hockley |

Library of Congress Cataloging-in-Publication data available on request.

ISBN: 978-1-6672-0048-4

Printed in China

26 25 24 23 22   1 2 3 4 5

## *About the Authors*

**Robin Muir** is a photographic historian and writer on photography. He has curated major exhibitions at the National Portrait Gallery, the Victoria & Albert Museum and the Yale Center for British Art, New Haven. His most recent exhibitions are *Vogue 100: A Century of Style* and *Cecil Beaton's Bright Young Things* (both National Portrait Gallery, 2016 and 2020). Formerly Picture Editor of *Vogue*, he is currently a Contributing Editor with the magazine.

**Josephine Ross** is a literary and royal historian, the acknowledged expert on Cecil Beaton's career with *Vogue* and an authority on the life and works of Jane Austen, the subject of her most recent book, *Jane Austen and her World* (2017). Her previous books include *The Monarchs of Britain* (1982); *Beaton in Vogue* (1986); *Royalty in Vogue* (1989); and *Society in Vogue: The International Set Between the Wars* (1992).

**Cover**
(Front) The Princess of Wales, 1990, by Patrick Demarchelier.
(Back) Princess Elizabeth, 1948, by Cecil Beaton.

**Page 2**
Near Buckingham Palace, Royal Wedding Day, 1981.

**Page 4**
Photographers outside the Grosvenor Chapel, Mayfair, 1970, by Lichfield.